OREGON III

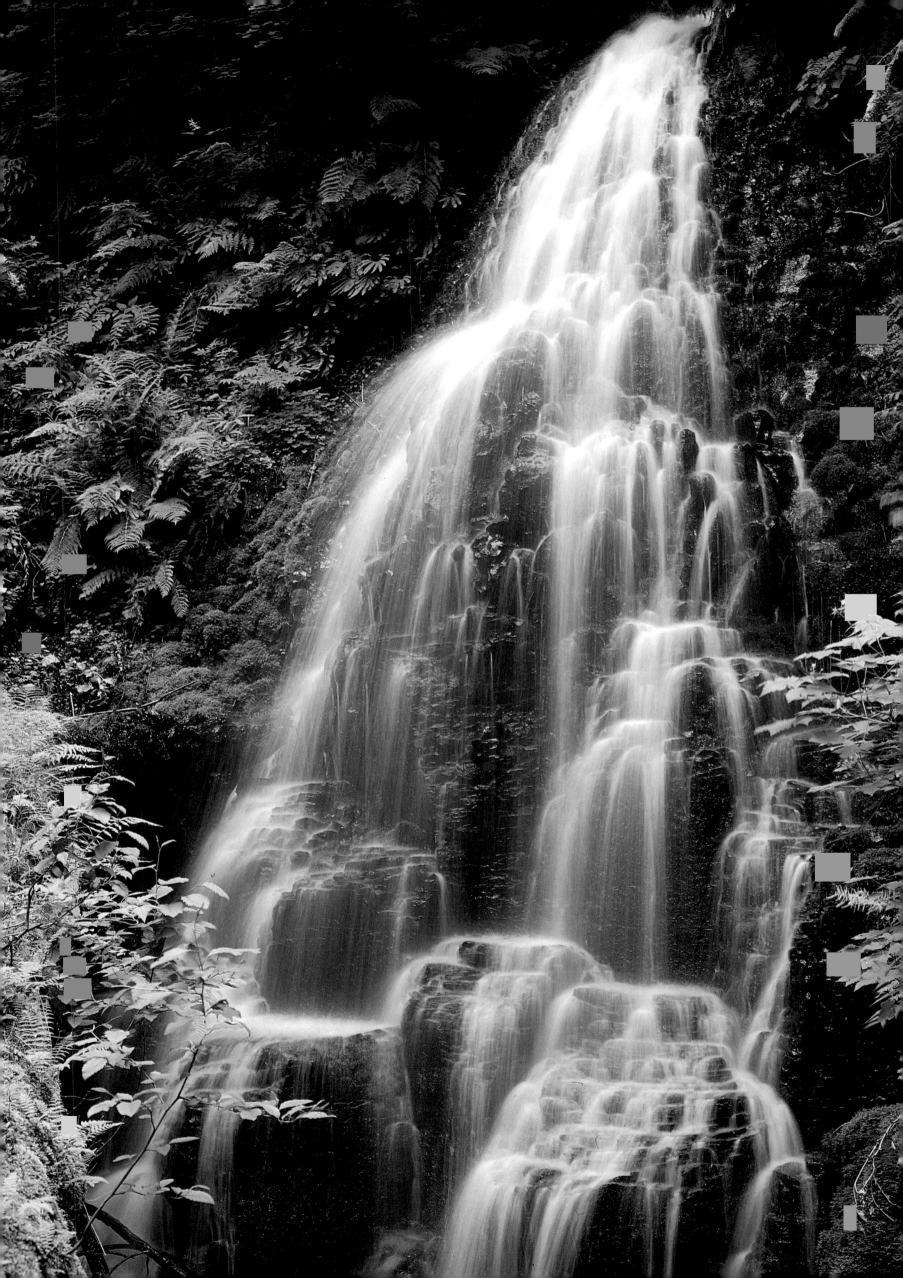

OREGON III

PHOTOGRAPHY BY RAY ATKESON

TEXT BY RICHARD ROSS

GRAPHIC ARTS CENTER PUBLISHING COMPANY
PORTLAND, OREGON

International Standard Book Number 0-932575-28-5
Library of Congress Catalog Number 86-083247
Copyright © MCMLXXXVII by Graphic Arts Center Publishing Company
P.O. Box 10306 • Portland, Oregon 97210 • (503) 226-2402
Editor-in-Chief • Douglas A. Pfeiffer
Designer • Robert Reynolds
Cartographer • Tom Patterson
Typographer • Paul O. Giesey/Adcrafters
Printer • Bridgetown Printing Co.
Bindery • Lincoln & Allen
Printed in the United States of America
Eleventh Printing

■ *Frontispiece:* Fairy Falls dances down a lava cliff in the Mount Hood National Forest. Located above Wahkeena Falls in the Oregon Cascades, Fairy Falls can be reached by a two-mile trail climb from the Columbia Gorge.

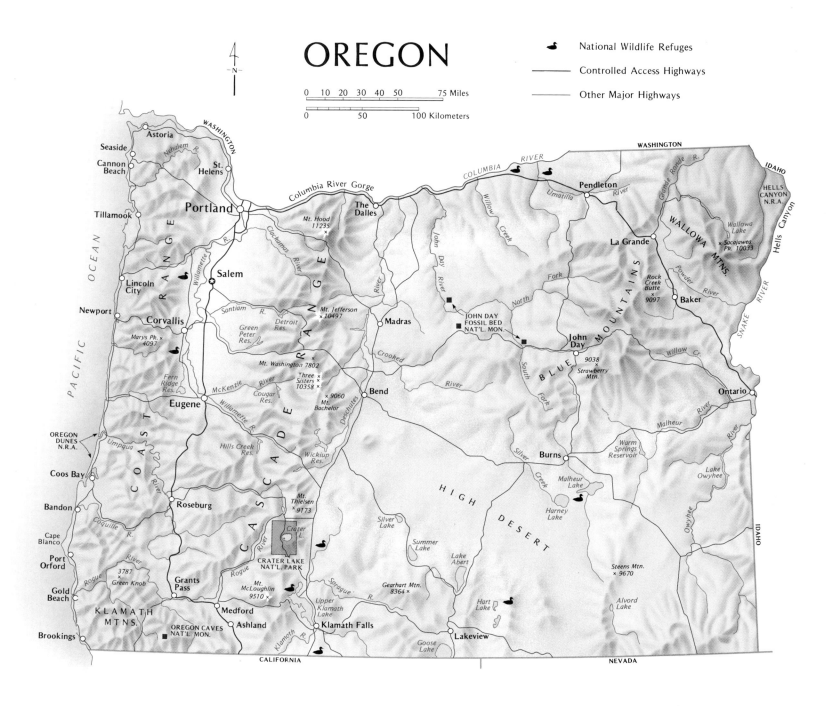

OREGON

National Wildlife Refuges

Controlled Access Highways

Other Major Highways

0 10 20 30 40 50 75 Miles

0 50 100 Kilometers

N

WASHINGTON

WASHINGTON

IDAHO

OCEAN

PACIFIC

Astoria

Seaside

Cannon Beach

St. Helens

Nehalem R.

Columbia River Gorge

COLUMBIA RIVER

Umatilla

Pendleton

HELLS CANYON N.R.A.

Grande Ronde R.

Tillamook

Portland

The Dalles

Willow Creek

Willamette R.

Mt. Hood 11235 ×

Clackamas River

WALLOWA MTNS.

Wallowa Lake

Hells Canyon

Lincoln City

Salem

COAST RANGE

John Day River

La Grande

× Sacajawea Pk. 10033

Newport

Corvallis

Santiam R.

Mt. Jefferson × 10497

Madras

North Fork

Rock Creek Butte × 9097

Baker

Powder River

Marys Pk. × 4097

Green Peter Res.

Detroit Res.

JOHN DAY FOSSIL BED NAT'L. MON.

BLUE MOUNTAINS

Willow Cr.

SNAKE RIVER

Mt. Washington 7802

Crooked

John Day

9038 × Strawberry Mtn.

Eugene

McKenzie River

Three Sisters × 10358

Cougar Res.

× 9060 Mt. Bachelor

Bend

River

Deschutes

Ontario

Willamette R.

Fern Ridge Res.

Malheur River

OREGON DUNES N.R.A.

Umpqua River

Hills Creek Res.

Wickiup Res.

Silver Creek

Warm Springs Reservoir

Coos Bay

Bandon

Roseburg

Mt. Thielsen × 9173

South Fork

Burns

Malheur Lake

Lake Owyhee

Cape Blanco

Crater L.

HIGH DESERT

Coquille R.

Port Orford

Rogue River

CRATER LAKE NAT'L. PARK

Silver Lake

Harney Lake

Owyhee River

Gold Beach

3787 × Green Knob

Grants Pass

Rogue River

Mt. McLoughlin 9510 ×

Summer Lake

Steens Mtn. × 9670

Brookings

KLAMATH MTNS.

Medford

OREGON CAVES NAT'L. MON.

Ashland

Upper Klamath Lake

Sprague R.

Gearhart Mtn. 8364 ×

Lake Abert

Hart Lake

Alvord Lake

Klamath Falls

Klamath R.

Lakeview

Goose Lake

CALIFORNIA

NEVADA

IDAHO

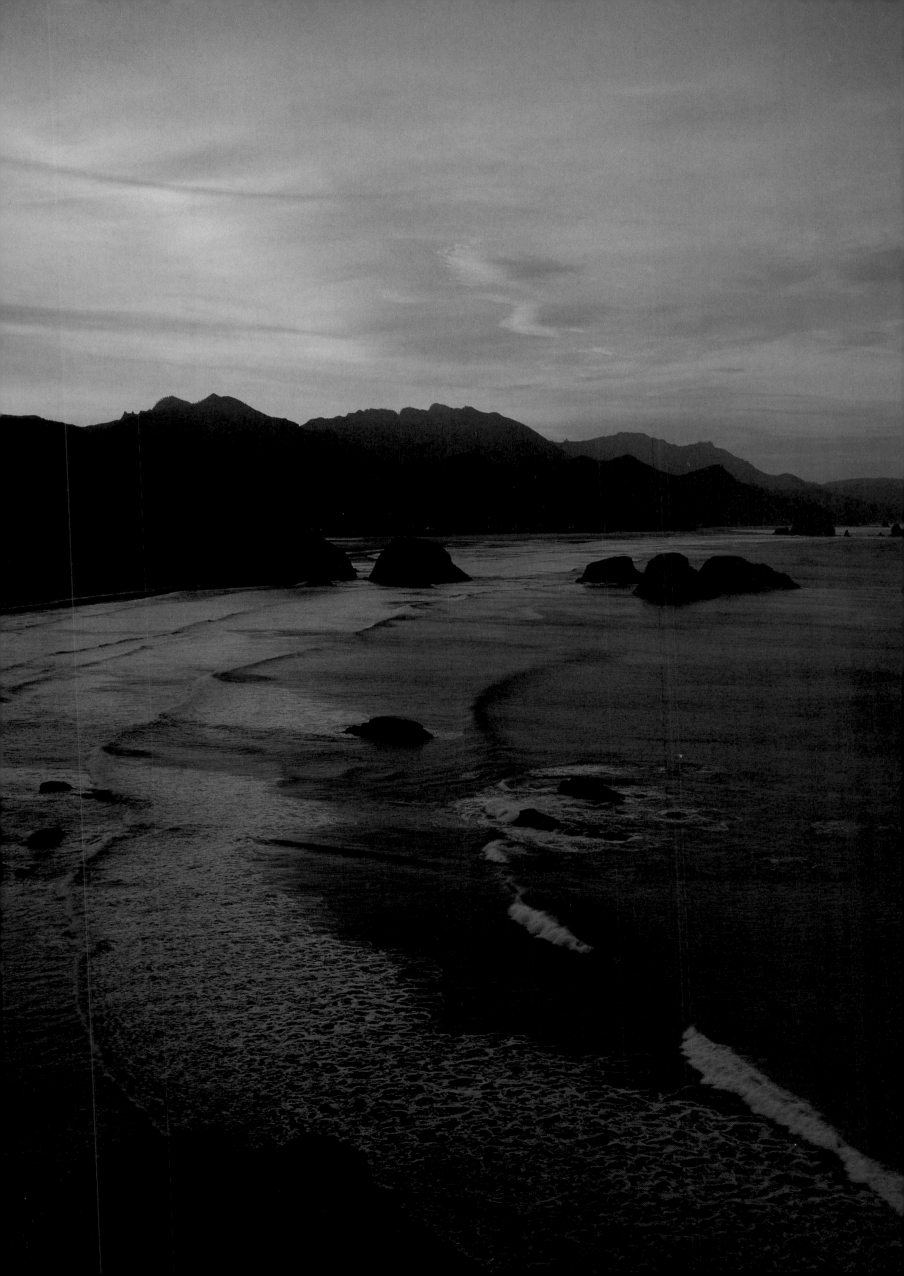

■ *Left:* The coastline stretching south from Ecola State Park to Cannon Beach is one of the most photographed areas on the Oregon Coast. ■ *Below:* Morning fog veils a forest of stately evergreens and autumn-tinted maples.

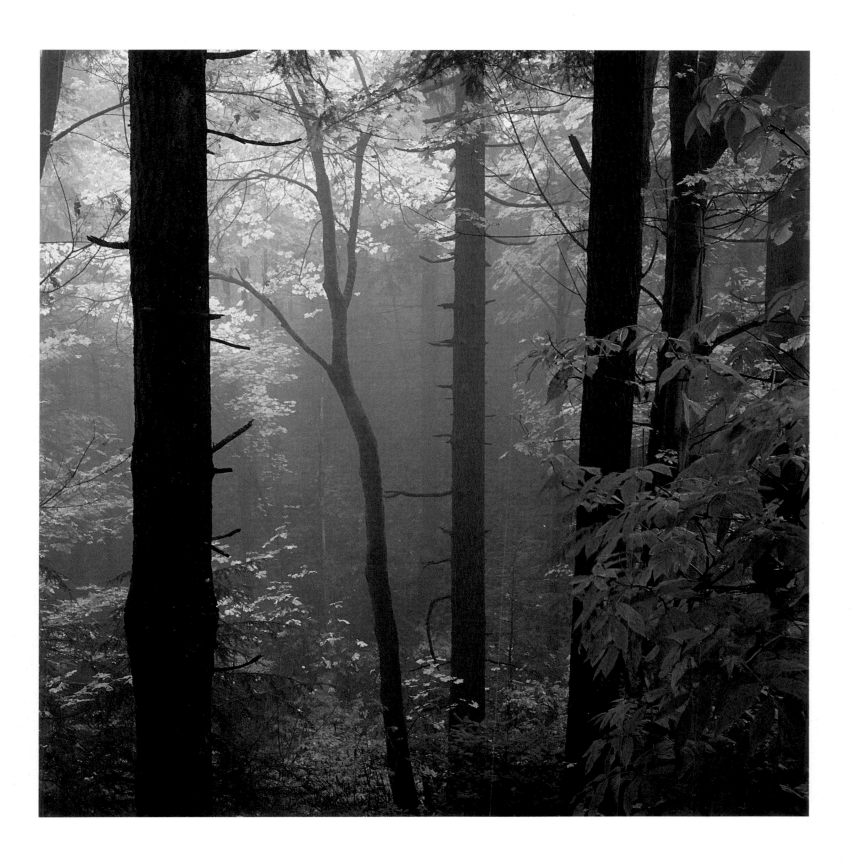

■ *Below:* Creamy plumes of bear grass fill an Alpine meadow in the Mount Hood Wilderness. Bear grass grows about four years before it blooms and dies. Sometimes, bear grass has been called squaw grass because its strong, slender leaves were used by Indian women to make hats and baskets.

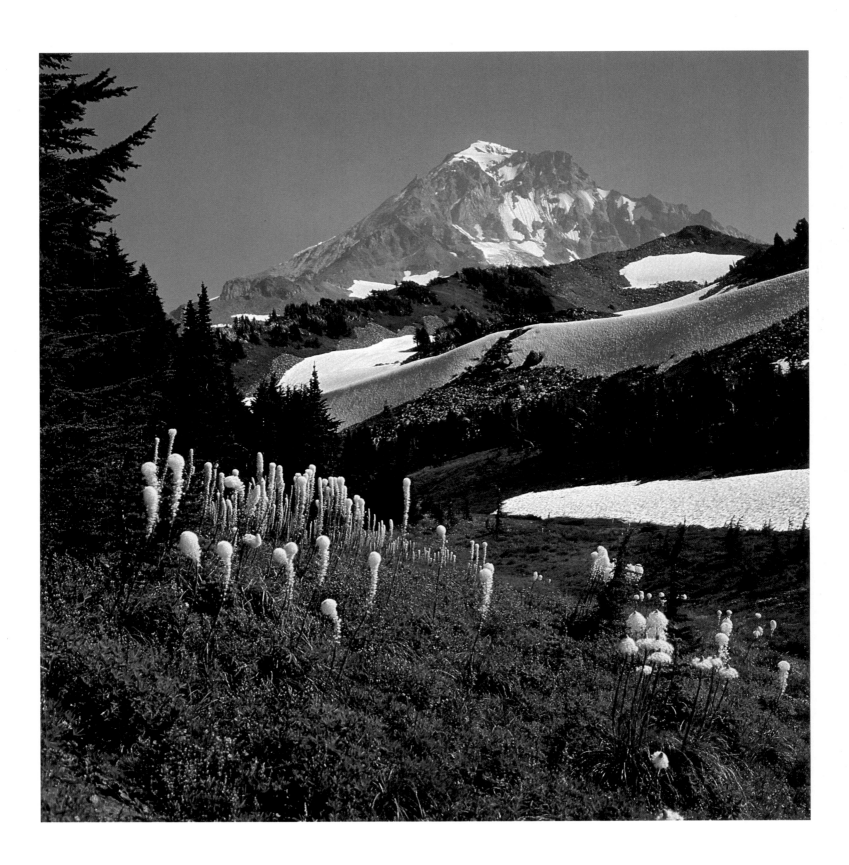

■ *Below:* The Painted Hills of the John Day Fossil Beds National Monument change colors seasonally — with rain, cloud, and sun. The yellow wildflowers, *Cleome lutea,* are commonly called Bee Flower. *Chaenactis douglasii*—tubular flowers that flourish in dry sandy soil—have a characteristic rusty hue.

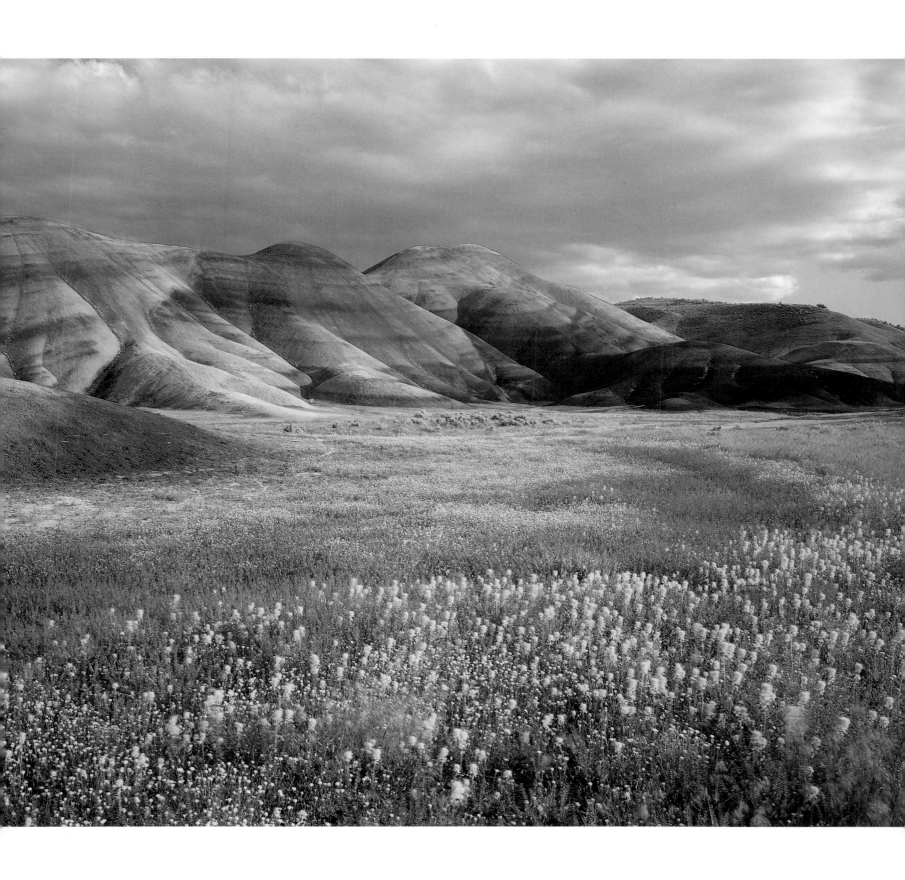

■ *Below:* Autumn is a favorite time of year for hiking among the brilliant leaves of the state's native maple trees. Trails in the Columbia River Gorge offer tangible proof that Oregon, with all its rich history, is still ready for exploration.

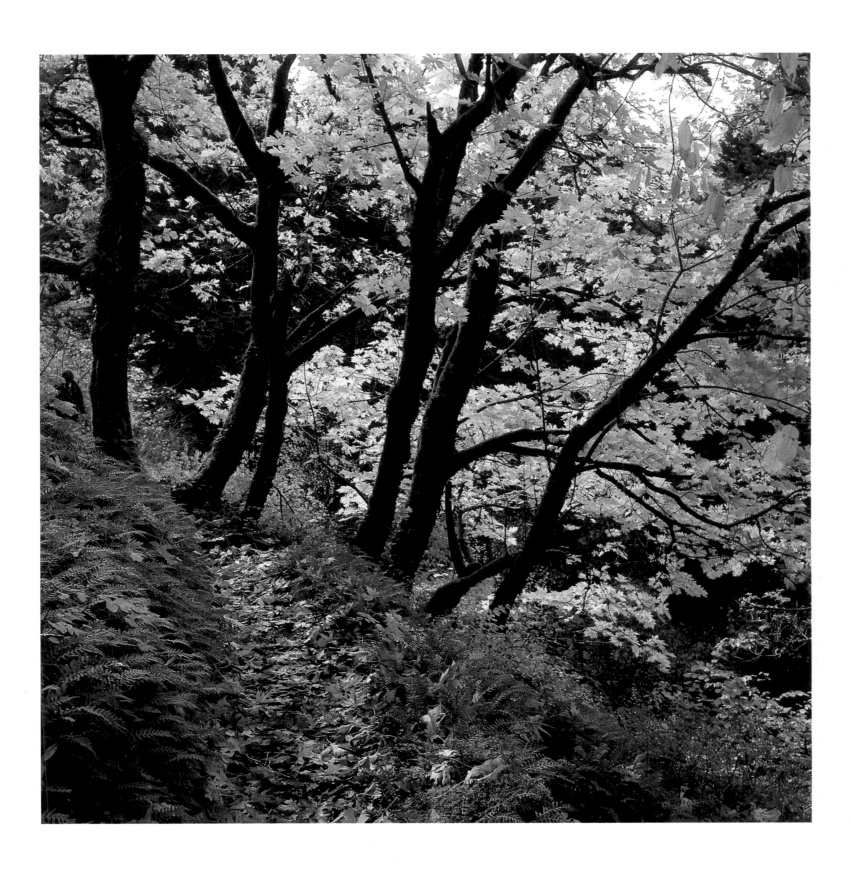

■ *Below:* Russell Lake, at an elevation of nearly six thousand feet, is a principal source of the Breitenbush River and nestles in Jefferson Park, the most popular recreation area in the Mount Jefferson Wilderness. In the late summer, the park's kaleidoscope of flowers is highlighted by scarlet Indian paint brush. Mount Jefferson provides the 10,495-foot backdrop.

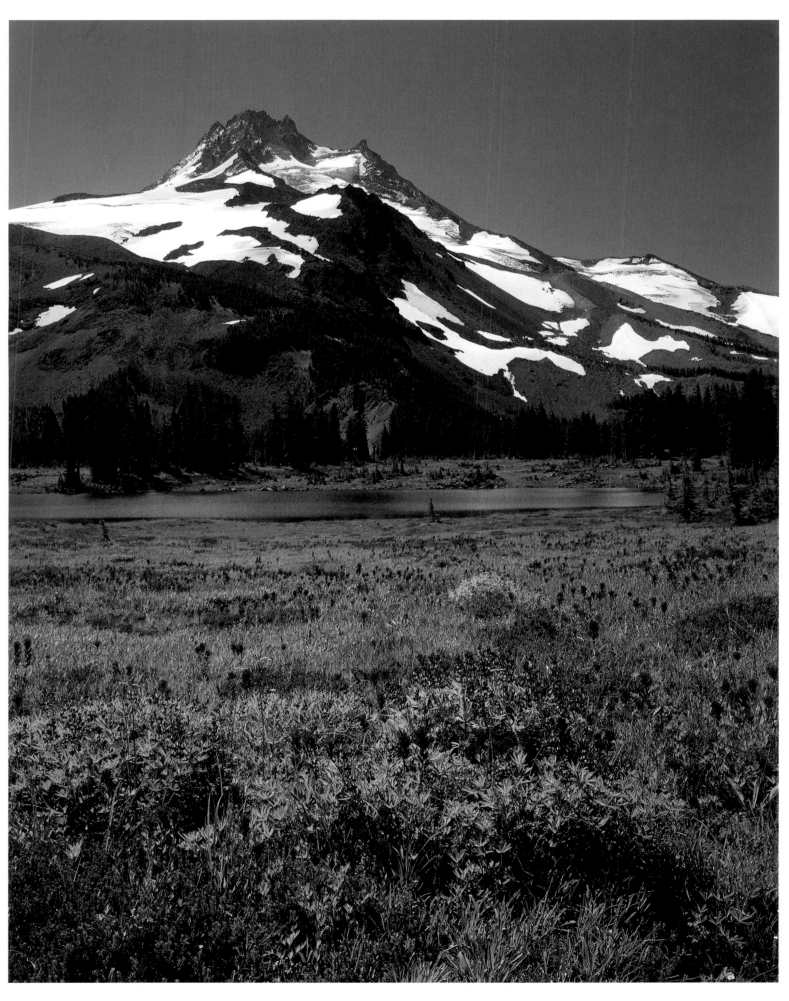

OREGON
COAST

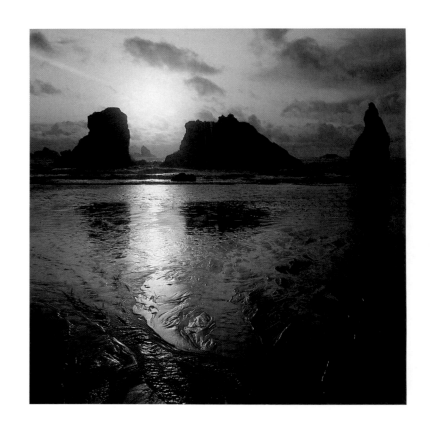

You could put nine of the nation's Northeastern states — Maine, New Hampshire, Vermont, Massachusetts, Connecticut, Rhode Island, New Jersey, Delaware, and Maryland — inside the borders of Oregon and still have 9,903 square miles left over. We are not crowded here. On better than 62 million acres of land, there are 2,660,000 of us. That's about forty-three people to every one thousand acres.

Land gives Oregonians room to be different. This robust mix of population ranges from loggers to cowboys, from artists to ranchers, from makers of wine to silicon wafers. To comb through this rich diversity and accumulate a wealth of stories about Oregon's people from which to select the few that space allows here, my wife, Barbara, and I spent long weekends traveling the state, often to places that in our thirty years of living in Oregon we had seldom, sometimes never, seen. Here was our chance—a chance to visit the familiar and well-loved as well as the unfamiliar and to talk with the movers and shakers and with scores of individuals who never made a headline.

Our usual practice was first to seek out the area's newspaper editor or publisher. People in the news business usually know the citizens who are making a difference in the community and others who are just plain interesting. Our visits confirmed the pervasive presence of a hot-blooded independence among people across this state. You don't tell an Oregonian what to think or how to dress or how to vote. Furthermore, they are conservationists to a fault. They recycle their bottles and they zealously guard their fresh air, forests, and beaches.

Oregon has 429 miles of ocean beach. The most popular of the northern beaches borders the city of Seaside, fifteen miles or so south of the Columbia River.

Brooks Dareff, Managing Editor of the *Seaside Signal* pointed out to us some of the people who are making a difference in Seaside. Among them are two remarkable young graduates of Seaside High School. Still in her thirties, Rhonda Tuveng is a corporate vice president and manager of the Seaside Branch of the Bank of Astoria and the president of the Seaside Chamber of Commerce—a professional standing she has achieved without a college education. Her boss is also without a college degree. A 1963 graduate of Seaside High School, Cheri Savage is President of the Bank of Astoria and, at this writing, the only female bank president in the state. Cheri worked her way from an entry-level job as receptionist to Chief Executive Officer.

On a whole different level, another person putting her talents to work for the community is Teresa Taylor, who plants and tends all the flowers in the plantings along Seaside's redesigned Broadway, the main street of the city. Teresa grows her flowers from seed. At first she simply volunteered, but now she has a contract with the Chamber of Commerce.

Then there is Bunny Doar of Gearhart, who began with the *Signal* back in 1947 as a photo technician. She recently wrote a book describing Seaside's history over the past eighty years. A neighbor of hers is Royal Nebeker, an expressionist painter who studied in Oslo, shows his work all over the world, and teaches at Clatsop Community College.

A recent addition to the entrepreneurial colony in Seaside is a couple from the Spokane area, Pat and Rosemary Link. After ten years in Seattle and fifteen years in Chicago, where Pat worked for *Time* Magazine, they decided they had had enough of big cities. In Seaside one warm March night, Pat spotted a classic three-story house set back from the beachfront promenade. They bought it and set about restoring it.

This is the century-old house built by Alexander Gilbert. A former Astoria saloon keeper who moved to Seaside and developed most of the city from Broadway, south, Gilbert was sixty-five when he served as mayor in 1914. Now Gilbert's House has been rewired and replumbed, and the Links operate it as a bed and breakfast and a place to hold mini-conferences. They can accommodate groups of up to twenty people.

Nine miles south of Seaside is picturesque Cannon Beach. Artists and craftsmen by the dozen have come here to live and work. To name but a few: Harry and Hanne Greaver, who create their own drawings and paintings and then they make prints which they sell in galleries in Oregon and around the world; the Hannens, Jim and Deborah, who do beautiful stained glass work; and the Worcesters, Bill and Sally, who blow glass. There is also Jean Auel, the nationally known writer who has specialized in novels of prehistoric times.

We gleaned a great deal of this information from a delightful visit one forenoon with Judge Herbert Schwab and his wife, Barbara, sitting in their cozy home on "the front" as we say of Oregon beach homes that are right on the ocean shore. Herb, as he is known to his friends, is the brother of retired Portland City Commissioner, Mildred Schwab, with whom he swaps stories daily by phone between the beach and Portland. A circuit judge for seven years, Herb resigned and went back to private law practice because, he told me, "I had to get three kids through private colleges." About the time they left school, the Oregon Court of Appeals was created, and Schwab was appointed to that court. He served from 1969 to 1981. When he retired, he was Chief Judge of the Court of Appeals.

Herb told me a delightful group meets most informally every morning at a local cafe for coffee and conversation. "Sometimes there will be two of us, Alfred Aya and me, and some mornings there will be as many as a dozen. And it's everybody from people like Les Shirley, to whom the cost of the coffee was a significant thing, to fellas who are millionaires two or three times over."

According to the judge, the buildings in Sandpiper Square and a number of others here belong to Maurie Clark, who used to be with the Portland insurance agency, Cole, Clark and Cunningham. Maurie Clark is one of the key heirs of the Clark & Wilson Lumber Company, which became Willamette Industries. A wealthy man, Maurie is very modest and self-effacing.

That brings us to Alfred Aya. Alfred went to school with Tom Wendel, son of Harold Wendel, who for years ran Lipman's department stores. Tom is an amateur musician and while he was at Yale he got to know *National Review* publisher William Buckley, who is also a talented harpsichordist.

Through Tom Wendel, Alfred met Buckley years ago and they developed an interesting relationship. Buckley also writes fiction about international intrigue and in his list of acknowledgements writes, "to my friend ... Alfred Aya." It seems that Buckley has a way of getting all involved with his plots and needs help unraveling things. He sends his manuscripts out to Cannon Beach and Alfred helps figure out solutions for the stories. Now, anytime Buckley is anywhere in this area, Alfred may be gone for several days. And if you ask him, he'll say, yes, he had dinner with William Buckley.

Another Cannon Beach resident, Gainor Minott, descends from an old Portland family related to the Glisans and the Flanders. Gainor lives in the old family house up on Ecola Head. Back in 1932 her family, the Minotts, the Glisans, and the Flanders donated half of the 451-acre tract at Ecola Point, along with their oceanfront homes, to the state of Oregon. The state purchased the other half of the property from another owner for $17,500. Ecola (the Indian word means Big Fish) provides one of the most magnificent and probably most photographed shoreline vistas on the Pacific Coast.

At the other end of the economic spectrum was Les Shirley, who recently died in his late seventies. Les came from La Grande in eastern Oregon. Serving in the Army Cavalry, he rose to the rank of sergeant. He was active in the American Legion and he hoisted the flag on all patriotic holidays. But the remarkable thing was that Cannon Beach did not have a street cleaning service so Les rigged up a cart with a garbage barrel on it, a shovel, and a broom, and every morning, rain or shine, he was out cleaning the streets, doing it on his own. He became kind of an institution, and people would complain if he didn't show. In time, some merchants began paying him for the work.

Les would stop in at the restaurant after he finished cleaning the streets. He would sit in with the coffee klatch until somebody in the group said something Les didn't think was 110 percent patriotic, and then he would take off in a huff.

At the north end of Cannon Beach, just below Ecola Park, is a little triangle park. Some while before he died, the citizens of Cannon Beach had a plaque made and held a dedication ceremony naming that piece of ground Shirley Park in honor of Les Shirley. Les just couldn't believe it — "they named a park after me." Everybody felt good about that.

Barbara Schwab described as "just darling" a resident of Arch Cape, some six miles south of Cannon Beach. This is Bridgette Snow, who is full of pep and sparkle and every New Year's Day takes a dip in the ocean.

We drove down to talk to Bridgette, because we also had heard she writes poetry in the sand. She says this all started because she and some other beach people used to write messages to each other on the beach. As time went on the messages became more elaborate and developed into her poetry offerings.

Bridgette and her late husband, Berkley, moved to the beach in 1956. That New Year's Day she tried to persuade him to go into the ocean with her but to no avail. However, she went in and has done so ever since on New Year's and sometimes in between. Often, if Bridgette goes in by herself, her friends, who could be anywhere from five to fifty years younger, will stand there and hold the towel. Bridgette is almost ninety.

Tillamook, thirty or so miles to the south of Arch Cape, is dairy country and famous for its Tillamook cheese. But the area is also seeing a resurgence of its earlier role in blimp manufacture. A company called Aerolift has been using one of the World War II blimp hangars for the manufacture and testing of a new invention called a Cyclo-Crane. It is being proposed for aerial logging, and the Defense Department is examining its feasibility for lifting tanks and personnel carriers in landing operations.

Randy Sims, editor of the *Tillamook Headlight-Herald,* and his assistant, Lorene Dye, told us about a Bay City business with international connections. Dick Crossley, his father, Art, and two others built the Tillamook Country Smoker from scratch. They started out in a shed where they smoked meat and pounded out jerky. Now they package and sell pepperoni and jerky, not only in many parts of this country but in Japan as well.

Randy Burnworth owns Video Ventures. He is manufacturing video components here and marketing them nationally. One of his inventions enables home video buffs to create graphics and split-screen effects. Randy figures his coastal location serves to protect him from industrial spies.

The Tillamook County Pioneer Museum, which is now run by Wayne Jensen, has its roots in the work of a master taxidermist, the late Alex Walker. Walker created the most remarkable displays of birdlife found anywhere in the country, and the museum draws more than fifty thousand visitors every year.

Mildred Davy has served on the museum board for at least twenty years. But that is only one of several boards she serves. Now past her seventy-fourth birthday, she is also the General

Manager of KTIL and, in addition to running the radio station, is on the air every day doing four different programs. She says, "It just gets in your blood, you see?"

When you talk about the Lincoln County beaches farther south and the influences that make this area vibrant, you have to discuss the people who have made Salishan such a success: John Gray, the developer; his architect, John Storrs; and Alex Murphy, Salishan's first manager. But there are others in the company who have become almost legendary.

There is Phil DeVito, maître d'hôtel and cellar master, who has laid away the second or third largest stock of fine wines west of the Mississippi. DeVito's reputation reaches across the nation. Then there is Gwen Stone, who serves Salishan president, Hank Hickox, as concierge and curator of art. The lodge has an extensive collection of its own and exhibits the work of Oregon artists, including many from Lincoln County.

Among those whose works are frequently displayed in the Gallery at Salishan — Frank Boyden lives at Cascade Head and works in steel and ceramics, and Del Smith also lives at Cascade Head and does delicate, yet grand wood carvings of birds, which are collectors' items.

Dave Juenke used to own a chain of newspapers along the coast in Tillamook, Seaside, Ilwaco (Washington), and in Lincoln City, where he and his wife, Margaret, have lived for twenty years. When Dave talks about some of the people who have shown leadership in the Lincoln City community, he speaks of Ross Evans, first mayor when the city was formed out of a handful of small towns along Highway 101 — a huge job of organization. He also mentions Al Hatton, who operated the Standard Oil Chevron distributorship. Hatton took over as mayor and led the transition to a city manager form of government.

But Juenke says some of the most important contributors to this community are members of the Morgan family. Kenny Morgan, Sr., and his wife, Lucy, have been involved in dozens of civic projects. A member of the board of directors of the local bank, Kenny Morgan, Sr., built the first major modern market in town, Kenny's IGA. For the past ten years his son, Kenny, and daughter-in-law, Diana, have been running the store, and are following in their parents' footsteps — involved in helping everything that is going on in town.

A little farther south, in Depoe Bay, Delphine Kreielscheimer runs a gem museum and goldsmithing school called Thundering Seas. She has traveled all over the world and has a valuable collection of artifacts, including a big ivory Buddha from Thailand. Delphine Kreielscheimer has donated all of her land and her holdings to Oregon State University and is teaching classes in goldsmithing and silversmithing as a part of Oregon State's continuing education department.

Anyone who has spent much time around Depoe Bay knows about the Sea Hag. That is the restaurant and bar owned by Gracie Strom. Gracie is considered one of Depoe Bay's fascinating fixtures. She has been in business here for a quarter of a century and she has fun at what she does. Motto of her place: "Seafood so fresh the ocean hasn't missed it yet." To entertain bar customers, Gracie plays the bottles on the back bar. "I just use a couple of bar spoons on our regular liquor bottles. They're not tuned ... when they get empty, they sound better to me."

Another colorful fixture is Captain Stan Allyn, who runs Tradewinds Charter Boats. Gracie says Stan is a typical sea captain. He has lived in Depoe Bay for forty years and he can tell the blarney stories that people love to hear. In his seventies, he runs the *Kingfisher* and takes folks out on whale-watching trips.

Some of the most inspiring ocean vistas are found on the central Oregon Coast, which stretches from Cape Foulweather on the north to Cape Perpetua on the south. A promotional videotape describes it as a haven from the frenetic pace of city living. In fact, Rand McNally's retirement guide lists it among the nation's one hundred best retirement places.

Ivan Smith did the narration on that videotape. He and his wife, Thelma, moved to Yachats after Ivan retired from TV news anchoring in Portland some years ago. Ivan keeps very involved in what is happening along the central coast — fund-raising for community projects, Chamber of Commerce work, and City Hall politics. I asked him how he would describe his home and he said, "Rest, relaxation, and romance. It's all of those things, but it's also solitude and tranquillity for rock fishing or walking, golfing or just sitting in the sun."

Ivan ran off a rich list of interesting residents of the area. Among them are Leigh Green, who moved to Yachats in 1945 with his wife, Thelma. They operated a grocery store and served as postmasters from 1960 to 1972. In his seventies, Leigh operates a one-man sawmill up the Yachats River. James Gibbs, a local historian, has published several books about lighthouses and shipwrecks. He and his wife, Cherie, operate the Cleft-of-the-Rock Lighthouse, the only privately-owned lighthouse on the Oregon coast. Keith Miller, former governor of Alaska, lives in Yachats, as does former Oregon Congressman Robert Duncan, who is a member of the Northwest Power Planning Council.

Tom Becker has had a hand in a lot of commercial ventures in the Newport area. Tom developed radio station KNPT, sold that, and concentrated on a number of other businesses — the Undersea Gardens and the Wax Museum, to name a couple. He worked with Dr. John Donaldson to create the original salmon-ranching system which Weyerhaeuser operated as Ore-Aqua.

Tom Becker and Mo Niemi developed a new oyster farm at Yaquina Bay. Of course, seafood is Mo Niemi's lifeblood. She

and Tom operate three restaurants, and Mo owns two others herself. Her husband Dutch is a fisherman and helps to supply her restaurants. Mo does two benefits every year. She opens her restaurant at Newport and people come in for whatever charitable cause. They cook the food, wait the tables, and take the money. Mo supplies the materials and the facilities — and 100 percent of the proceeds will go to the cause — whatever it may be. (Born more than seventy years ago on the Mojave Desert, Mo was named Mojave by her father — Mo for short.)

Also based in Newport is the Oregon Coast Council for the Arts, which counts Mo among its hundreds of supporters. The sponsor of performances and exhibitions, the Council is behind the new Central Coast Performing Arts Center. Alice Silverman is another of the council's strong local fund-raisers.

At Coos Bay, the House of Myrtlewood claims to be the home of myrtlewood, which grows naturally in three local counties. Darrel Beaumont started the business in 1929. The present owners, Leslie and Barbara Streeter, bought it in 1972 and named Edsel Hodge their foreman. Having been with the company since he was seventeen years old, Edsel worked with the House of Myrtlewood for fifty years before he retired. The lathe work — shaping bowls, candleholders and the like — is done by both men and women. Arley Sagan has been turning for twenty years. Barbara says, "It's a treat to watch him...the way he touches the piece...there's a love of wood there."

On our way through Port Orford, we stopped to talk with Pat Masterson, who runs a photography shop on the main street. Pat describes some of the young artisans who have come here to work. There is a talented woodworker named Rick Kirk who is edging forty. He drove through Port Orford, liked what he saw, and stayed on. He makes masterful furniture — bureaus and chairs and the like—nicely done. An inventer named Bob Sutton also lives and works in Port Orford. Sutton frequently works in welded aluminum. He is described as a mental giant when it comes to mechanical design. One very successful item he developed is an aluminum watertight hatch cover for boats. He turned the fabrication rights over to Freeman Marine Company at Gold Beach, and they ship them worldwide.

A man who might qualify as the "Sage of Curry County" is Bob Van Leer of Gold Beach. He and his wife, Betty, publish the *Gold Beach Curry County Reporter* and have lived here thirty years. The newspaper was established forty-two years before that. Besides publishing the paper, the Van Leers raise lambs and geese, pigs and rabbits, and an emu. Bob says he slaughters his animals to eat (the emu excepted, of course). He cuts up the meat in a rather well-appointed butcher shop he has out back. Bob and Betty also raise orchids and they have an extensive garden. They live about two miles up Hunters Creek, not more than five minutes out of town. Bob says one of the magnets that draws visitors to Gold Beach is the Rogue River. There are three principal riverboat lines running passenger jet boats up the Rogue and there are a dozen or more men who make their living piloting these big boats through the gorge.

We ask Sam McCartt, who works at Jerry's Jet Boats, what it takes to be a good boat pilot. He says, "You've got to have personality. You can't ever have a bad day. You're always in a good mood. You've got to have some style...to tell stories in an entertaining way." He adds, "We get people from foreign countries...there's an English Lord on the river today...and we get people from all over the United States...Wilt Chamberlain, Dan Fouts, Carl Weathers...we'll send about three hundred people a day up the river during the busy season."

Gloria Sevey also works at the jet boat office. She worked for Delta Airlines for years and was a secretary in the Middle East. When she decided she'd had it with cities, she moved here. She says, "I plan on living here the rest of my life. I have this job at Jerry's and a job at Tu-Tu-Ton Lodge. I cook out there. In the winter I work at the employment office." Her husband is a sheriff's deputy and also guides on the Rogue River on the side. Gloria says, "You have to do a lot of things to make it here."

A unique coastal resort is Tu-Tu-Ton Lodge — accent on the second *Tu* — six miles up the Rogue on the north bank. To help you feel "away from things," there are no television sets or telephones in the rooms. Laurie and Dirk Van Zante operate the lodge, and Laurie says the name means people by water, people by river, as the Tu-Tu-Tons were a sub-tribe of the Rogue Indians.

Dirk's family lived in the San Francisco Bay area and came to the Rogue to fish. It was always a family dream to own a lodge on the Rogue, and finally in 1969, his stepfather, Ralph Priestly, who was an architect, and Dirk's uncle, Herman Ellingsen, who was a building contractor, chose this land on which to build their lodge. The Van Zantes have eighteen units—that is, sixteen units and two suites — and plan to build six more suites.

The intent and style of the lodge have always been very personal. Laurie says, "We learn everyone's name and make out a seating list for every evening. Guests are seated at tables of eight." About famous guests, she says, "We had James Baker, the U.S. Treasurer here. We have a lot of powerful people who stay with us, but we never ask what anyone does. We had The Captain and Tonille. They played and sang for us one night, and Batman, Adam West was here. His little girl was asked, 'Is your daddy Batman?' She said, 'Yes, but he doesn't fly around and act funny unless he has his suit on.'"

The Oregon Coast is a family place where life is never in a hurry and the beaches are forever preserved by state law for free and uninterrupted use by the public.

■ *Right:* A veil of spindrift unfurls from the crest of a Pacific breaker as it rolls in toward the Oregon beach against an offshore breeze. Access to the Coast is made easy by Oregon's famed state parks system, which provides overlooks, campsites, picnic facilities, and trails to the beach. More than sixty Oregon state parks flank the ocean shore.

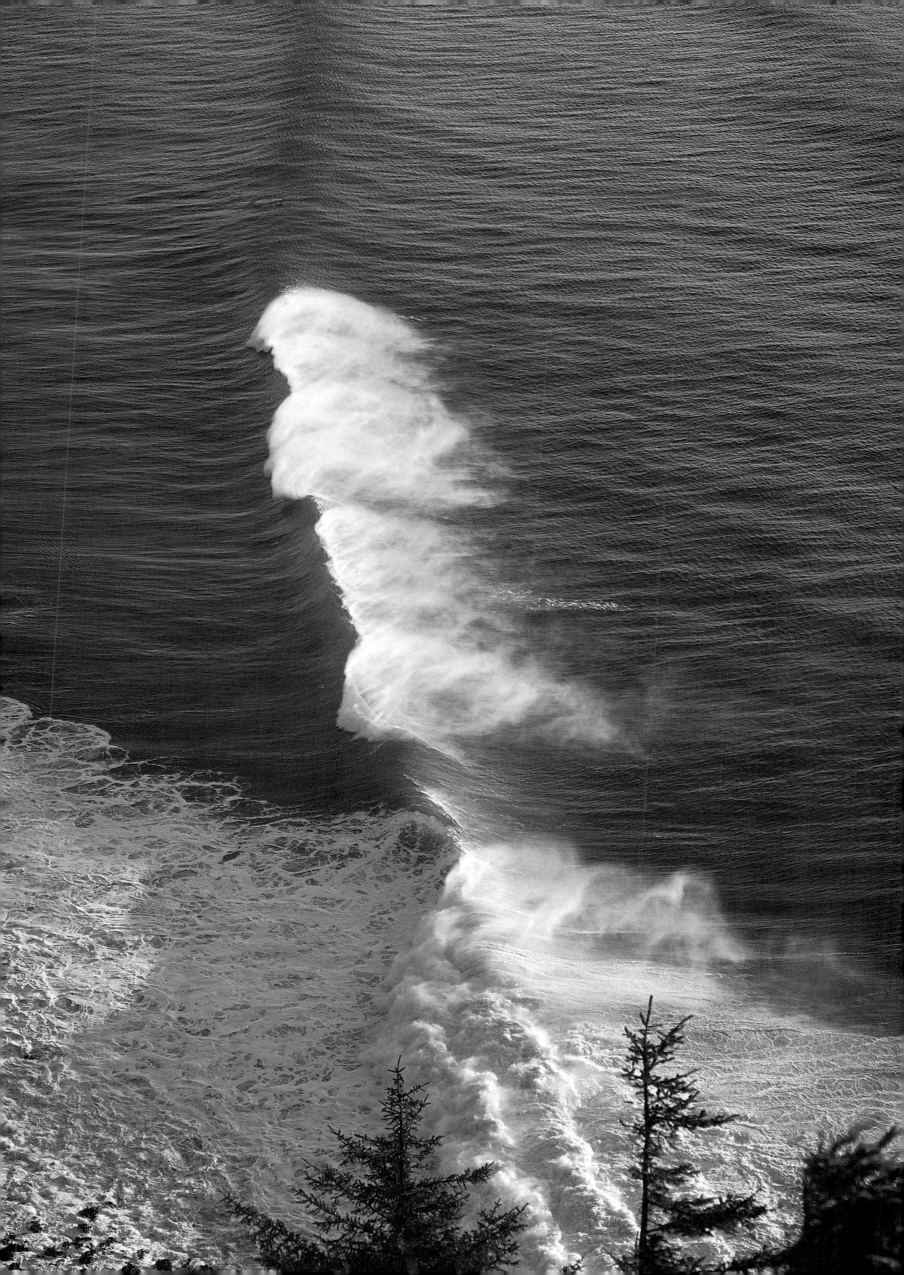

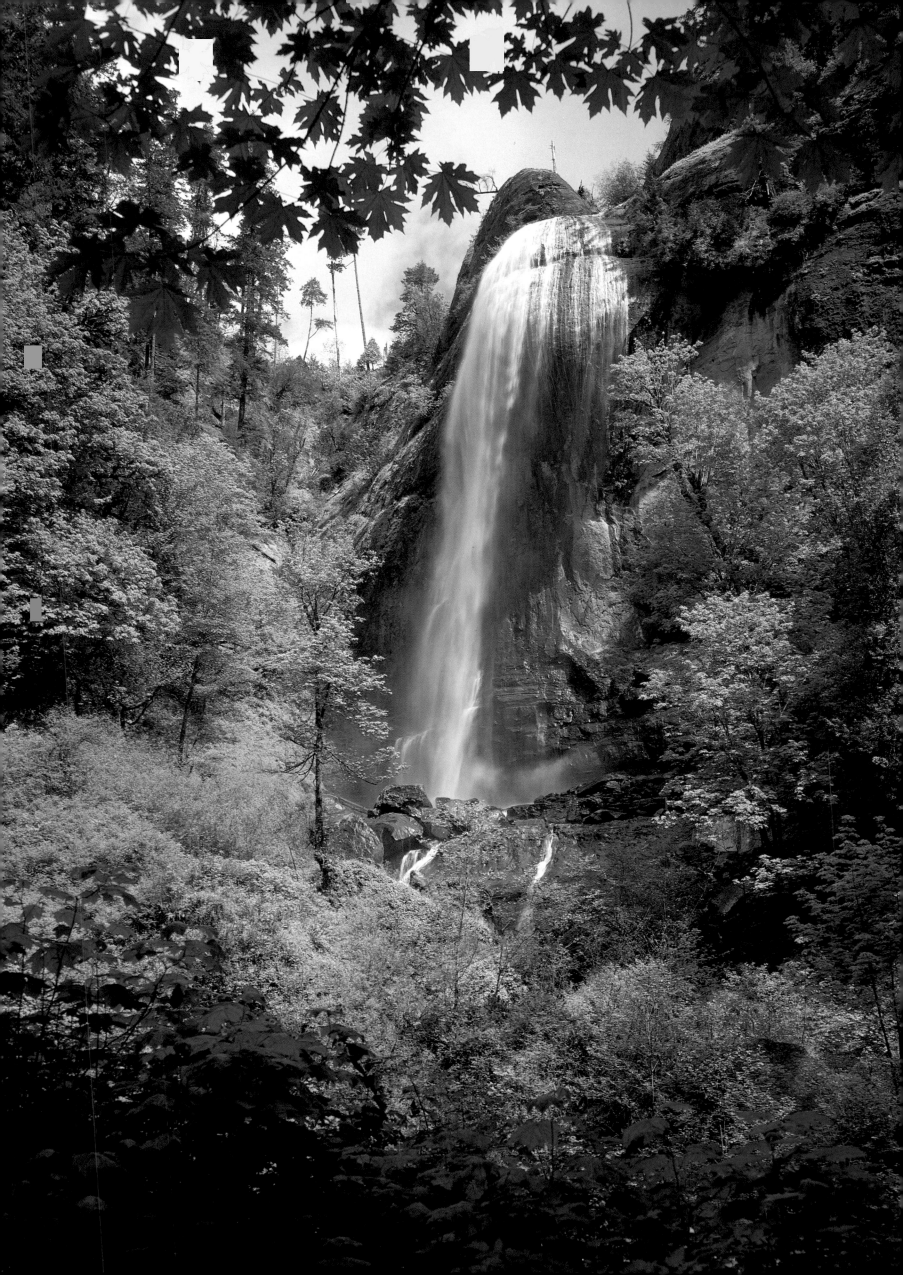

■ *Left:* Silver Falls drapes a shimmering mantle over a picturesque rock dome, then plunges into the forests of Golden and Silver Falls State Park in the Coast Range. ■ *Below:* A tremendous breaker explodes against the cliffs during a lull in a storm at Shore Acres State Park. ■ *Overleaf:* Pacific surf lashes the sandstone face of Cape Kiwanda at sunset.

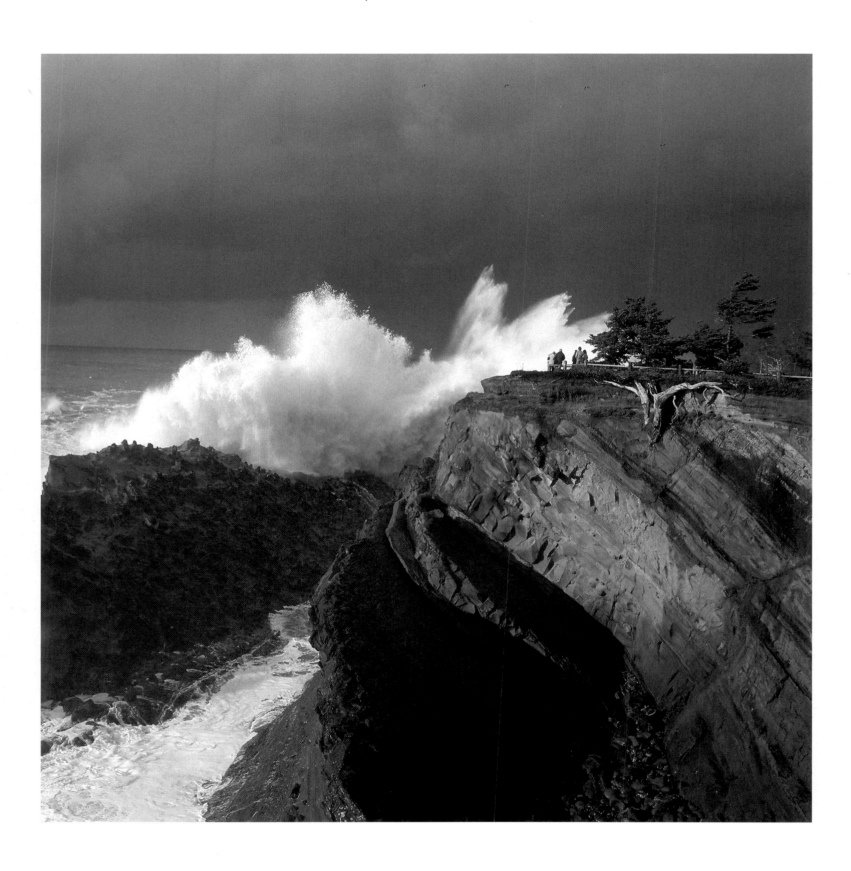

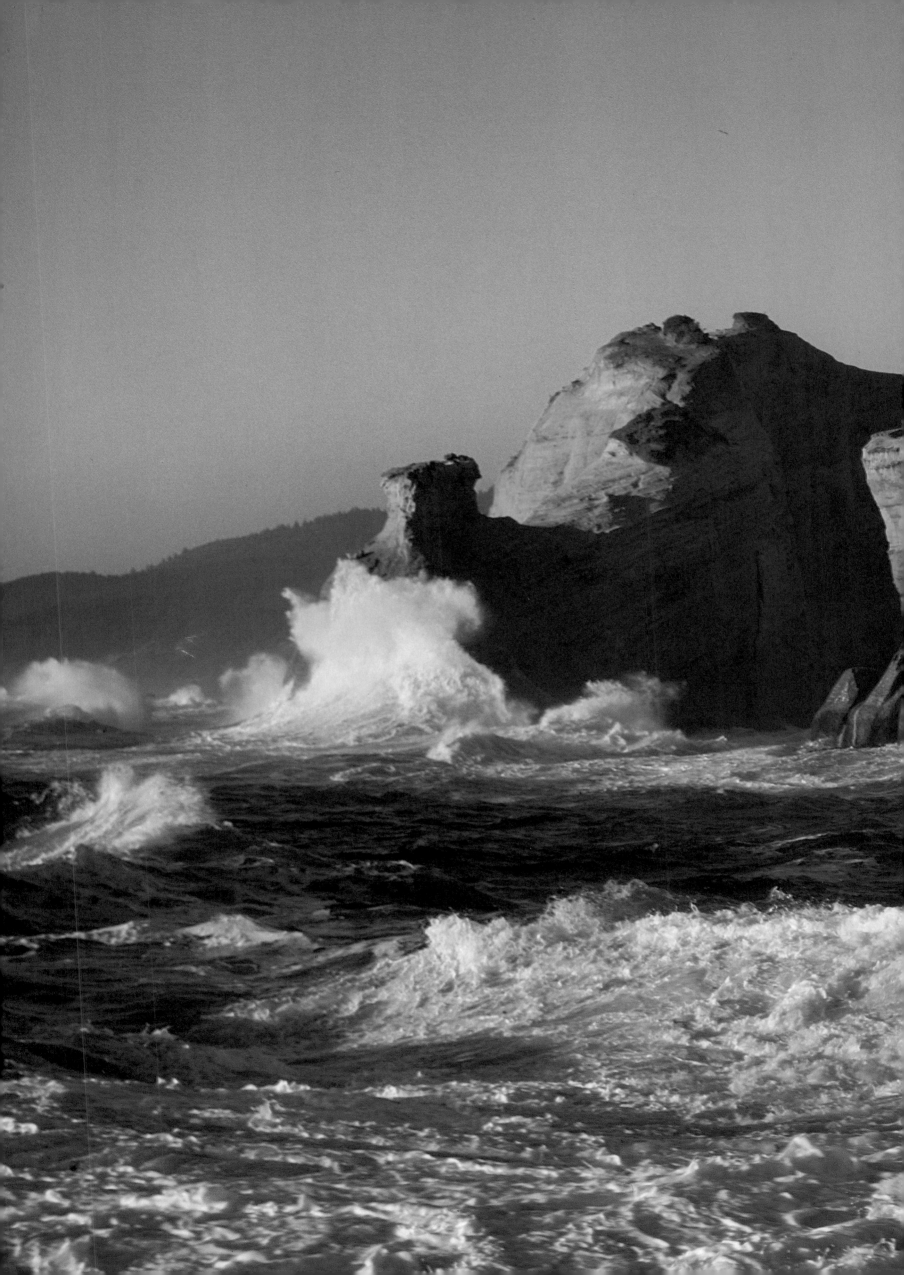

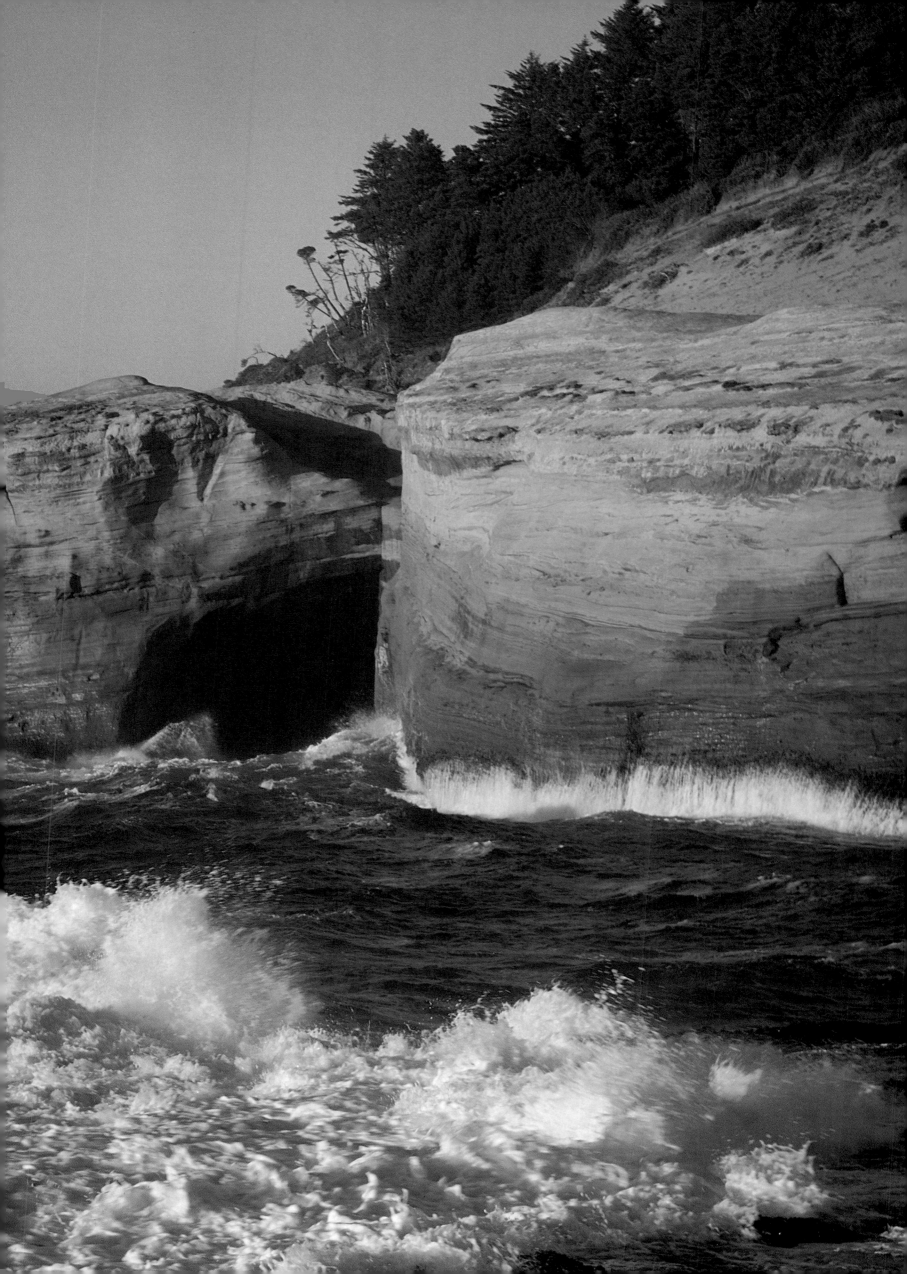

■ *Below:* Heceta Head Lighthouse flashes its warning high above Devils Elbow State Park on the central Oregon Coast. The federal government built nine lighthouses along the Oregon coast. Six of them are still in use, providing guidance to coastwise ships and boats. ■ *Right:* Sun rays slant through the forest mist above the shoreline at Cape Meares.

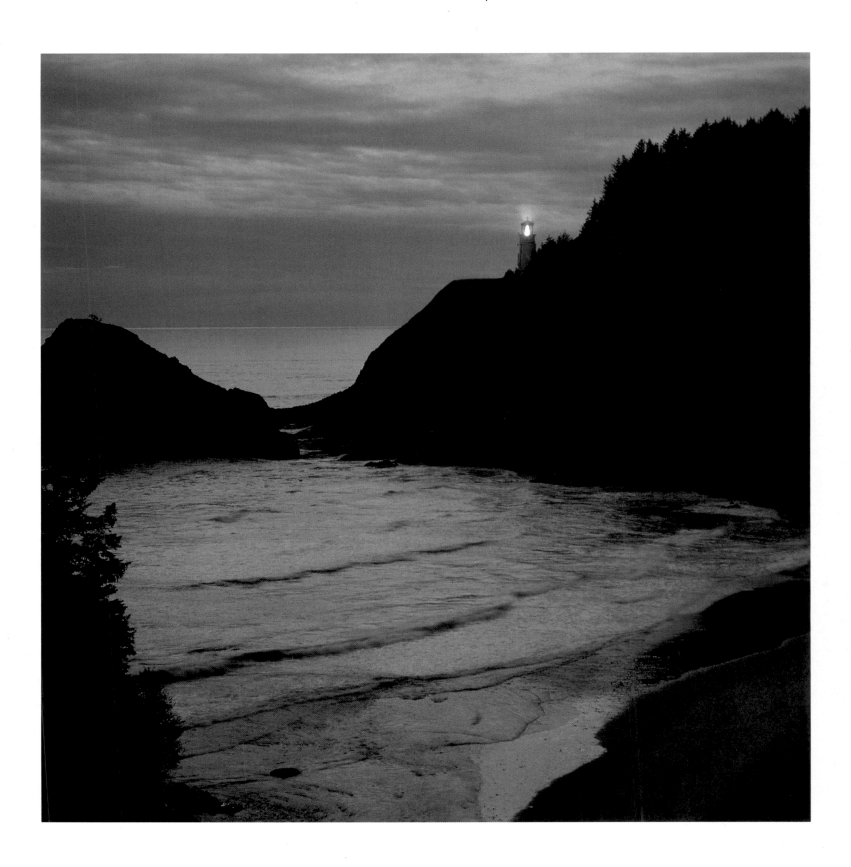

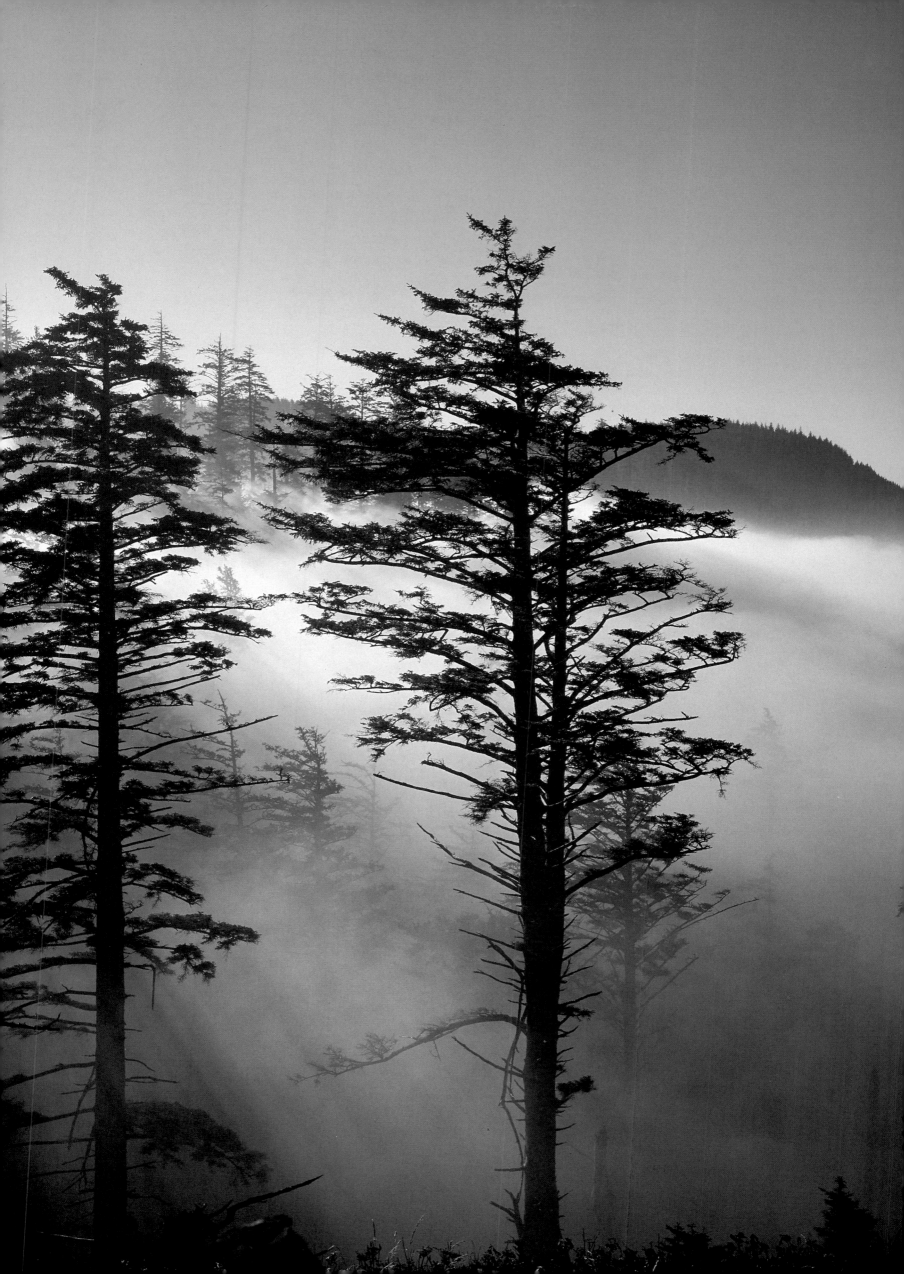

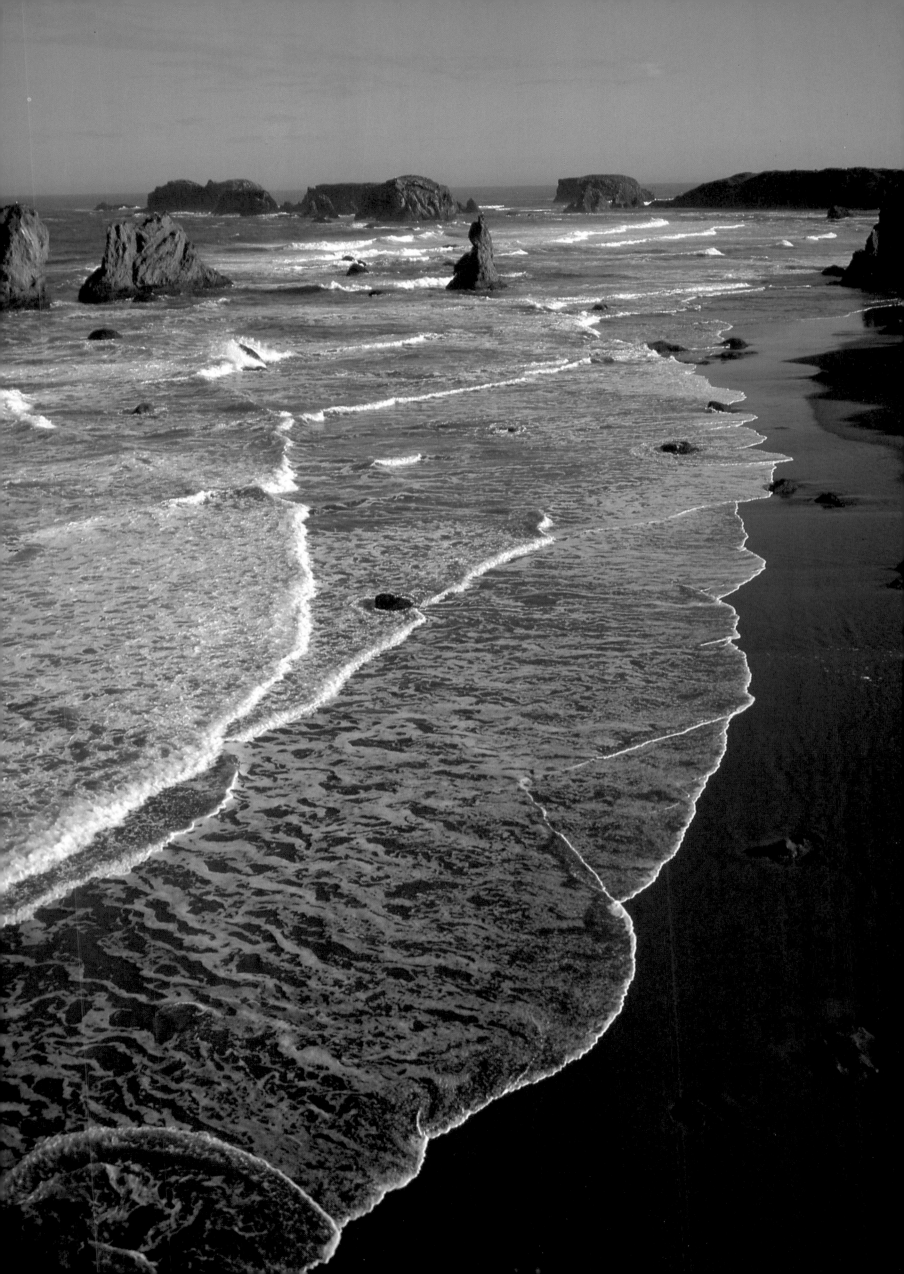

■ *Left:* On a quiet day, surf pushes sea foam past rock statues offshore at Bandon. In wilder weather, local enthusiasts proclaim Bandon-by-the-Sea the "Storm Watching Capital of the World." ■ *Below:* Cannon Beach, with its famed "Needles," is home to twelve hundred year-round residents.

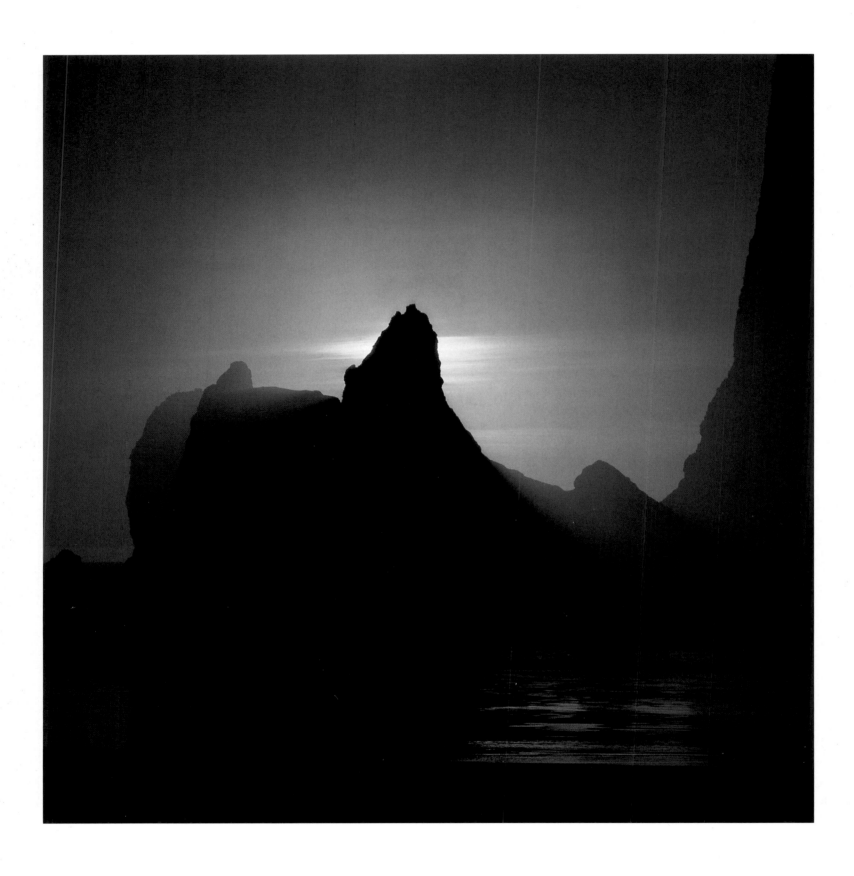

■ *Below:* Every oceanside community offers public access to the beach. It has been that way since the 1960s, when the Oregon Legislature passed an extraordinary bill forbidding commercialization of beaches and guaranteeing their free and uninterrupted use. Today, beachcombing and quiet walks on the sand are available to all.

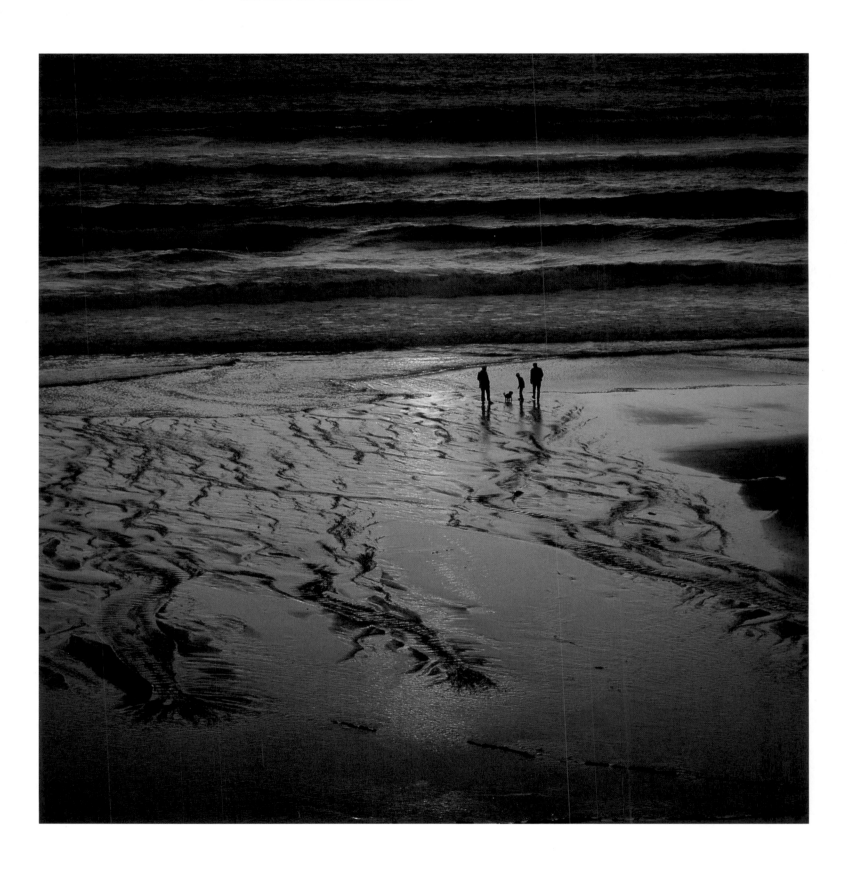

■ *Below:* Rugged headlands reach down to picturesque crescent-shaped beaches on the central Oregon Coast. This area, just south of Cascade Head, can be reached only by foot or at times by boat. The sandspit guards the Salmon River Estuary. ■ *Overleaf:* Oregon Dunes National Recreation Area stretches nearly forty miles south of Florence.

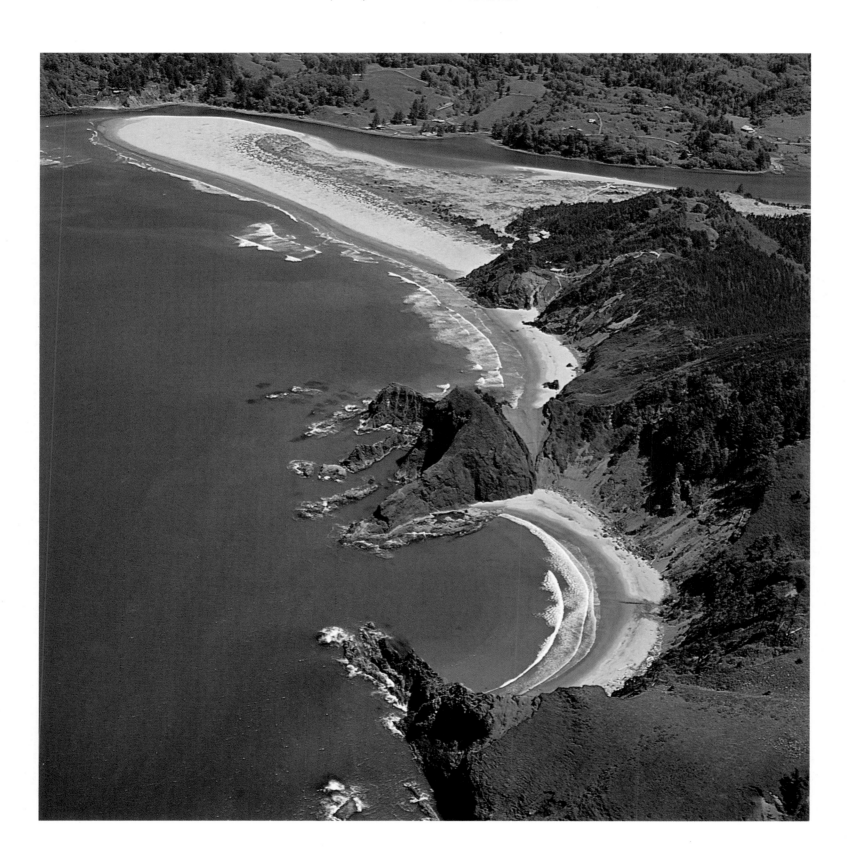

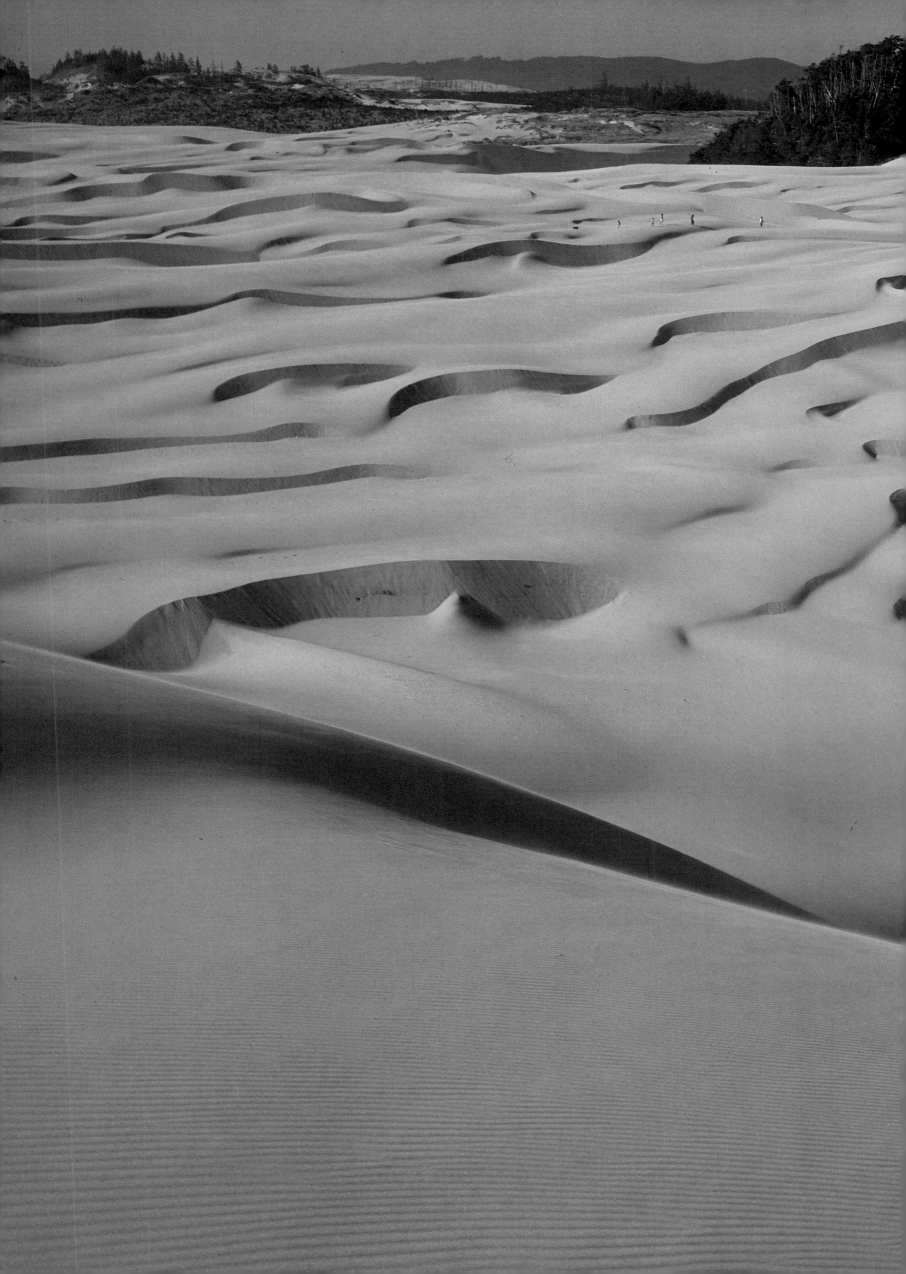

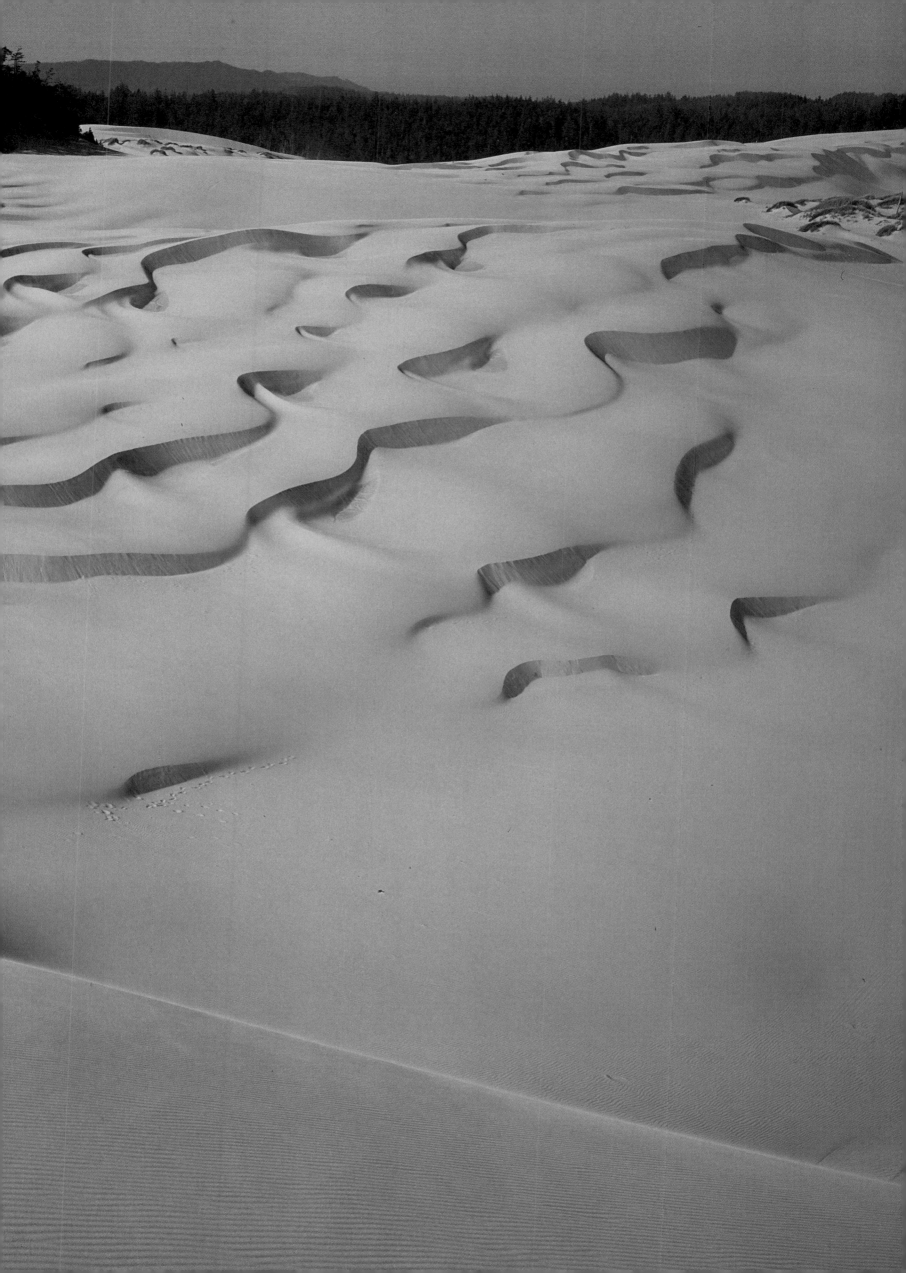

■ *Below:* Pristine seascapes reward sightseers all along the miles of Oregon's coast. Double rainbows arching over the Pacific surf are fairly common after a rain has fallen or when the sea mist is rising into the afternoon sun.

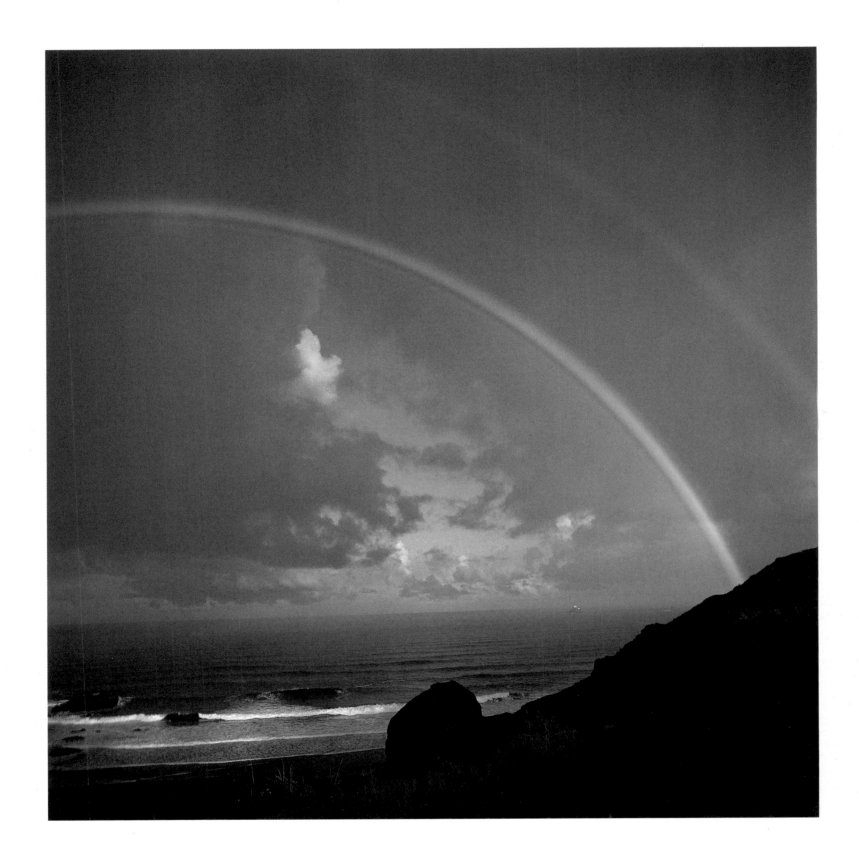

■ *Below:* Coast Guard helicopters regularly patrol Oregon beaches, and approximately six hundred personnel operate nine Coast Guard stations along the coastline. Helicopters are based at Coos Bay and at the Astoria Air Station, which also has two fixed-wing jet surveillance planes. In addition, the Coast Guard operates two cutters and a buoy tender.

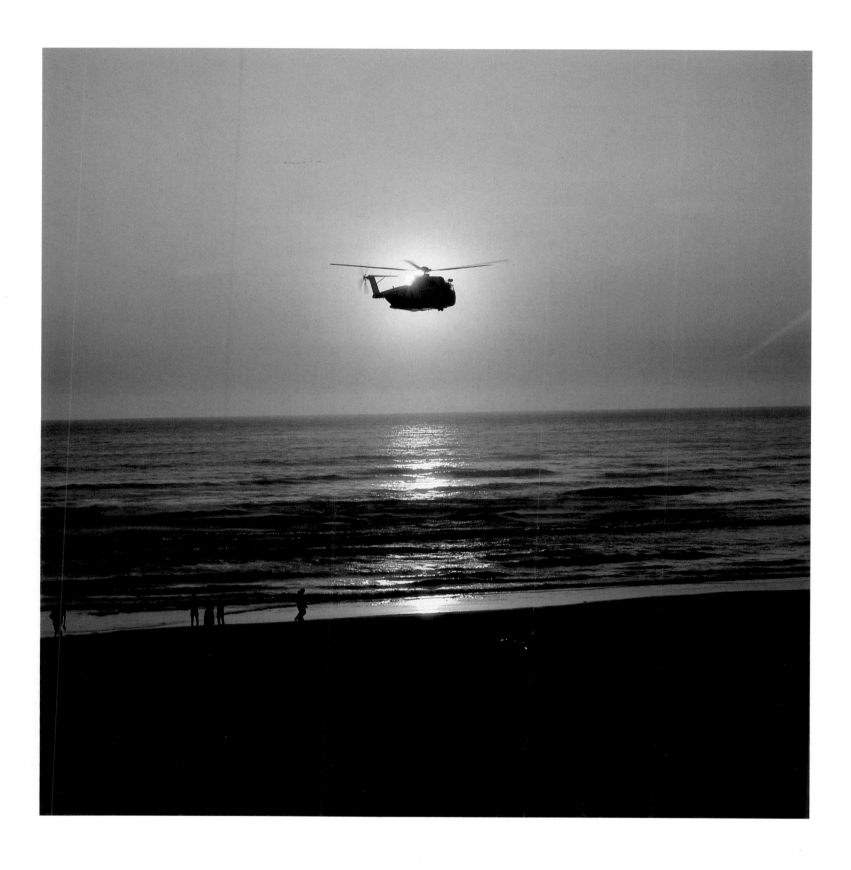

■ *Below:* Cannon Beach is better known for its sand sculpturing competition, the annual Sandcastle Contest, than it is for the piece of weaponry that gave the town its name. A ship's cannon reportedly washed up on the sands in 1846.

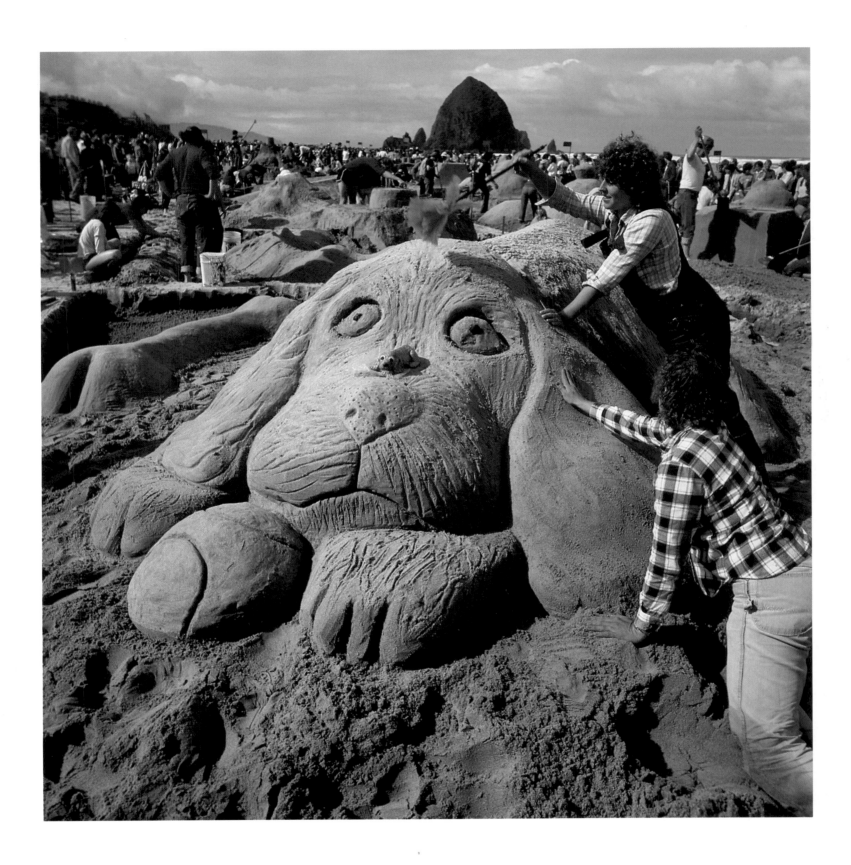

■ *Below:* Winter on the Oregon Coast sends angry breakers hammering against the shoreline rocks, chiseling and polishing with incessant repetition. Winds whip against the headlands, and the Pacific heaves up its driftwood and assorted flotsam.

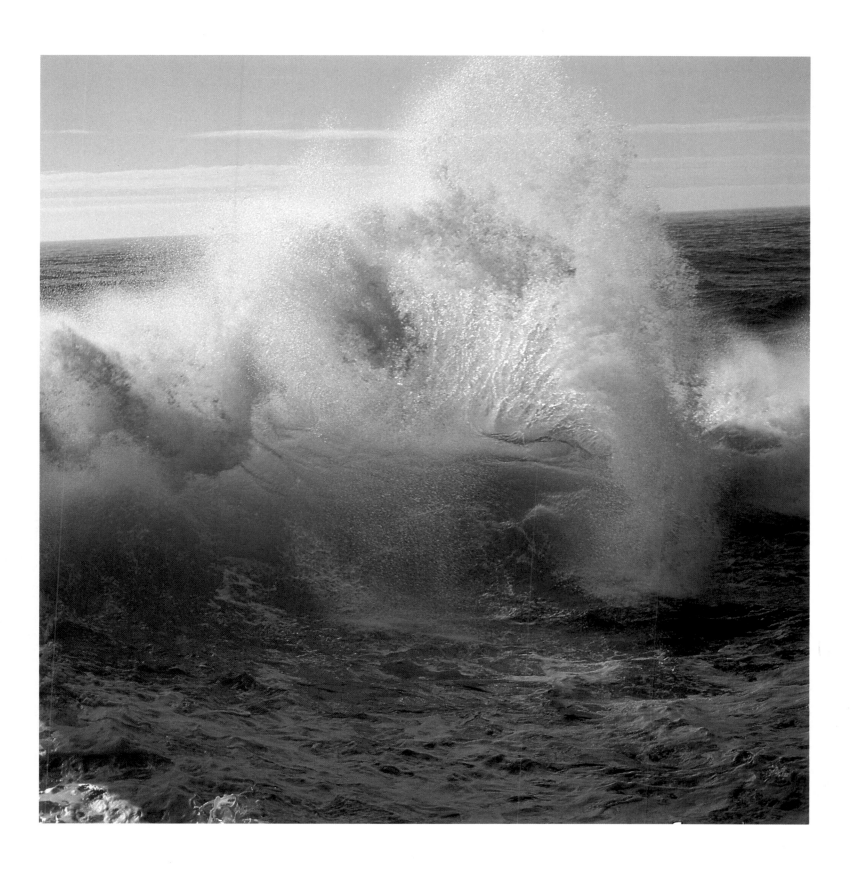

■ *Below:* Hug Point State Park, an 80-foot wide strip of land, lies south of Cannon Beach between Highway 101 and the ocean. Clatsop County once built a road around the point which could be used only at low tide, when travelers had to hug the rocks to make it around the point safely. The land was included in the state parks system in 1957.

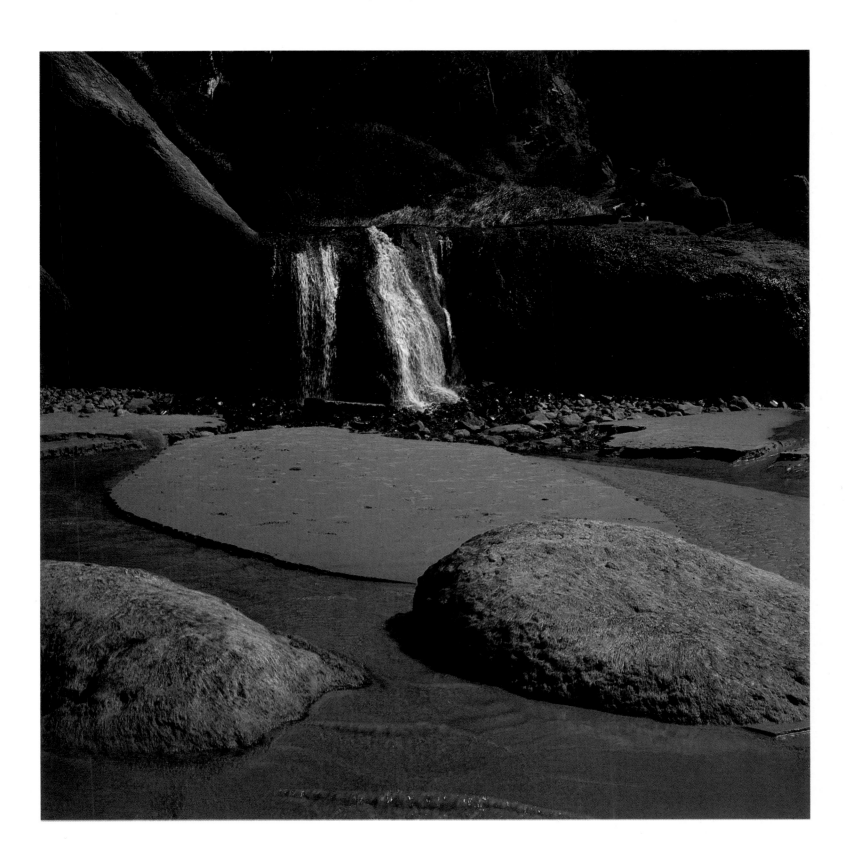

■ *Below:* The first white man of record to see Crescent Beach, now in Ecola State Park, was William Clark of the Lewis and Clark Expedition. He arrived in January, 1806, to buy whale oil and blubber from the Indians. ■ *Overleaf:* Newport's Yaquina Bay is the home of the Hatfield Marine Science Center and the hub of Oregon State University's coastal research.

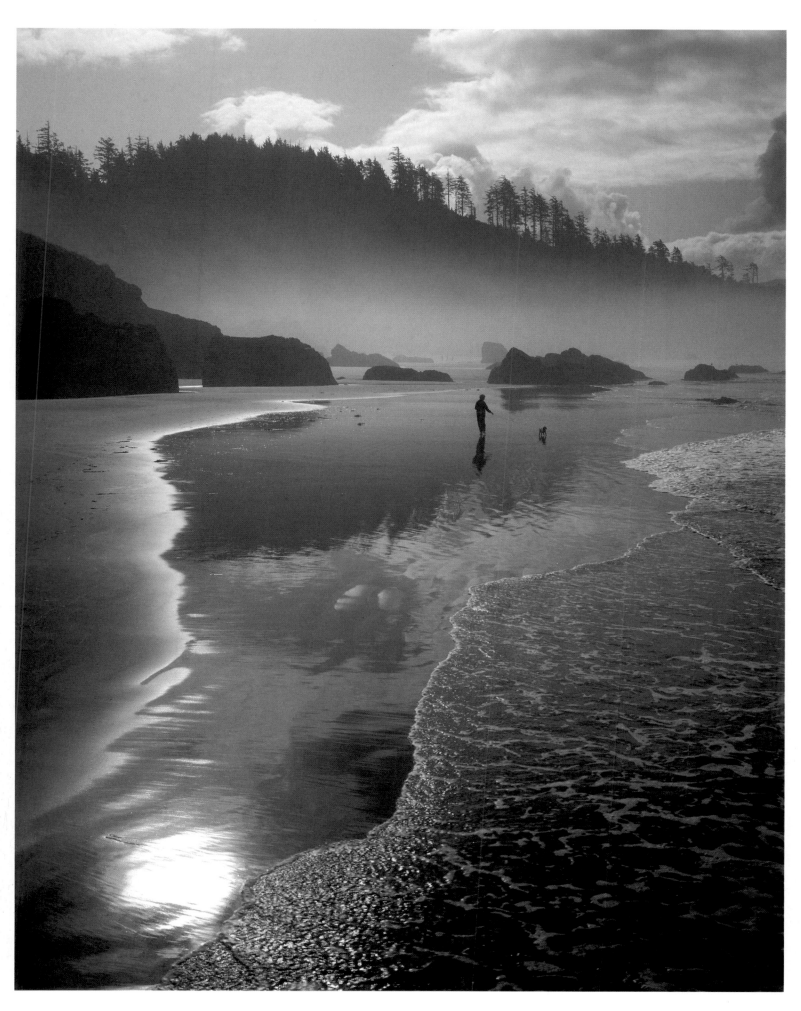

■ *Below:* Above Crescent Beach, prevailing winds have sculpted a spruce tree into the shape of a lyre. The Bird Rocks punctuate the six-mile shoreline of Ecola State Park. In all, the park covers over thirteen hundred acres of thickly wooded land.

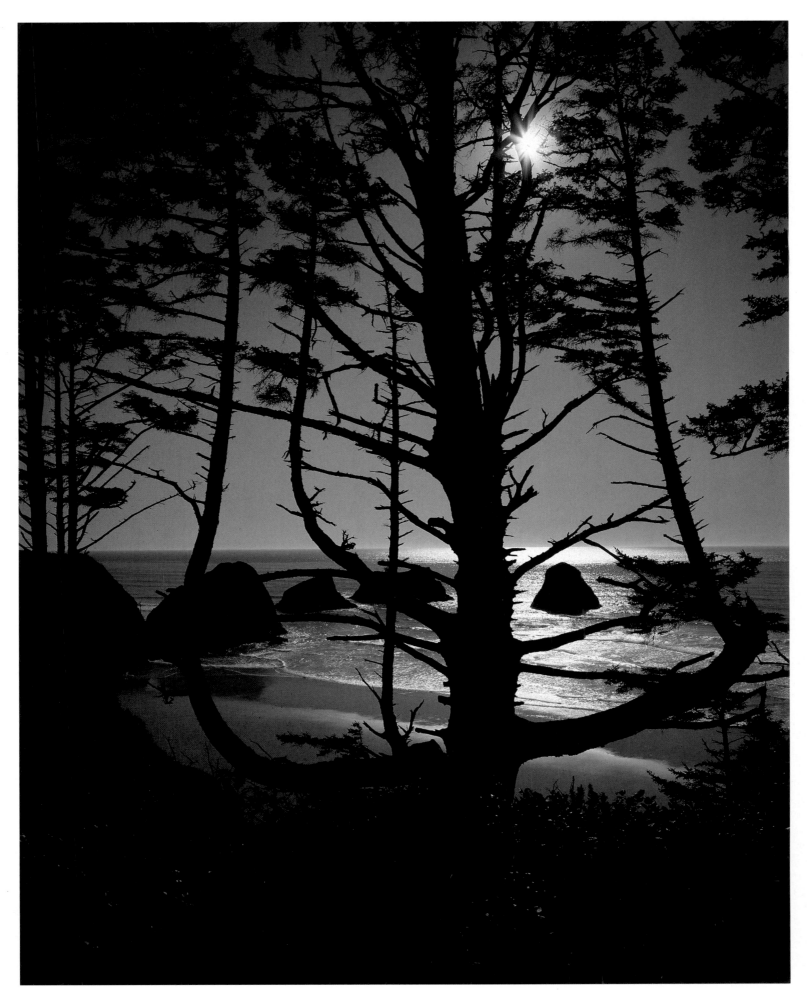

■ *Below:* Just south of Siletz Bay, at Gleneden Beach, Salishan is billed as "The Resort on the Oregon Coast." The lodge looks out over a challenging eighteen-hole golf course, dozens of luxurious beachside homes, and the Marketplace, which invites visitors to explore twenty-three unique shops.

■ *Below:* The rhododendron grows wild in the coastal mountains as well as in the Cascades. It may be a solitary bush two or three feet high or a mass of bloom reaching fifteen feet up under the trees. ■ *Right:* This moss-covered maple tree is in the Coos River Valley, near the international port of Coos Bay, the cultural and fishing center of the south Coast.

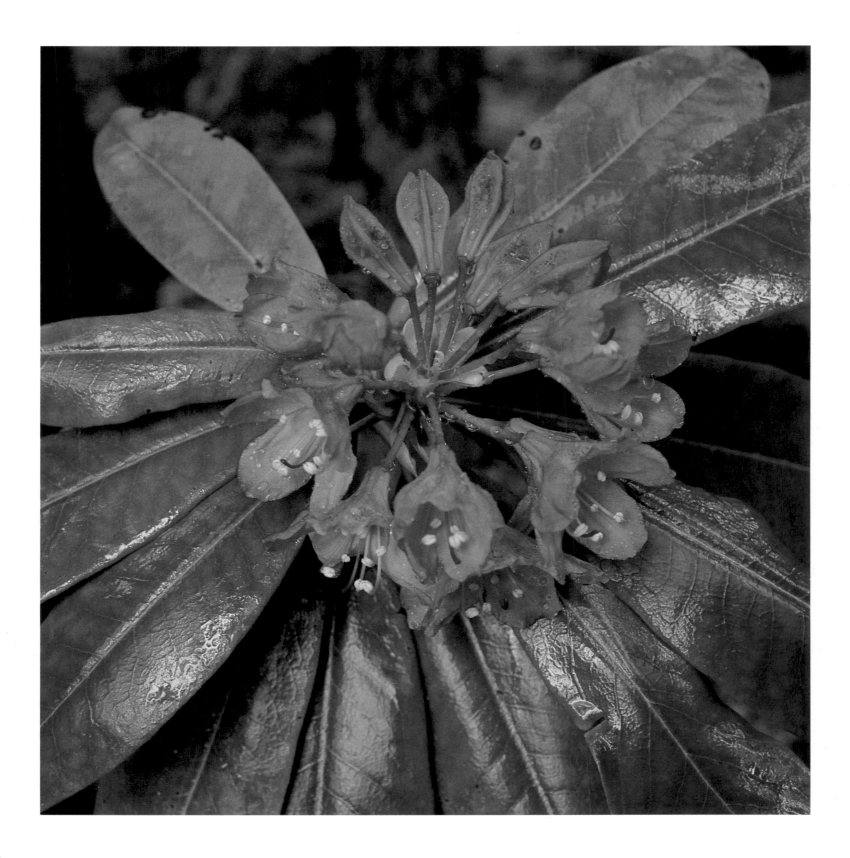

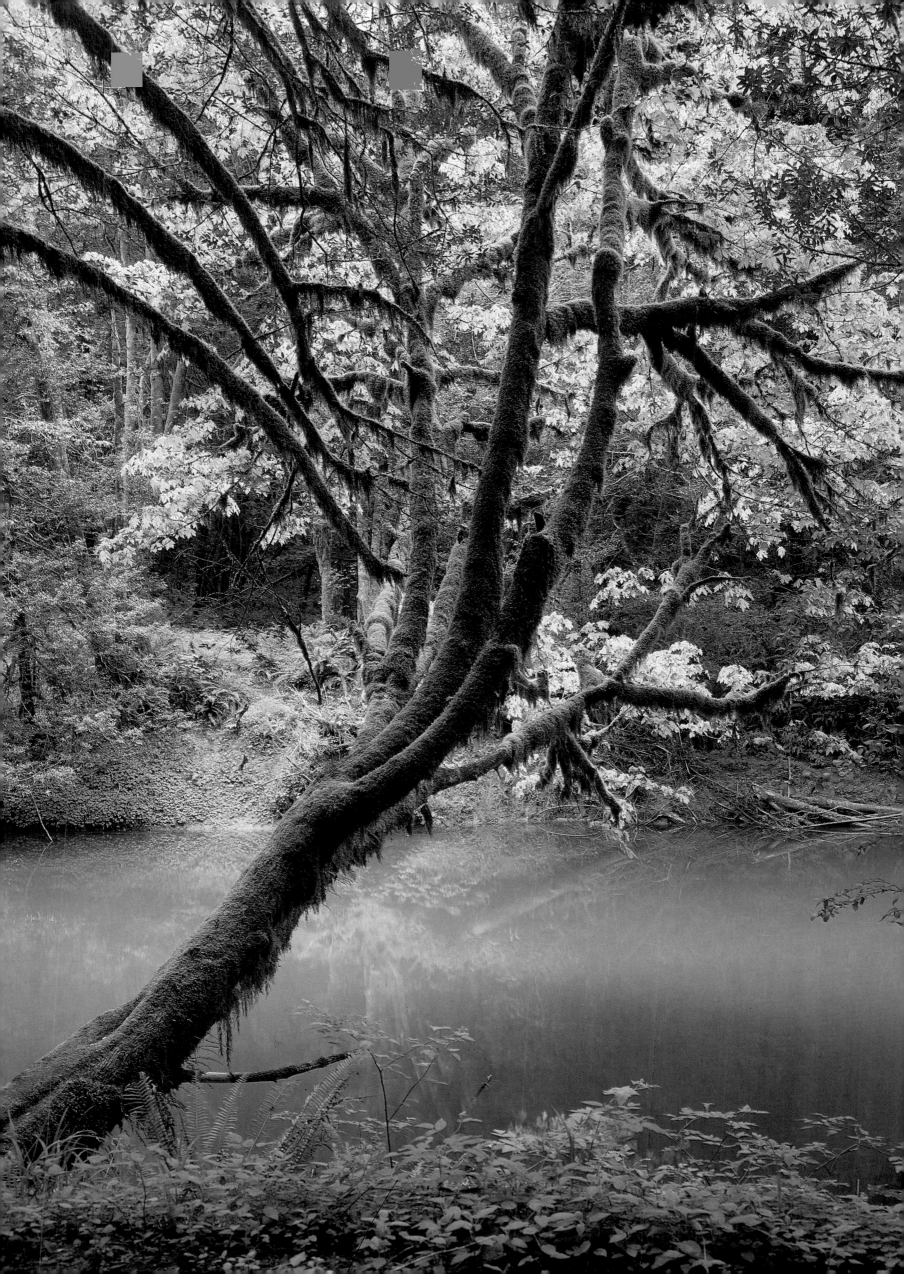

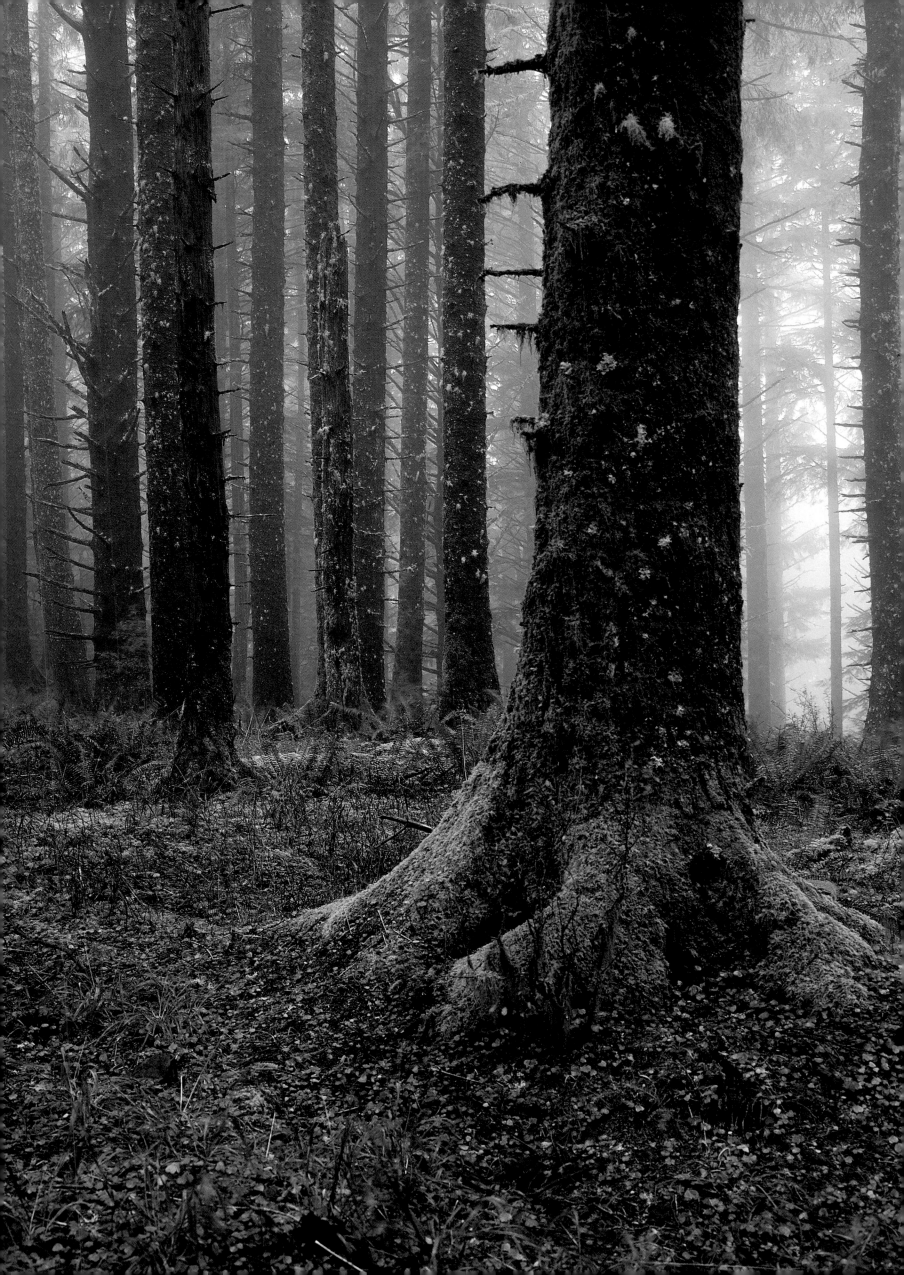

■ *Left:* Coastal mists veil a forest of giants on Cascade Head, a study area set aside by the United States Forest Service. ■ *Below:* A wealth of memorabilia from the sea is preserved in Astoria's Maritime Museum. ■ *Overleaf:* Like a magnet, the setting sun draws artist and photographer alike to capture the silhouetted Twin Rocks off Rockaway Beach.

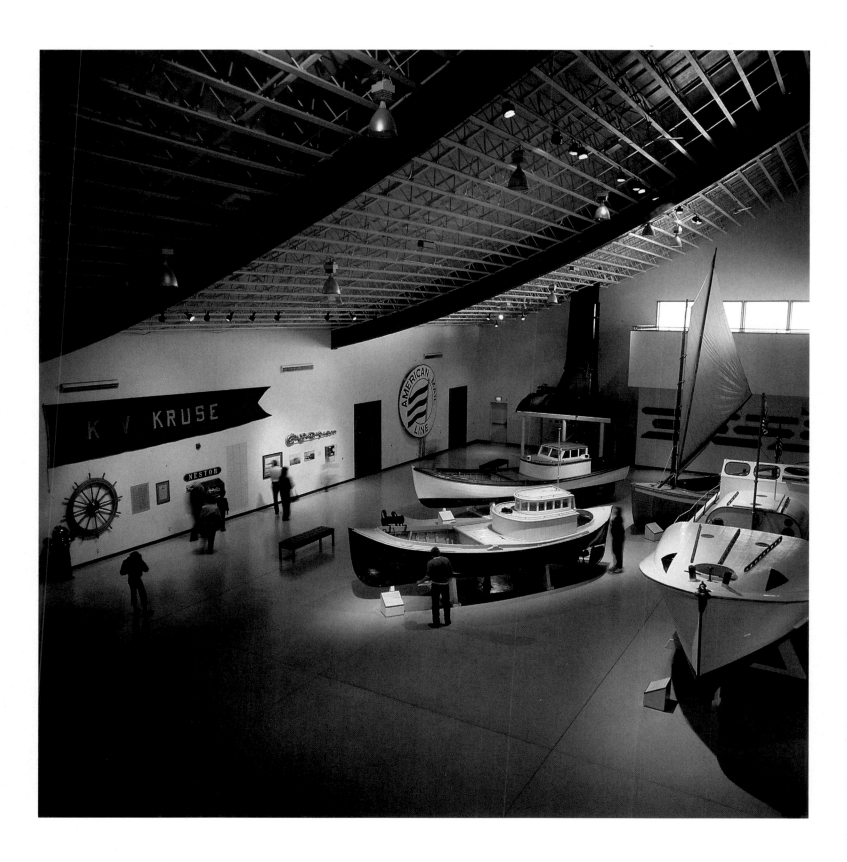

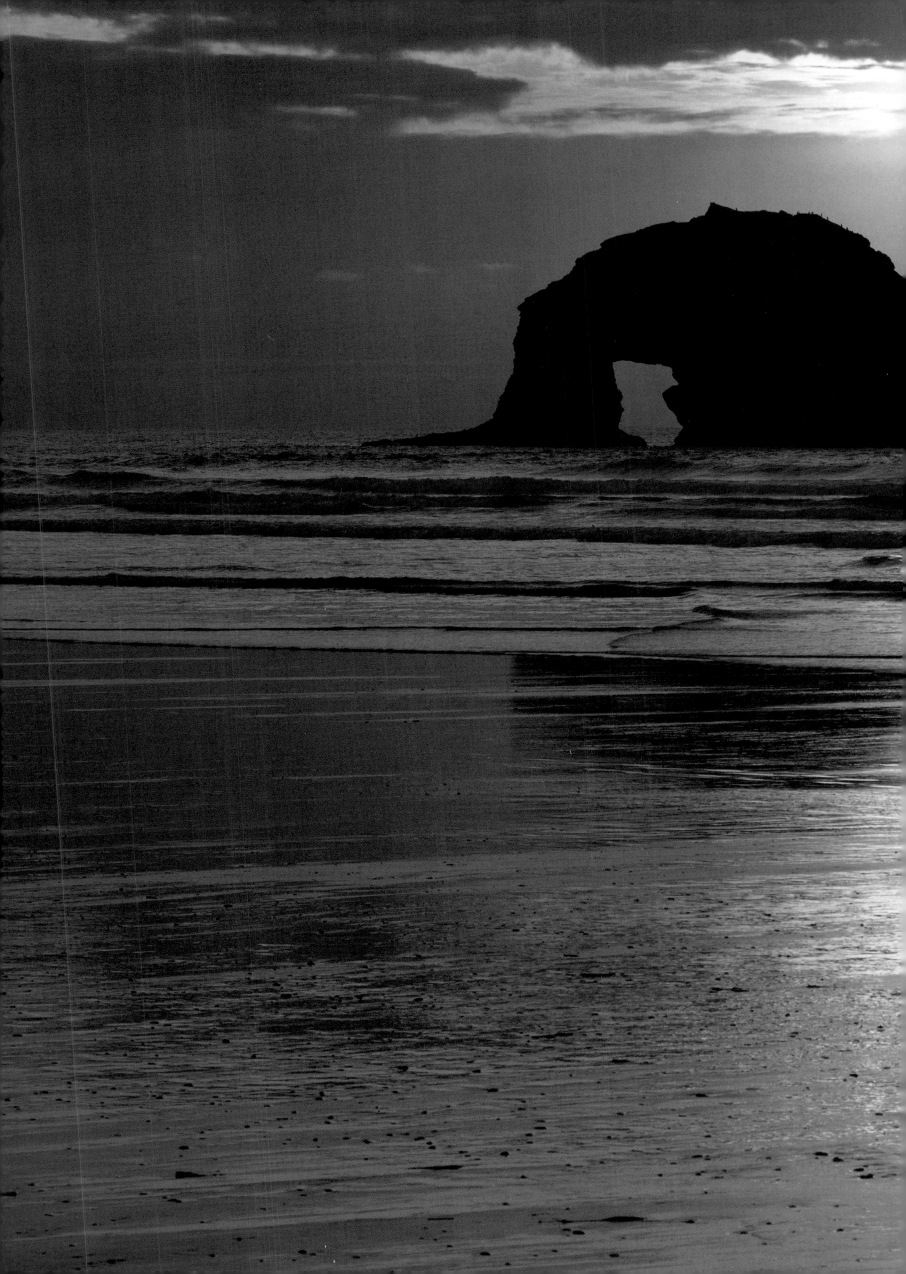

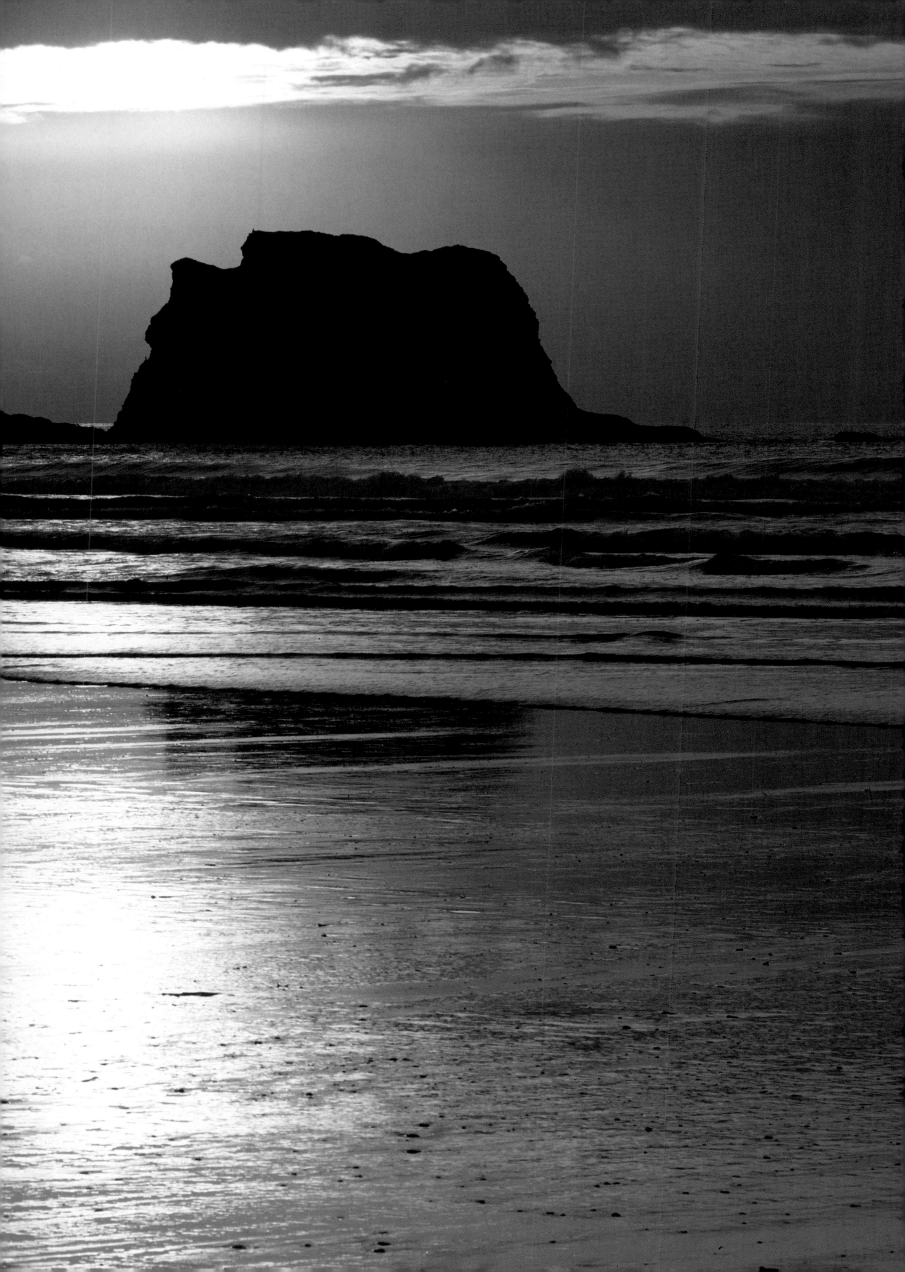

■ *Below:* At low tide, coastal explorers find a wealth of prizes. Each tidal pool will hold many delicate marine creatures like starfish and sea anemone. ■ *Right:* Cape Perpetua, at 800 feet, is the highest point on the Oregon Coast. Pictures taken from its crest have the look of aerial photos. The scene to the south, along Highway 101, is known as Devil's Churn.

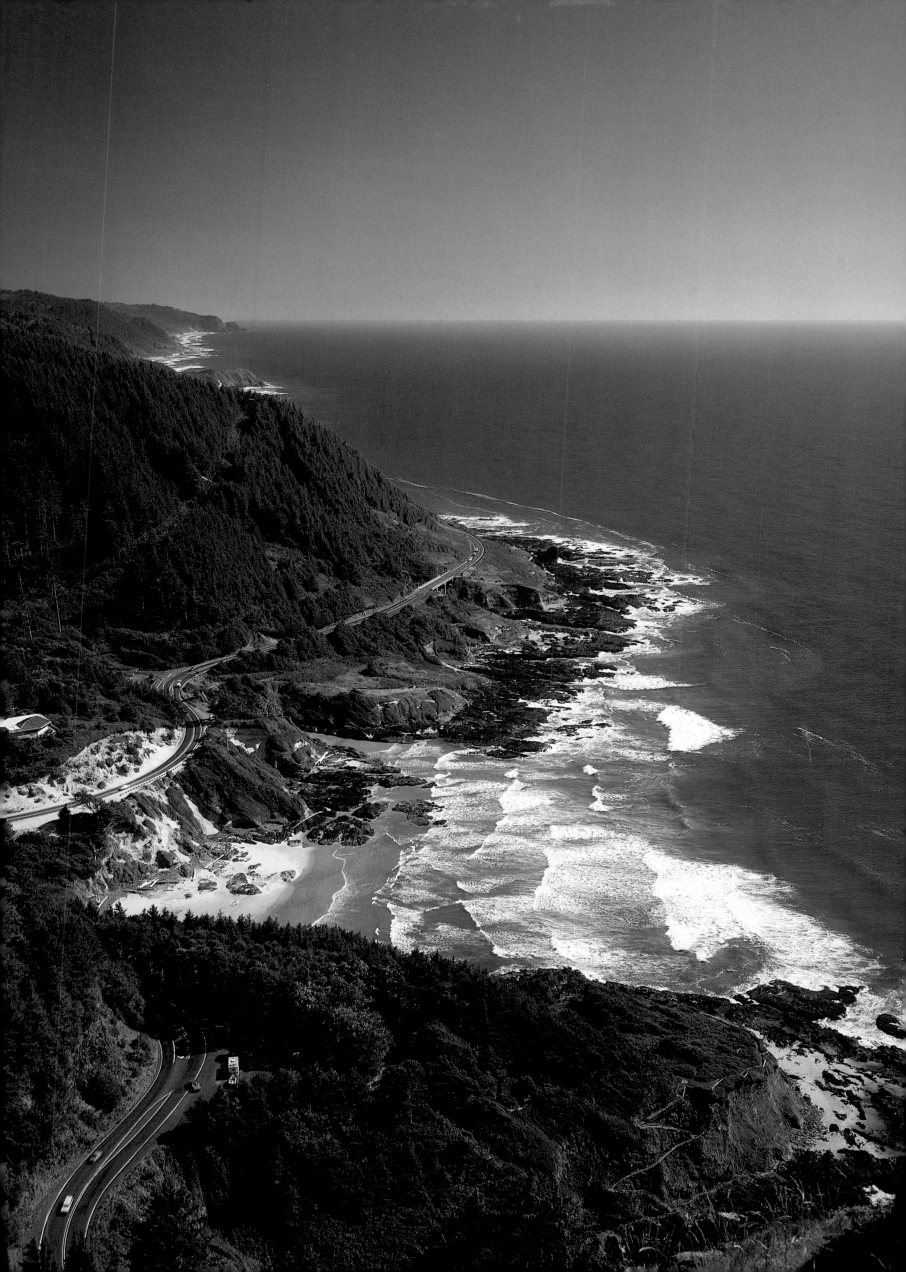

COLUMBIA
RIVER

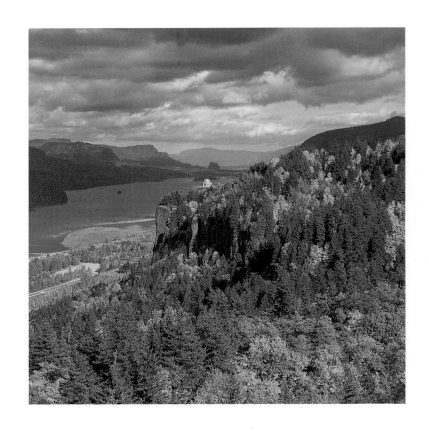

One hundred and fifty years ago, that portion of the Oregon Trail lying within what is now the state of Oregon constituted the last four hundred miles of the nineteen hundred-mile journey from Independence, Missouri. But the final part of the trek often proved to be the ultimate test of pioneer mettle. With provisions running low, and men, women, and animals nearing exhaustion, the travelers faced the largest rivers and most rugged mountains they were to encounter. The Dalles marked a turning point — a demand for a decision between two options for the last hundred miles to their destination, the Willamette Valley. Some took the Barlow Road — the land route that required crossing the perilous steeps of the Cascade Range. Others braved the Columbia River by raft, facing the mighty hazards of foaming rapids.

Today, the dams on the Columbia harness the rushing of the river, forming great long ponds of slack water arrayed in stair steps down from the Rockies, and the Columbia is a significant avenue of water commerce. The Army Corps of Engineers operates shipping locks at the four dams along the Oregon stretch of the Columbia River and four more dams on the Snake River, which opens the waterway to barge traffic all the way from the Pacific Ocean to Lewiston, Idaho, four hundred miles inland. There are six barge companies that ply the river waters twenty-four hours a day, most between Portland and Lewiston.

Five generations of the Shaver family of Portland have made the river their life's work. George Shaver, who is in his sixties, says he started when he was fourteen years old, rafting logs in the Willamette River in the slough at the head end of Sauvie Island, just downstream from Portland. Now his son, George, the fifth generation, works with the Shaver Transportation Company.

It takes a crew of five people to operate a towboat with its barge load. Crew members work six hours and take six hours off. Those six hours off are spent eating, reading, or sleeping. They live on the boat for maybe two weeks at a stretch, and then they may not be back at it for two weeks. George Shaver says the towboat master will earn forty to fifty thousand dollars a year. They take a great deal of pride in their work. They handle large tows in all kinds of water and weather — "sometimes blacker 'n heck, and blowin' . . . that takes skill."

Each of those three or four barges may contain up to thirty-seven hundred tons of cargo. The pay loads will range from petroleum products to grain or chemical fertilizers and will include a wide spectrum of goods in shipping containers. Corps of Engineer records show that on an average day more than twenty-one thousand tons of cargo will pass through the locks at Bonneville Dam. About a third of that will be moved to or from points in southeast Washington or Idaho via the Snake River.

Dredging crews do not work the rivers upstream from Portland. The main channel depth will run anywhere from thirteen feet in the more shallow places down to almost two hundred feet, and the river pretty much maintains its own channel. But from Portland downstream dredge operators maintain a shipping channel forty feet deep and six hundred feet wide all the way to the Columbia River bar below Astoria.

One Portland man has made the study of the rivers his life's work. He is Ogden Beeman, a hydrologist and a sought-after consultant on harbors from the United States to the Orient. Beeman came back to Portland to serve as the Port of Portland's expert on river depths and seasonal changes. He has devised a river-level reporting system based on rain and snowmelt, how much water is being let out at the upstream dams, and how much the tributaries are adding to the mainstream so that the port will know exactly how much water is in the river at any given moment. Such information has a very real bearing on how ships load in the harbor. Sometimes, though the channel is forty feet deep, the river may be several feet deeper and this can allow a heavier shipload. So Beeman's work is essential to the harbor operations. It is also extremely important to the Columbia River pilots who guide those huge cargo ships up and downstream between Astoria and Portland.

In the maritime world, the river pilots are considered the elite of the whole profession. Rex Pollitt, a pilot for many years, who is in his late fifties, started working on towboats in the upper Columbia at the age of sixteen. He used to pilot the sternwheeler *Portland* on what he describes as some of his more memorable trips. He's done it all — piloting coastwise tugs and harbor tugs, and serving as captain of a Portland Fire Bureau fireboat.

Rex says the Columbia River is one place where a foreign ship master really welcomes a pilot to come aboard and take his vessel along a very difficult route. He says in one day there may be as many as ten ships inbound on the Columbia and ten outbound — and at other times you might make the whole trip and not see another big ship.

But according to Rex, it is not traffic of the other big ships you worry about, it is the recreational boaters. In Multnomah County alone there are more than fifteen thousand small craft registered, and Rex says, "Some of them don't realize when you have a ship 1,100 feet long and 178 feet wide set in motion you can't suddenly stop or change course to avoid a collision. At fifteen knots on a large ship it might take over a mile to bring it to a halt, even in an emergency." Rex makes one other point, "When you have all that weight in motion and have to stay within the channel . . . when you are giving orders to the engine room, you have to be right the first time. You don't get a second chance at it." Little wonder the river pilot's pay is over $100,000 a year.

Oregon's first licensed Columbia River pilot was Captain George Flavel. He made a fortune guiding sailing ships across

the Columbia River bar and it was he who built, in 1885, the city of Astoria's most famous house, a handsome Victorian mansion which now serves as Clatsop County's museum. Since the historical society has outgrown that space, volunteers are refurbishing the old City Hall building to house more museum artifacts. Volunteers working on the project include Henry Weinhardt Wagner and his wife, Barbara. Henry's great-grandfather was Henry Weinhardt, who built the Blitz Weinhardt brewery in Portland. When young Henry retired as a stockbroker, he showed up in Astoria, bought an old house with a tremendous view, and along with Barbara began helping to preserve the area's history for others to appreciate.

Another museum which is the city's pride and joy is the Maritime Museum. The brainchild of the late Rolf Klep, a commercial artist raised in Astoria, it is widely regarded as the best maritime museum in the West and has an outstanding display of ship models and artifacts. Inside the museum is a reconstructed bridge of a Navy destroyer, and moored alongside the building is one of the last Columbia River lightships that used to mark the entrance to the river.

The thriving fish canning industry that once was a mainstay in Astoria's economy is considerably lessened now. Of the score or more of fish-processing plants that used to operate here, only a few remain—some of the Alaska pack is still canned here—but now, to take up the slack, Astorians are turning to tourism.

Tourism is, of course, a natural for Astoria. This is the site of the oldest settlement in the West, for here, in 1811, fur trader, John Jacob Astor, established his headquarters. According to J. W. (Bud) Forrester, who publishes *The Daily Astorian*, the people of Astoria have become increasingly aware of the importance and value of the area's history. They sponsor a "Living History" program during the summer months at the Fort Clatsop National Memorial—the place where the great Lewis and Clark expedition reached its terminus in 1805. To demonstrate what some of life was like in those days, local townspeople and the National Park Service rangers make candles, smoke meat, and fire flintlocks using the same methods the pioneers used almost two hundred years ago.

There is inspiring beauty to be found here along the lower reaches of the Columbia River, but it is the Gorge, where the river cuts through the Cascade Range between The Dalles and Portland, that is most famous for scenic splendor. Travelers revel in the parks and the miles of hiking trails and they marvel at the numerous sparkling waterfalls that plunge over the great high walls of rock—eleven waterfalls within one twelve-mile stretch.

In the early 1900s, wealthy Northern Pacific Railroad attorney, Samuel Hill, foresaw the effects the coming of the automobile could have and he became a chief proponent of a paved highway that would travel the river's edge on the Oregon shore and open the state to tourism. Another Samuel, Samuel Lancaster, engineered the Columbia Gorge Highway project through Multnomah County. In those days there were very few paved roads outside the cities of Oregon and only twelve thousand cars in the whole state. The colorful timber baron of the time, Simon Benson, was so confident the new highway would generate tourist traffic that he built a destination resort at Hood River for the travelers. This charming edifice, the Columbia Gorge Hotel, is still a popular stopover point for tourists.

Needless to say, the original Columbia River road has been superseded by the modern U.S. Highway 84, but twenty-one miles of the original highway with its intricate stone-work railings and bridges are still intact and maintained by the state, and that stretch of road was inscribed in the National Register of Historic Places in 1983, thanks to Oregon Highway Division historian, Dwight Smith.

Hood River is the gateway to one of the nation's most scenic and productive fruit-growing valleys. But in international windsurfing circles, Hood River has gained a new and different reputation. Years ago you might have found as many as a dozen people windsurfing on the river here. Today there are about a thousand on weekends. The phenomenon that attracts them— the river running east to west, and the wind coming up the valley from west to east — creates water ramps or waves that give the surfer exhilarating wave jumping and high-speed "reaching" (moving *across* the wind).

Robin Young operates Wind Rider, one of twenty-three windsurfer outfitting stores between Hood River and The Dalles. He says people come here from all over the world. During the Pro-Am events, racers came from Japan, Germany, Sweden, Canada, and all over the continental United States and Hawaii. Robin calls this the windsurfing "Mecca" of North America. He insists that the only other place with great winds is Maui, but this area on the Columbia draws many more windsurfers.

Windsurfing tends to be a young people's sport (and many world-renowned hang gliders have turned to it), but Robin has seen people in their eighties sailing. Its appeal is that it is so physical — being propelled by the wind. Robin says, "You are holding on to the wind, so to speak, as opposed to being propelled by an engine."

Thus, the harnessing of the mighty Columbia has changed its character, but it has not stolen its majestic grandeur. And the people who earn their living on the river, whether by gillnet fishing, or moving cargo, or running sightseeing cruises, are joined by swimmers and water-skiers, powerboat cruisers and sailboat racers . . . all of them embracing the river as their own special place.

■ *Right:* An impressive network of hiking trails winds among the cliffs of the Columbia Gorge. Hikers follow a scenic trail on a narrow ledge above Eagle Creek, which empties into the Columbia River some forty miles upstream from Portland.

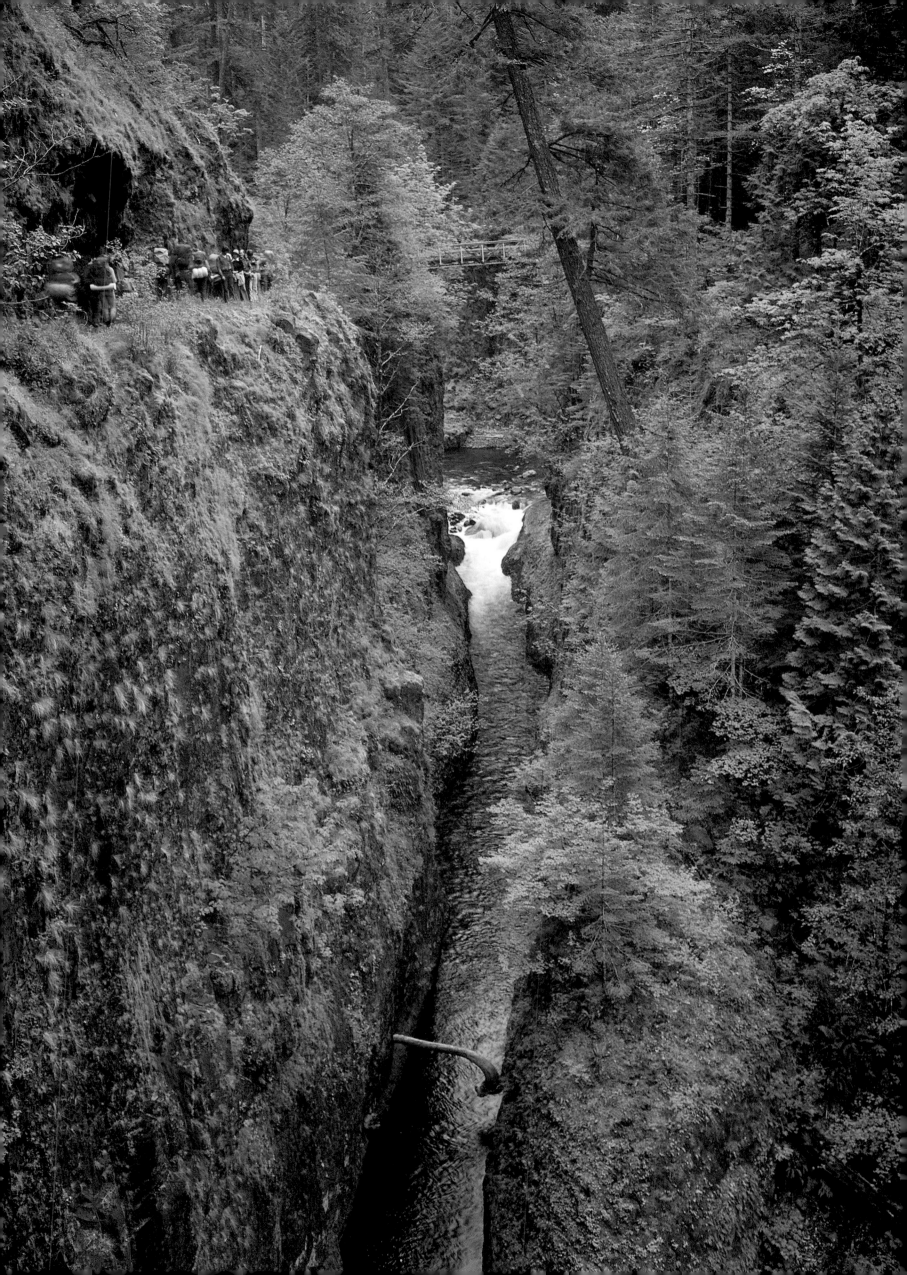

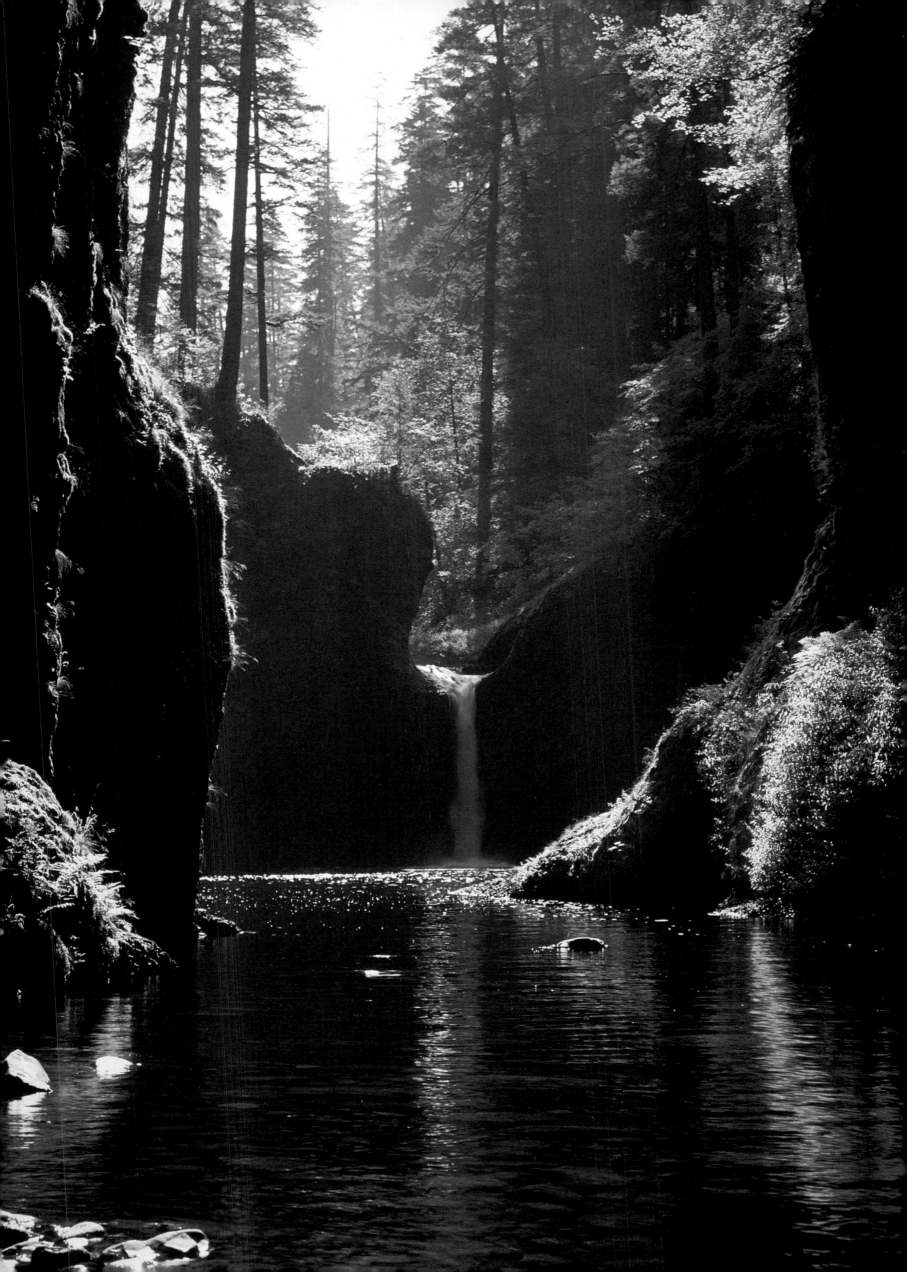

■ *Left:* Eagle Creek Punch Bowl Falls is aptly named. Just west stands Bonneville Dam—the first project built in the Columbia Gorge by the U.S. Army Corps of Engineers. ■ *Below:* At 620 feet, Multnomah Falls is one of the highest waterfalls in the nation as well as one of the most beautiful and popular tourist attractions in the Pacific Northwest.

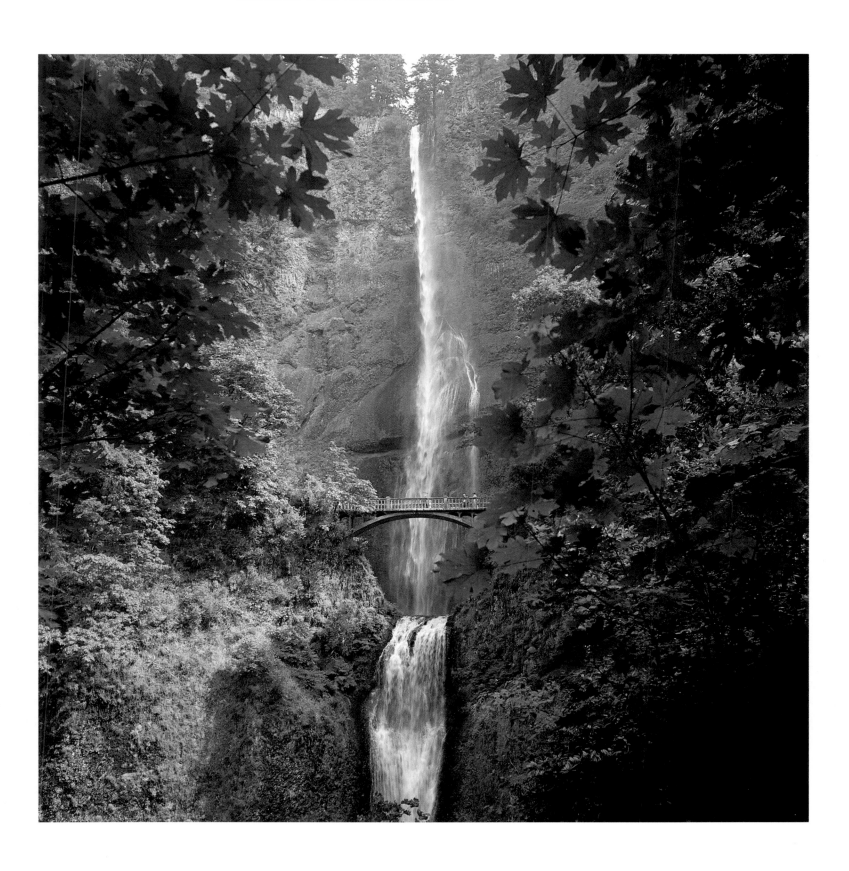

■ *Below:* Ice-coated branches add a wintry touch at the foot of Horsetail Falls beside the Columbia River Highway. Thirty million years of geologic history are to be found in the walls of the Columbia Gorge — a record of lava flows, erosion, and the massive uplifting of the Cascade Range.

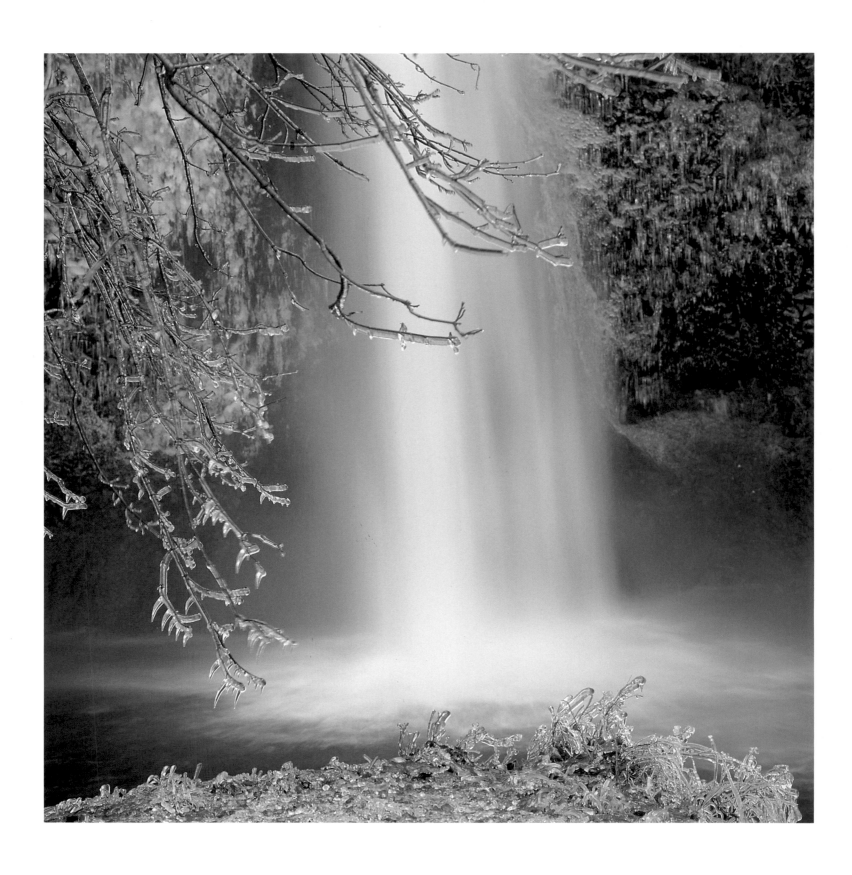

■ *Below:* The painstaking skill of Italian stone masons is still evident at Shepperd's Dell, where the old Columbia River Highway was once the only access by automobile through the Gorge. Twenty-four miles of this early 1900s roadway, marked U.S. 30 Scenic Route, are still open to use.

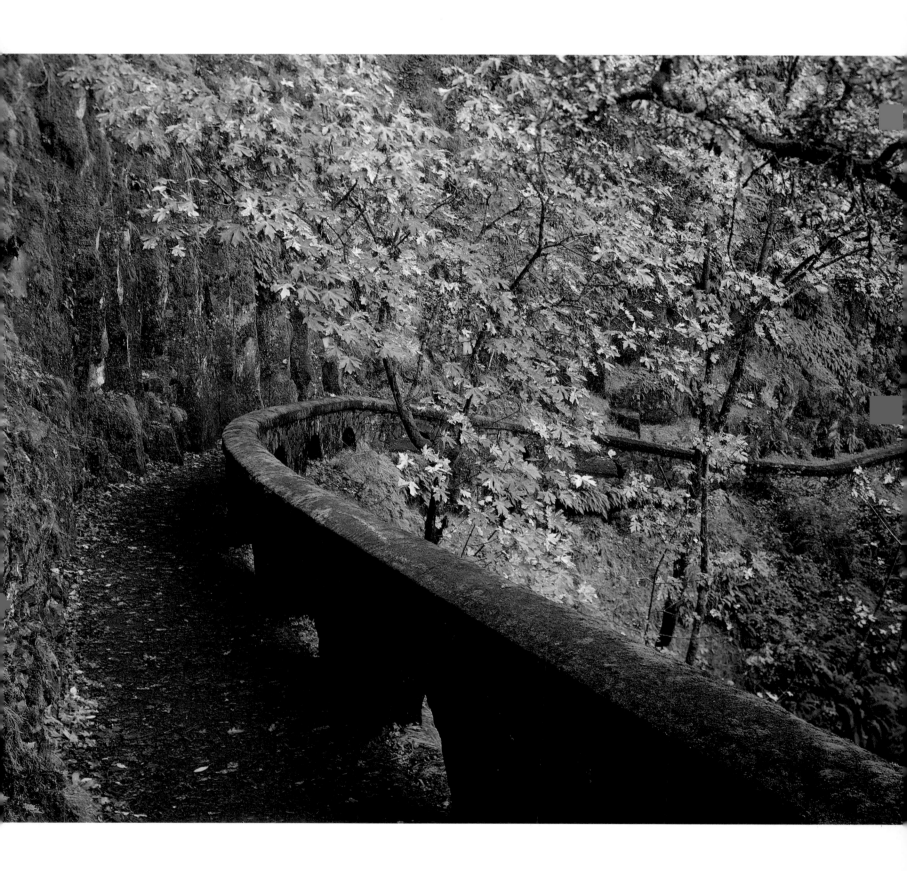

■ *Below:* Autumn yellows and browns provide the setting for
Wahkeena Falls as they cascade from the forest heights down to
the Columbia River. Wahkeena Creek and Falls get their name
from the Yakima Indian term for "most beautiful."

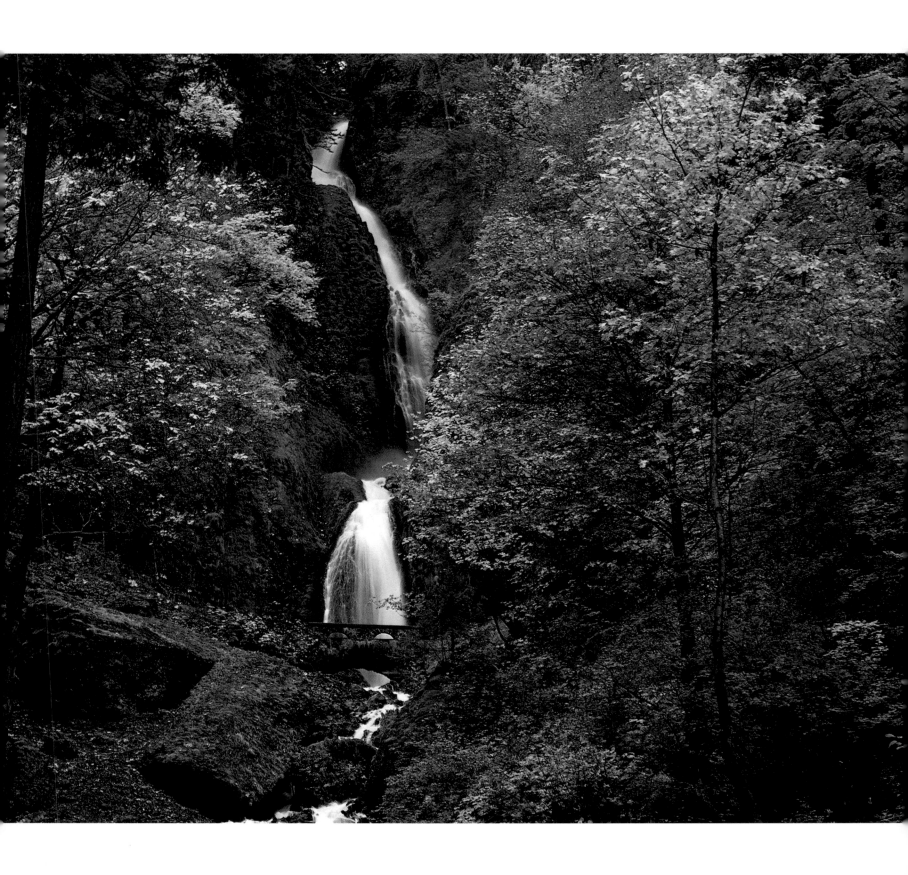

■ *Below:* Oregon offers unparalleled year-round boating opportunities. Some sailboat owners are racers — others are just cruisers. Whether sailing, powerboating, sculling, or canoeing, most pleasureboating takes place in Multnomah County — much of it here on the Columbia River, but also on the Willamette River, which flows through the city of Portland.

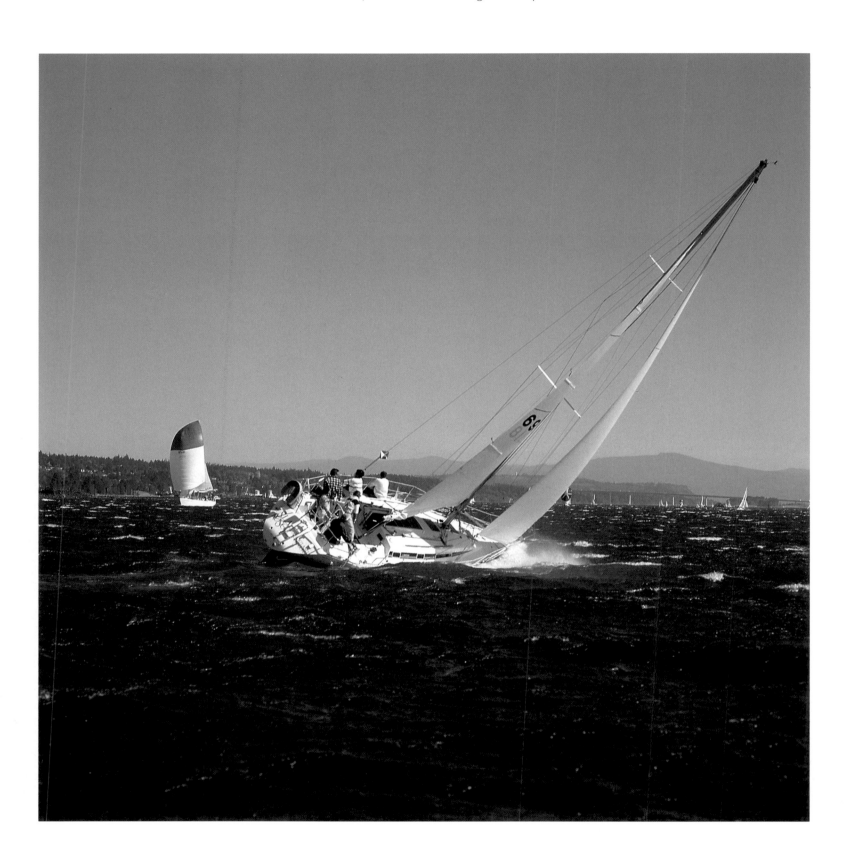

■ *Below:* Windsurfing is surging in popularity on the stretch of the Columbia between Hood River and The Dalles. Some enthusiasts have invested as much as ten thousand dollars in equipment. It is estimated that the sport, which attracts all ages, pumps ten million dollars a year into the area economy.

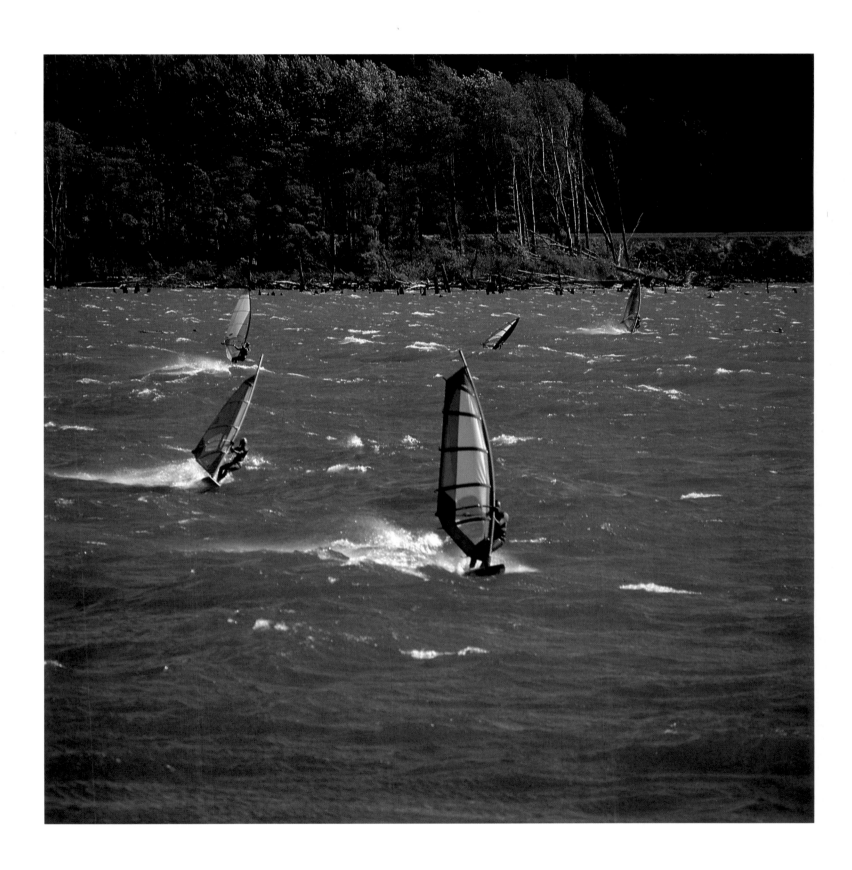

■ *Below:* A sunset paints the sky over the Columbia River Gorge National Scenic Area near Hood River. The Columbia is named for the ship of Captain Robert Gray, who discovered the great river on May 11, 1792. Little did he know that the Columbia carried more water, drained more land, and would produce more electricity than any other river in the West.

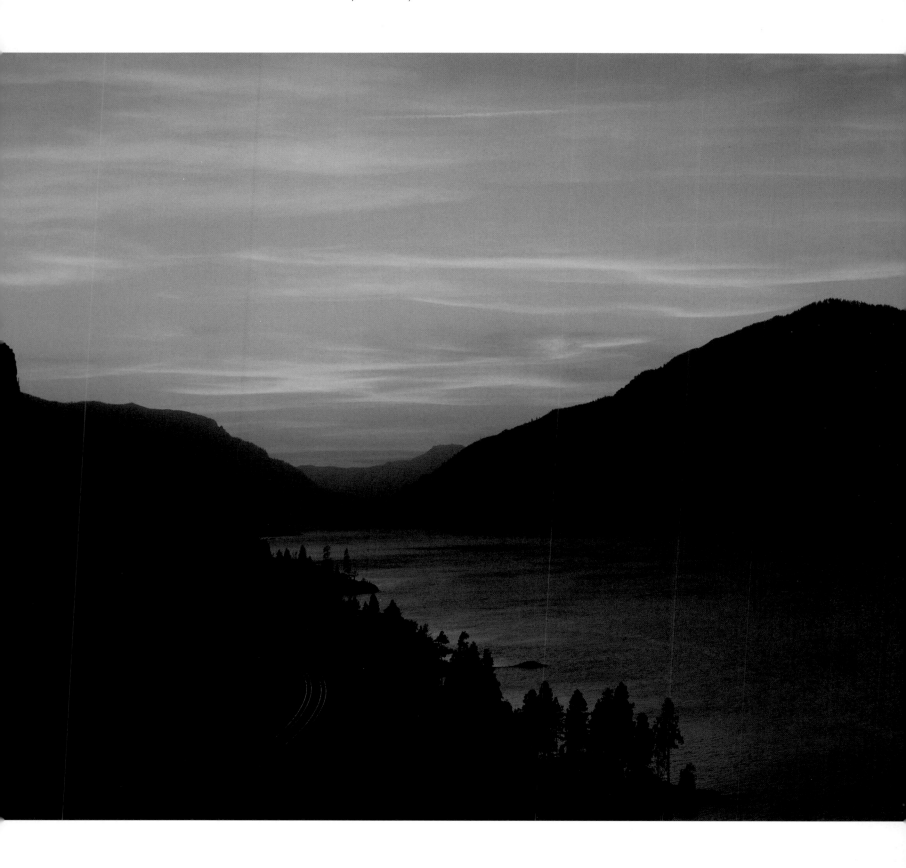

■ *Below:* A hillside above Hood River is blanketed with balsam root — one of several native plants that are commonly called sunflowers. About four inches across, balsam root blooms are found in many somewhat barren regions of the West. Hood River Valley is a leading producer of cherries and d'Anjou pears. In early spring, the valley is a sea of fruit tree blossoms.

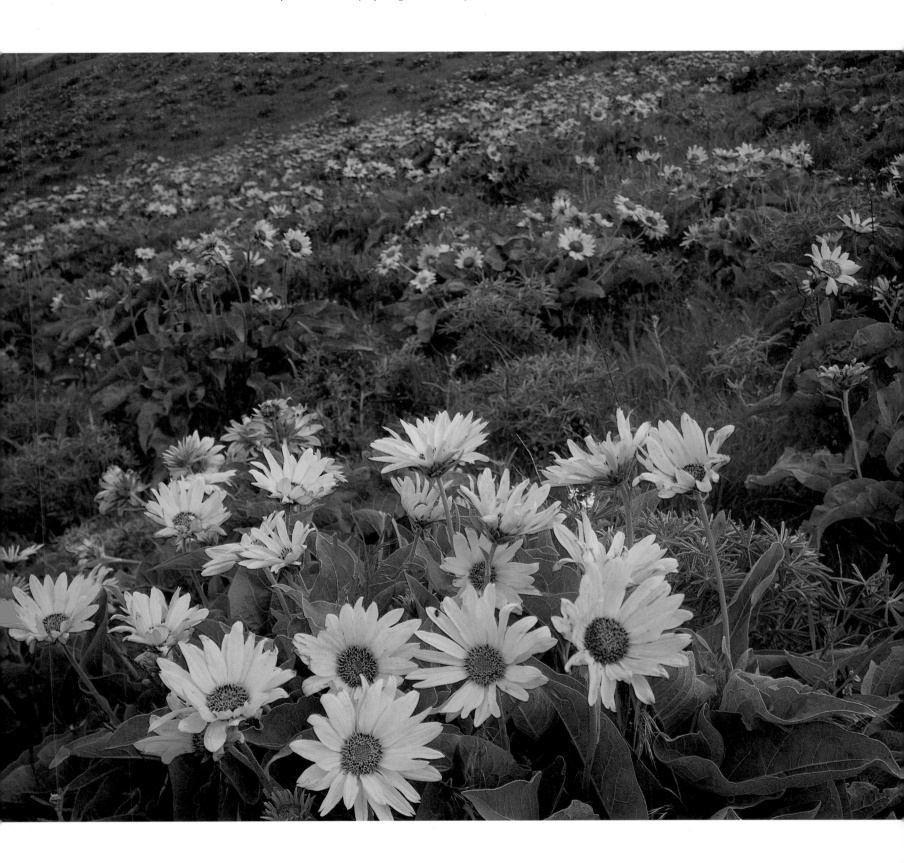

■ *Below:* Elowah Falls, on McCord Creek in John Yeon State Park, arches out from a lava cliff on its way to a rendezvous with the nearby Columbia River. While the park is named for a former Oregon Highway Commissioner, the stream bears the name of pioneer W. R. McCord, who built the original fish wheels near the mouth of the creek.

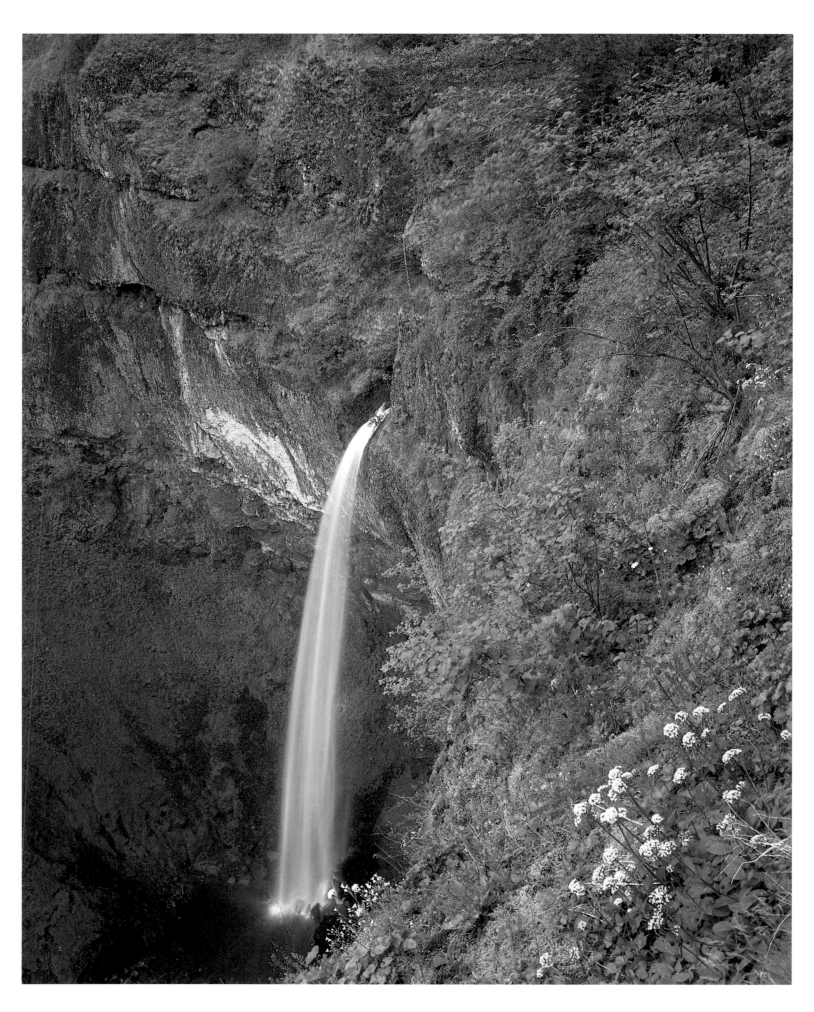

WESTERN
VALLEYS

WESTERN VALLEYS

It is in the western valleys that 70 percent of Oregon's people live — nearly 2 million of them. If you search for the names of those whose deeds had most to do with the character and the directions of this state in recent times, you face an awesome task of selection. So many names come easily to mind ... with space here for such a few.

We will start in the northern part of the valley, in Portland, which, when he was with the Convention and Visitors Association, Steven Morris called the "urban crown jewel in the tiara of a largely wilderness state." Morris said Portland is unique, a place where jeans and running shoes mix comfortably with tuxedos. Indeed, at the conclusion of a midsummer mountain ski race, hundreds of Rose Festival celebrants show up at a posh dance at a downtown hotel wearing Black Tie and Blue Jeans, the recommended attire for the evening.

In a place like this, who are the people who have helped to shape it? Morris is one. Another is Clayton Hannon, former Portland Rose Festival executive manager, who with his board of a hundred business volunteers made the festival one of the top five civic celebrations in the nation.

Here are some others I think should make the list:

Harry Glickman, the Trailblazers' president ... for bringing pro sports to Oregon ... first hockey, then basketball.

Harry Merlo, Louisiana Pacific Chairman ... for his support of pro tennis, soccer, and a myriad of other causes and for heading the State Advisory Committee of the Salvation Army.

The late Edith Green, former congresswoman ... who obtained support from the Rotary Club and the Salvation Army for the Greenhouse shelter for street kids.

Bob Ames, President of First Interstate Bank ... who has been so influential in bringing big-time auto-racing to Portland and in supporting a host of other projects.

U.S. Senator Mark Hatfield ... for bringing big money into Portland. There is a whole congressional contingent whose deeds are detailed in *The Oregonian,* but he is the leader.

Another money raiser of note ... attorney Ronald Ragen, who was the volunteer chairman of the drive to build and finance the Portland Center for the Performing Arts. In that same effort we recognize Mildred Schwab, who as city commissioner guided the project into being. This adds to her long list of good works in looking after our parks, police, and fire bureau.

On the subject of the arts, Oregon Symphony Music Director and Conductor James DePreist, superbly helped by his associate conductor, Norman Leyden, an established pops conductor himself, gives a most inspirational kind of leadership.

In the literary field, there is a great deal of talent in Oregon, but two names stand out: Oregon's Poet Laureate, William E. Stafford, and nationally acclaimed fiction writer, Ursula LeGuin.

No campaign to raise big money in Oregon will sustain itself for long without the participation of people like Don Frisbee, Chairman and Chief Executive Officer of Pacific Power & Light; Robert Short, his counterpart at Portland General Electric; John Elorriaga, who chairs the Board and is CEO at U.S. National Bank; Robert Ridgely, who runs Northwest Natural Gas Company, succeeding Ron Miller as CEO; and Bill and Sam Naito, who have breathed new life into many of Portland's historic buildings. Their support of what is good for their community has been consistent and generous.

One of the quiet contributors is Julian Cheatham of the Georgia-Pacific Corporation who has worked to improve the timber products industry and particularly the U.S. Forestry Center. Kenneth Self, who went from truck mechanic to Chairman of the Board of Freightliner Corporation, has served the state in many ways, heading the Economic Development Commission, and supporting the Shrine Children's Hospital. Credit for giving Oregon a leg-up in high-tech electronics must go to the men who pioneered in this field at Tektronix, Oregon's largest industrial employer and the source of so many silicon colony spin-offs. We are talking about the late Jack Murdock and Howard Vollum.

In the legal arena, Attorney General David Frohnmeyer has broken new ground in consumer rights cases for Oregon citizens. In the historical field, Tom Vaughan of the Oregon Historical Society has led that institution to Pacific Rim eminence.

In political leadership, one individual literally towered above the rest—the late Governor Tom McCall. This great conservation crusader led the way to cleaner air, cleaner rivers, cleaner roadsides, and greener river banks. And he did so with a flair that somehow made us proud of our accomplishments.

In Salem, Secretary of State Norma Paulus was a fearless guardian of elections and a meticulous overseer of the record-keeping and spending habits of state agencies. She was the first woman ever nominated to run for Governor of Oregon.

The man who edged her out in that race and then appointed her to the Northwest Power Planning Council, Governor Neil Goldschmidt, has shown leadership in a number of very visible ways. As mayor of Portland in the 1970s he ramrodded the construction of a transit mall downtown and he laid the political groundwork for the building of light-rail between downtown and the east side. He has two of the McCall traits: he is a fearless innovator and he loves to work in front of an audience.

Moving down the valley, we reach Eugene, Oregon's second-largest city. Tony Baker, the editor of the *Eugene Register Guard,* describes this as a very vocal community. He says the people here are much concerned about the quality of life in Oregon. "We don't always agree ... but the idea that a lot of people are talking about it, for whatever reason, is very important." As to

liberal versus conservative, Baker says the presence of the University of Oregon gives the place a liberal tilt, but without the university, the area would be considered very conservative.

Eugene is also the home of Lane Community College. Among many other accomplishments, Lane has captured a good reputation for theater work, in large part because of instructor Ed Ragozzino. Ed, who recently resigned as head of the Department of Performing Arts, feels Lane is a part of the community's cultural force. He describes Eugene's home of the performing arts, the Hult Center and the Sylva Concert Hall, as a world-class piece of architecture with two magnificent theaters.

One of the prime movers in the initial financing for the center was furniture dealer Maurie Jacobs. Maurie and other business people set out to raise $18,500,000. The top donors were Nils Hult, whose money came from the lumber business, and Carolyn Chambers, who runs Liberty Cable Company. Jacobs says, "Nils Hult committed himself for three million dollars and Carolyn came through with a million and a half. In all, the foundation gathered in about $9 million, and the people passed a bond program for the rest."

Jacobs talks of other people who have helped shape Eugene's direction. "Stub Stewart comes about as close as any I can think of to being the most important man in the community. Stub is Chairman of the Board of Bohemia Lumber Company. His efforts go to a multiplicity of good works ... Sacred Heart Hospital ... the Speech and Hearing Center ... Chamber of Commerce."

East of Eugene and up the McKenzie River, right where the Blue River flows into the McKenzie, lives a lady named Frances O'Brien. Frances has had a love affair with books most of her life. She always had a big collection of books in her living room and invited neighbors to come and borrow them anytime. This has been going on for more than a half century and people have been adding to her book collection from all over the nation, especially since Charles Kuralt taped a TV story on this country library, which now numbers more than 23,000 volumes. A small building behind Frances O'Brien's home was put up to house these books. There is no lock on the door, no office hours, and no need for a library card. The librarian, now in her mid-eighties, says there are no fines either: "If I can trust people that when they are through with the books they'll bring them back, that's all I ask."

The lifeblood of this whole section of Oregon, from the Cascade Range all the way out to the coast, is timber—the growing, cutting, processing, and marketing of wood products. It is Oregon's largest industry, for here grow more Douglas firs than in any state in the Union. It is an industry that was hard hit by the recession of the 1970s and radically changed.

Gary Jensen, a forester for Lane Plywood in Eugene, has been in the business a long time. He says, "We've changed from an industry largely controlled by large international corporations. The wood products industry is full of very independent people who have the drive to succeed. We saw these people come back in and say, 'My family has run this sawmill for thirty-five, forty, fifty years ... and I'm not going to lose the thing.' They slugged it out then and they are running the business today. And the big companies have been chased out because they don't find the returns profitable enough. They can take the dollar and make a better return somewhere else."

As for the loggers in the woods, Jensen says, "Loggers too are an independent breed. You don't tell 'em how to do anything and they are very competitive. They had a lot of problems ... some lost equipment and lost opportunities. Many have come back. But I can tell you, for those who didn't, there are two or three more who are willing to step into their shoes. We are blessed with all those trees on these hills ... so there's no question, the industry is coming back."

One of those fiercely independent competitors is Kenneth Ford, who owns Roseburg Forest Products Company. Jensen once worked for Ken Ford as a log buyer and he describes him as a "modern day Timber Baron." Ford did not go to college but instead took the road of hard knocks and went into the business of milling and manufacturing.

He is now the single-largest employer in Douglas County. He built sawmills in the Dillard area, a plywood mill just south of Roseburg, a green-end processing plant at Dixonville, and a plywood plant at Riddle which is one of the largest in the world. He owns a plywood complex over on the coast at Coquille and he has built a number of whole-log chipping plants. His company is the largest exporter of softwood chips on the West Coast. Ken's genius is in engineering, in constructing some of the industry's most durable and successful facilities, and in his aggressive approach to setting the industry pace.

The Rogue River Valley lies between the Siskiyou Mountains on the south and the Umpqua Divide on the north, the Coast Range on the west and the Cascades on the east. Sheltered as it is, Medford is called the banana belt of Oregon.

Otto Frohnmeyer, longtime Medford attorney and father of Oregon's Attorney General, told us, "Our biggest problem is that we are so close to California. (Medford is twenty-seven miles from the border.) They come up here with cash after selling their property down there ... and they can't believe how cheap it is to buy in the Rogue Valley or in Medford. Most of them are retirees, people who've had important jobs with big corporations. We have the largest settlement of Standard Oil retirees in this valley that they have anywhere in the world."

When Frohnmeyer talks about the people who have done the most for this area and for Oregon, he turns first to the late Glenn

Jackson. Chairman of the Board of Pacific Power & Light, Jackson's public service role was legendary, but his greatest contribution to Oregon may have been as Chairman of the Highway Commission. Under Jackson's skillful guidance, Oregon finished its part of the Federal Highway program well ahead of most other states. Jackson was also the spark plug in the development of Mount Ashland Ski Lodge and Medford's Rogue Valley Country Club and its golf course. He owned a string of newspapers from Ashland to Albany. The late Eric Allen, Jr., a former editor of the *Medford Mail Tribune,* liked to say that Glenn Jackson ran the power company with one hand and all these other things with the other.

Above everything else, Medford is known for its pear orchards. In the early days it was the prospect of making money raising pears and apples that drew easterners to southern Oregon. Among them came the Carpenter brothers — Leonard, Dunbar, and Alfred. Leonard arrived first, in 1908. When he learned it was impossible to grow pears without irrigation (Medford receives about nineteen inches of rain a year, most of it in the wintertime), he headed up a group that brought water down from Butte Springs through wooden pipes. That was Medford's first central water-supply system.

Leonard's brother, Alfred, arrived in the early 1920s. Alfred's wife, Helen, had a family connection with one of the founders of IBM, and as that industrial enterprise grew into giant proportions, the Alfred Carpenters prospered as well.

From 1950 on, Alfred and Helen Carpenter's influence began to be felt in a myriad of worthy community projects. Among them are the Rogue Valley Memorial Hospital, now known as the Rogue Valley Medical Center; the Red Cross building; the University Club; and what is now called the Mary Phipps Center on the Medford campus of Southern Oregon State College. Besides all this were handsome gifts to the Oregon Shakespearean Festival in Ashland.

Their philanthropies are continued through the Carpenter Foundation, which is looked after by the late Alfred Carpenter's second wife, and by Mr. and Mrs. Dunbar Carpenter. Dunbar, who still owns the orchard that his uncles started, also developed Medford TV station KDRV.

Some of the other interesting people who live in the Rogue Valley include former Medford Mayor John Snider, a frequent contributor to the Herb Caen column in San Francisco. John, who used to write some gags for Jack Parr and Phyllis Diller, says, "My best line for Phyllis Diller, which she still uses, is 'my legs don't go all the way up.' It's silly and inane, I know."

Film star Ginger Rogers has a place on the Rogue River which she has called home since 1940. She told us, "Of course, I have to leave it to go to my work. My work doesn't come to me. This became a refuge for me...there is such beauty here, and so far the fresh air is not spoiled by plastic or chemical plants or gas-cracking plants such as plague Beverly Hills. We have very good fishing here." Ginger Rogers says, "I chose Oregon mainly because I thought it promised a sense of peace and tranquillity away from the 'Hurry-Burry' of the film capital."

Another very popular resident of the valley is one of Oregon's "winningest" high school football coaches. Now retired, Fred Spiegelberg still lives in Medford. Spieg, as he is known, had one losing year in thirty-one years as head coach.

Talk of the Oregon Shakespearean Festival at Ashland abounds in southern Oregon, but there never would have been such a thing without one man, Angus Bowmer. It was his idea to go back to staging Shakespeare in the manner in which the writer intended — in a courtyard with the audience almost surrounding the players.

Bill Patton, the Festival's manager, tells how Bowmer started the Ashland theater: "Angus accepted a position at the Normal School, which is now Southern Oregon State College at Ashland. He was teaching Speech One and English. He discovered in the downtown area an abandoned chautauqua theater...just a shell with no roof. That brick wall reminded him of drawings he had seen of Shakespeare's theater, the Globe. Bowmer managed to get WPA funds to start his Shakespeare theater plan. The first performance was the Fourth of July, 1935. Bowmer never doubted it would continue. His first flyers labeled it "The first Annual Shakespearean Festival."

Angus Bowmer died in 1977, but the tradition he began has become one of the six largest not-for-profit theaters in the nation. This has been accomplished with the great care and skill of Artistic Director Dr. Jerry Turner, his dedicated staff, casts of talented performers, and community volunteers.

One of the most ardent of these is Virginia Cotton, whose friends call her Ginny. When she and her late husband, John, came to Ashland in 1946, the theater had been closed down during the war, and they set out to build a new stage. (John Cotton was in the lumber business.) Ginny helped set up chairs borrowed from the college. She says, "We did all kinds of jobs ... taking tickets ... putting money in cigar boxes ... the interest just continued to build and the festival flourished." Today, the Ashland operation has an annual budget of almost six million dollars and sells at least 92 percent of its capacity.

The Ashland Shakespearean Festival is a remarkable success story — a story that could not have been written without the talent, understanding, and enthusiasm of volunteers.

Up and down the state, in city after city, we have seen that same spirit of volunteerism motivating people throughout these western valleys. It would seem to be — The Oregon Way.

■ *Below:* Oregon's state capitol cost 2.5 million dollars when it was built in the late 1930s. Its dome is topped by an eight and one-half ton bronze pioneer created in New Jersey by sculptor Ulric Ellerhusen. In 1984, two artisans spent thirty-two working days replacing the statue's gold-leaf, which cost thirty-nine thousand dollars — all raised by Oregon school children.

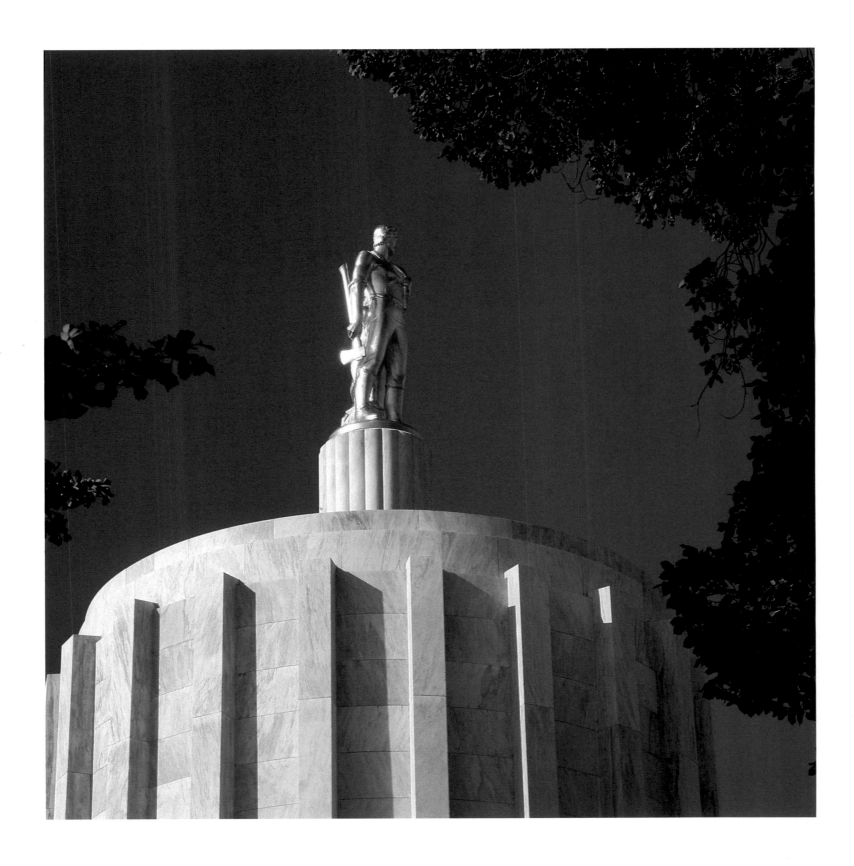

■ *Below:* Oregon grape, *Berberis aquifolium,* was selected as the Oregon state flower in 1899. The low-growing plant with its waxy, hollylike leaves is native to much of the Pacfic Coast. Yellow summer blossoms set edible blue berries in the late fall.
■ *Overleaf:* Crimson azaleas add a touch of brilliance to the famed Japanese Gardens in Portland's Washington Park.

■ *Below:* The Bybee-Howell House on Sauvie Island is the first plastered house built in Oregon. James Bybee built the house in 1856 and sold it in 1873 to Joseph and John Howell. Of the home's nine rooms, seven have fireplaces. The Oregon Historical Society manages the National Historic Landmark.

■ *Below:* Portland has grown gracefully into a big city without relinquishing its character and charm. ■ *Overleaf:* On the site of Portland's first schoolhouse, Pioneer Courthouse Square was created in the early 1980s as a focal point for civic festivities, impromptu or scheduled. Its design acknowledges Portland's brick, cast-iron, and terra-cotta heritage.

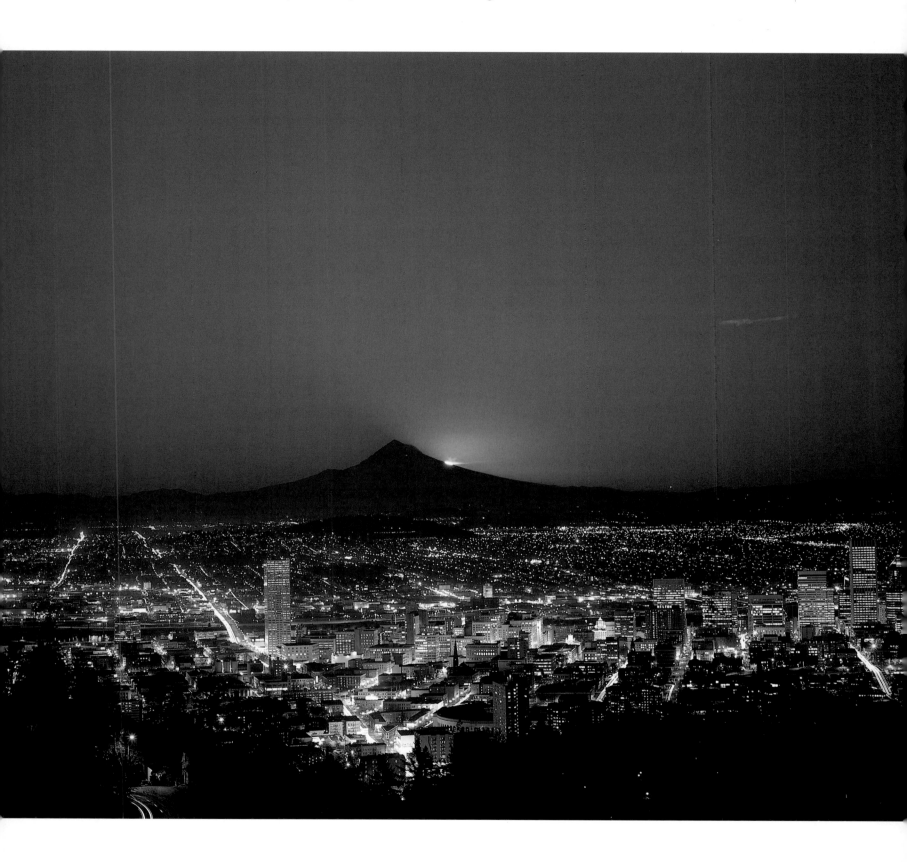

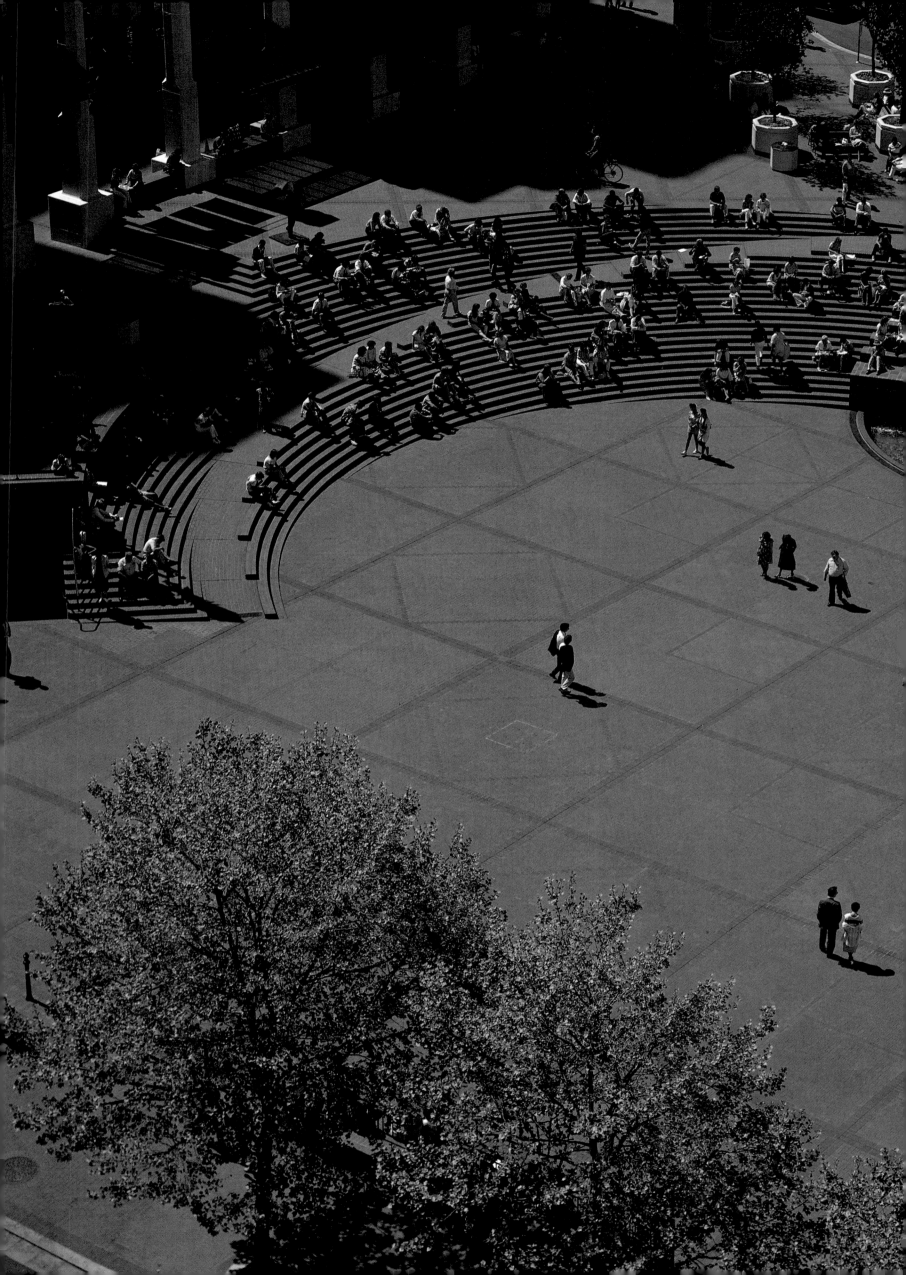

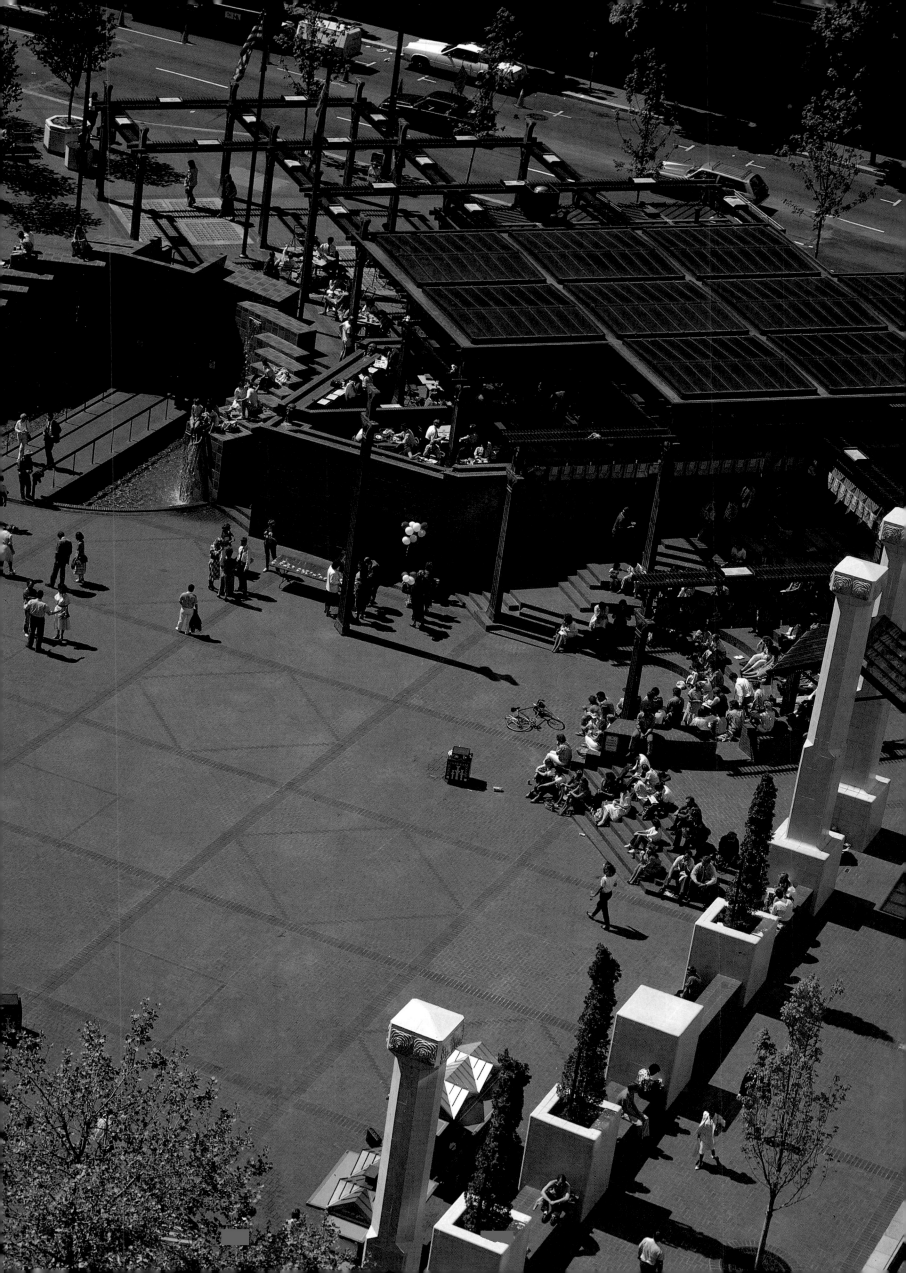

■ *Below:* The white blossom of the trillium, a familiar harbinger of spring, turns lavender or purple as it matures in Oregon's shady forests. ■ *Right:* Well-traveled trails circle through Silver Falls State Park, thirty miles east of the state capitol at Salem. ■ *Following Page:* A bountiful harvest of squash near Jefferson in the Willamette Valley waits for market.

74

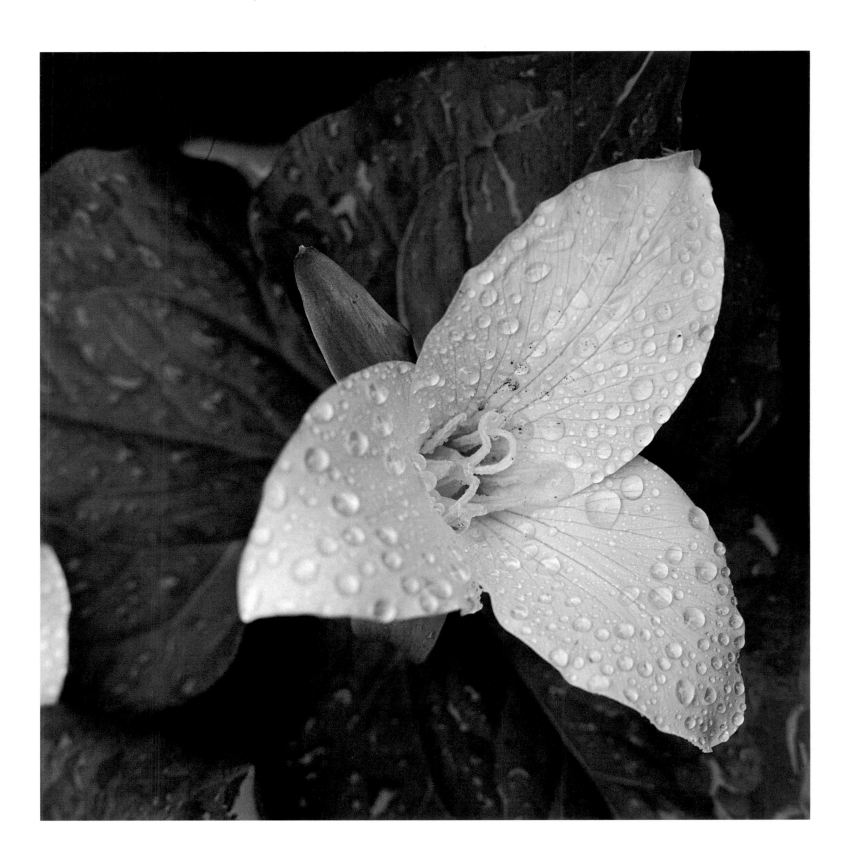

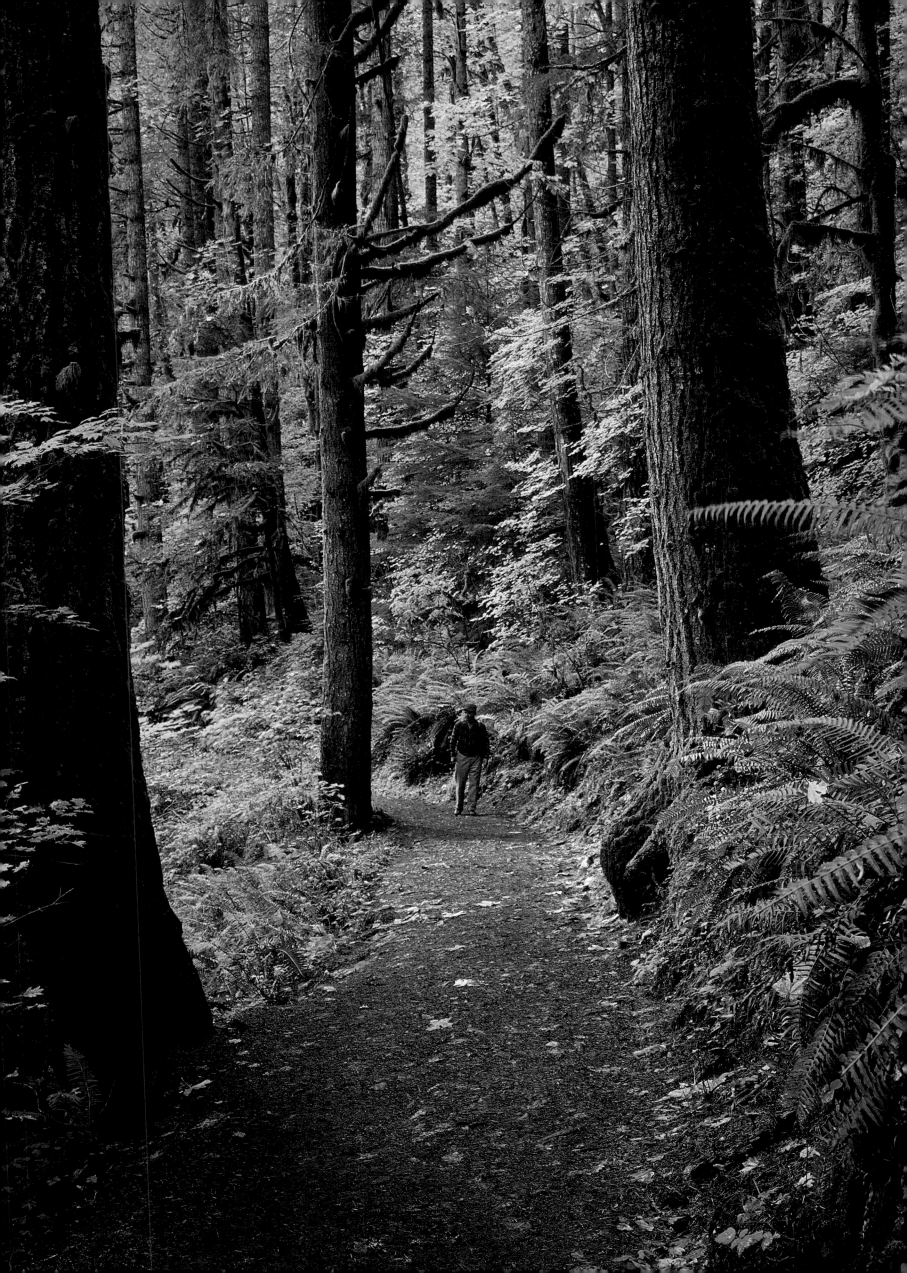

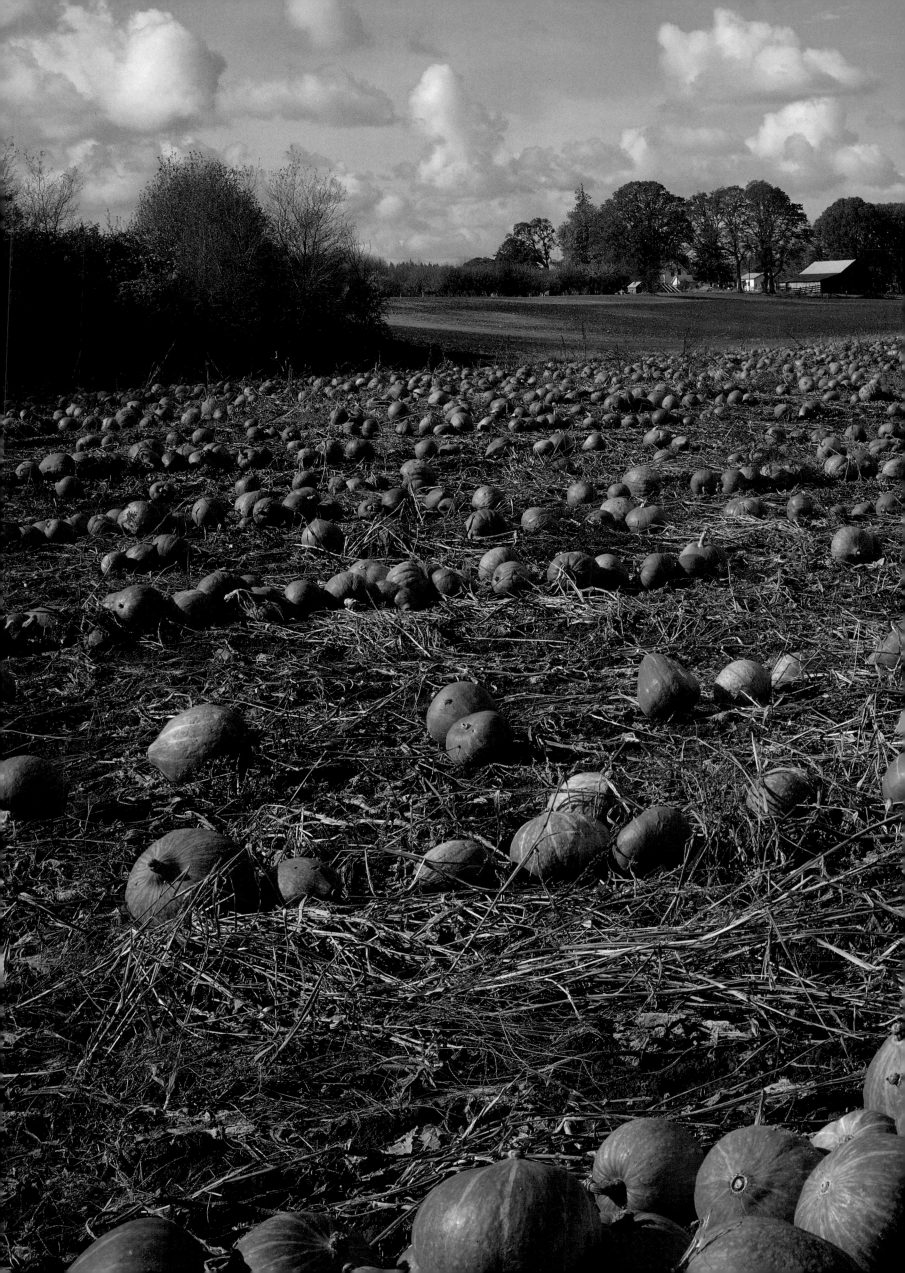

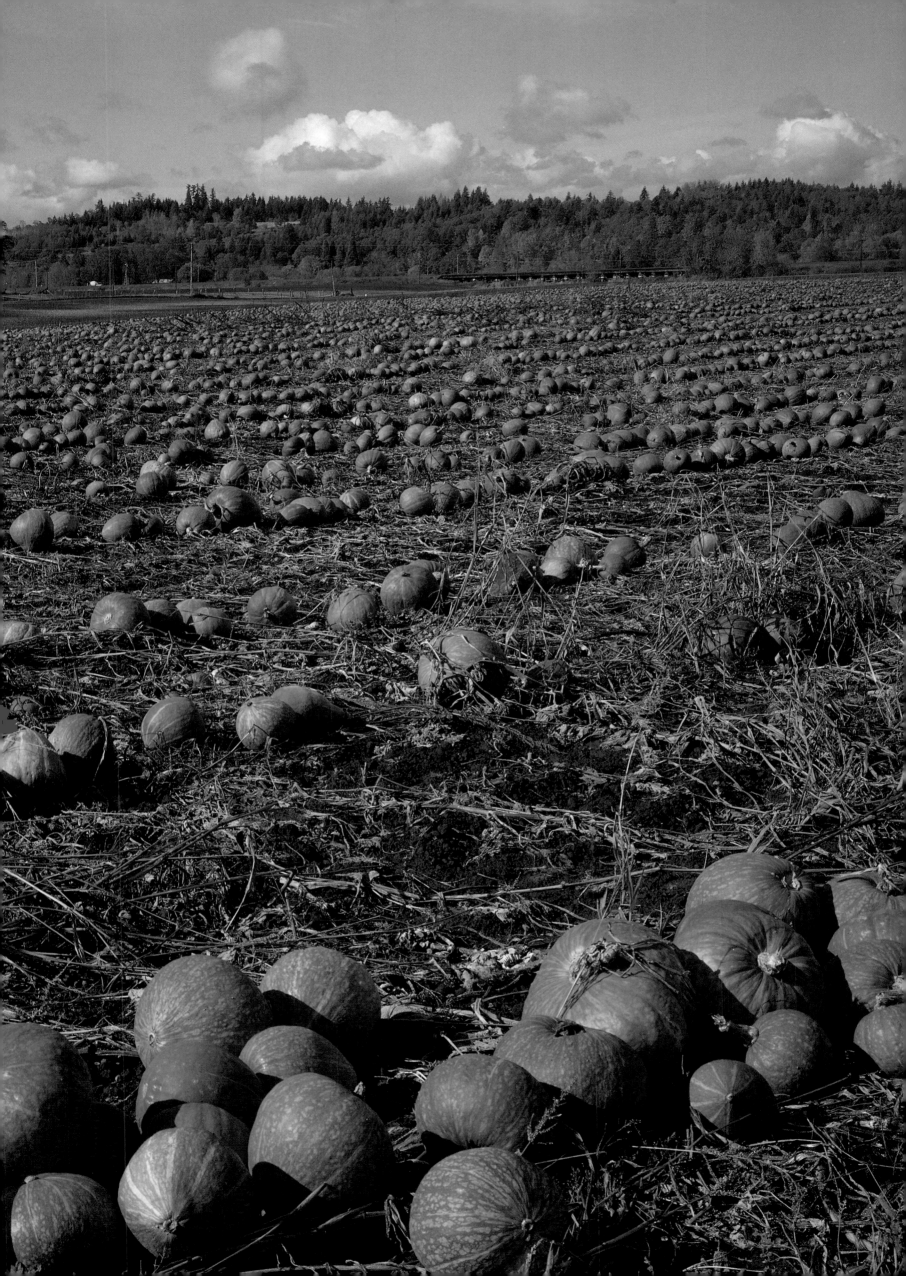

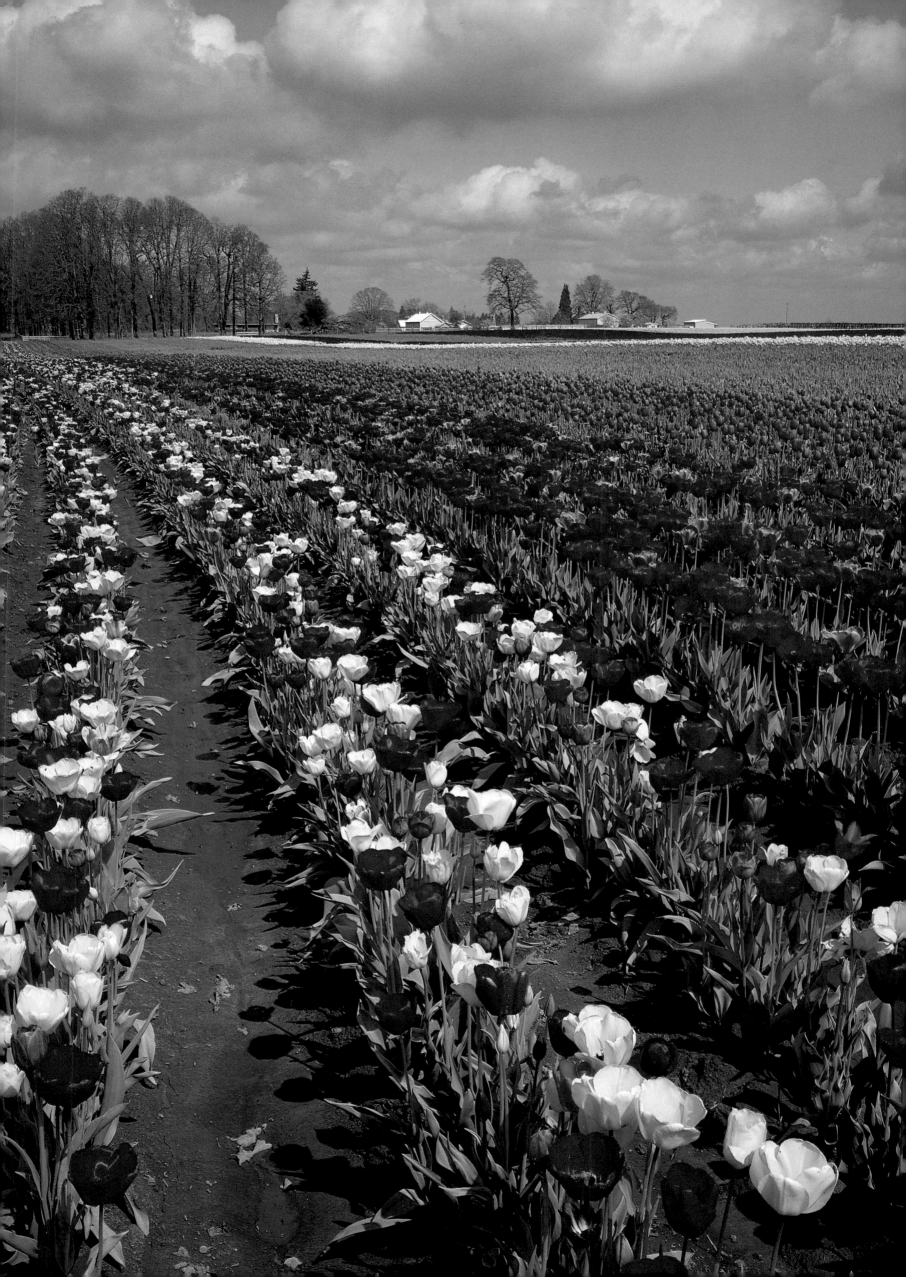

■ *Left:* A brilliant mosaic of tulips stripes the Iverson bulb farm near Monitor, in the central Willamette Valley. ■ *Below:* The Memorial Union Building is the hub of student activities on the Corvallis campus of Oregon State University, Oregon's oldest public institution of higher learning. Three other locations on the Coast extend the work of this Sea and Land Grant Center.

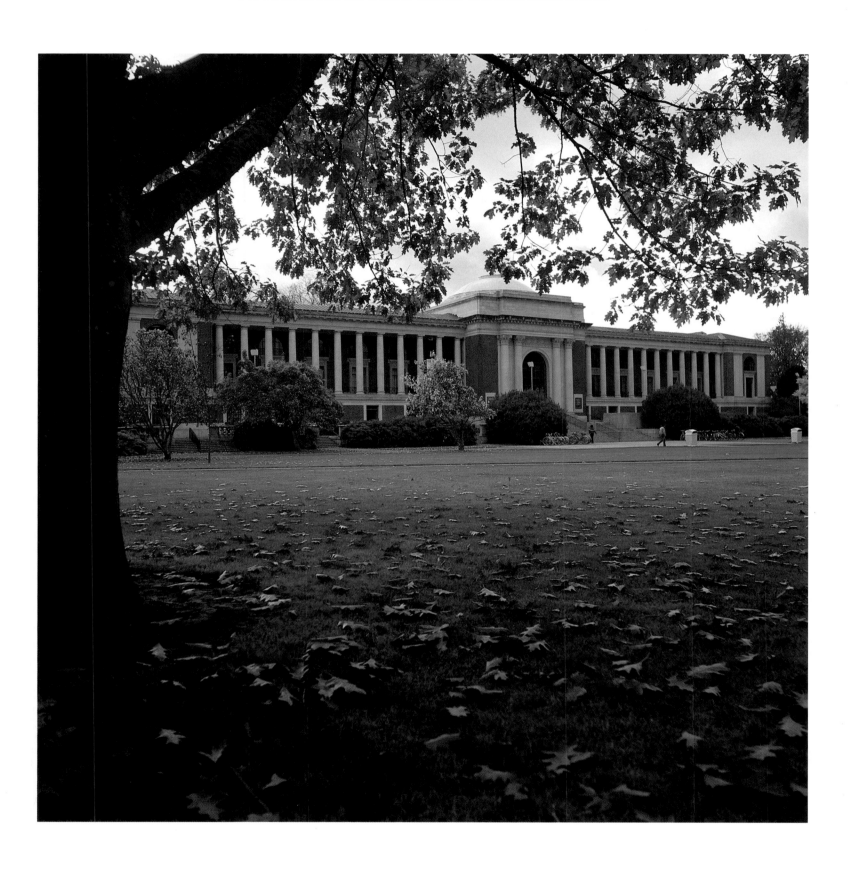

■ *Below:* Portland well deserves and cherishes its nickname, City of Roses. Chicago Peace, one of four names given to the Peace Rose, is one of more than ten thousand bushes of four hundred varieties in Washington Park's International Test Gardens. The city also maintains extensive rose gardens at Peninsula Park and in Ladd's Addition.

■ *Below:* Most of Oregon's people live in the Willamette Valley, creating a picture of busy urban life surrounded by the state's most fertile farmland. Fruit, vegetable, and grass seed farms are prominent here, but so are cattle and sheep operations. The sheep industry is on the rise again because of the surge of interest in lamb products and natural fibers.

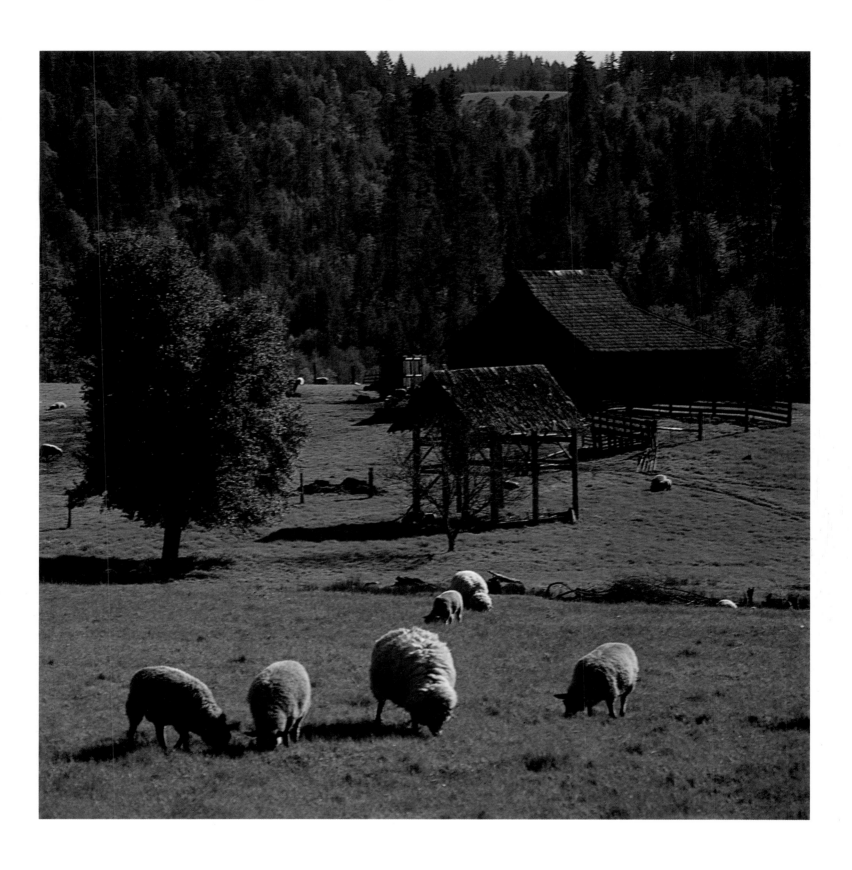

■ *Below:* Johnson Hall serves as the administration building on the University of Oregon campus at Eugene. The institution also operates a marine science center at Charleston and Pine Mountain Observatory near Bend. With more than sixteen thousand students, the university is the state's largest school, followed by Oregon State and Portland State universities.

■ *Below:* Winter transforms Silver Falls State Park into a fairy-land. The park's fourteen waterfalls are found in two gorges cut by the north and south forks of Silver Creek. ■ *Overleaf:* Lush pastureland borders the Umpqua River Valley in south-western Oregon. The Umpqua is the largest river flowing to the Pacific between the Columbia and San Francisco Bay.

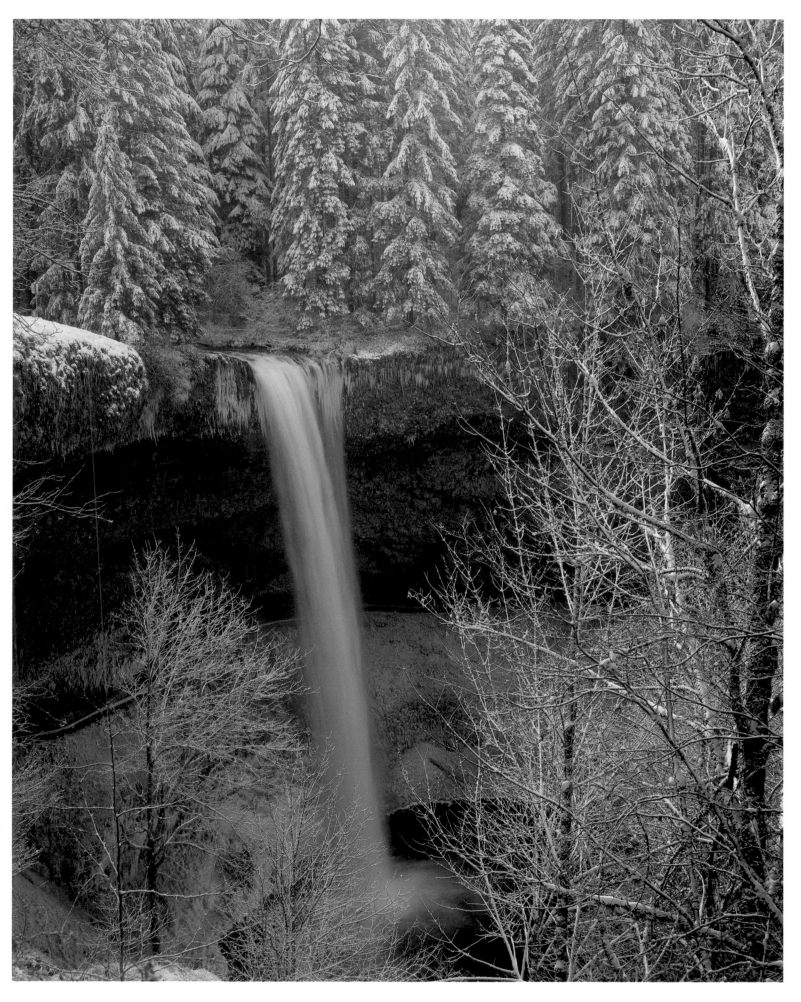

■ *Below:* Jacksonville is a southern Oregon monument to historic preservation. The entire town is a National Historic Landmark. Many buildings, such as the former County Courthouse, now the Jacksonville Museum, were built in the 1850s gold mining boom. In 1898, William S. Barnum tied Jacksonville to Medford with the Rogue River Valley Railroad.

■ *Below:* Pear blossoms frame a view of famed Table Rock in the Rogue Valley, just north of Central Point. The two Table Rocks, called Upper and Lower, are familiar landmarks rising almost a thousand feet above the Rogue River. Pear trees, a mainstay of the Medford economy, bloom in the spring and the city salutes them with the Pear Blossom Festival in April.

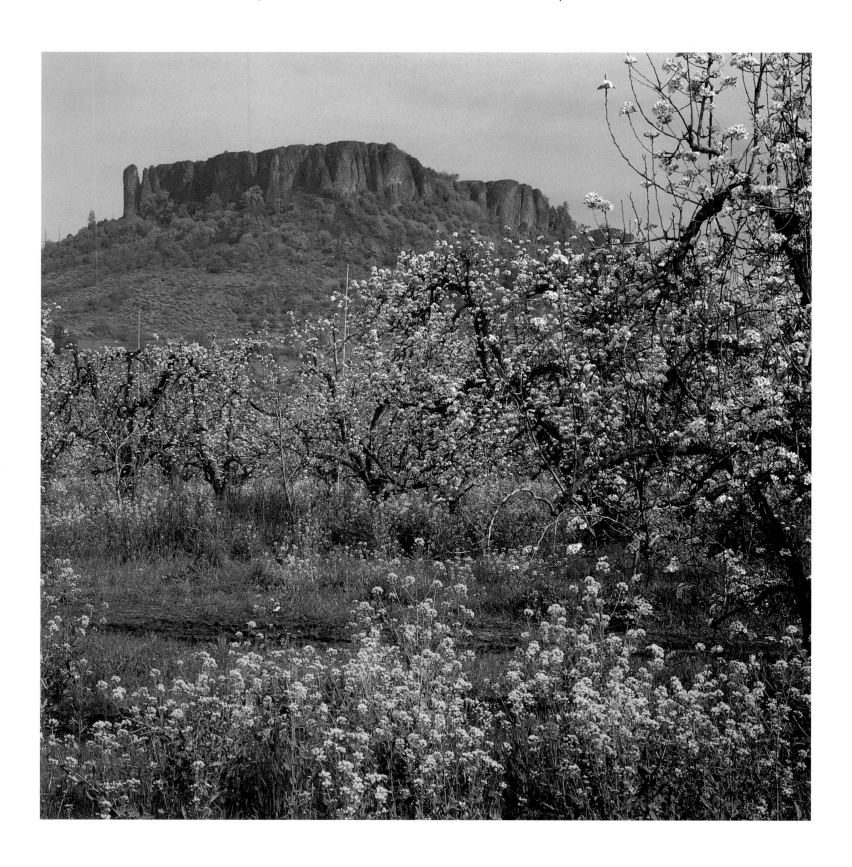

■ *Below:* Poet Joachin Miller called them the "Marble Halls of Oregon." He was writing about the Oregon Caves, now part of a National Monument. The caves are deep in the forests of the Siskiyou Mountains, where groundwater dissolved marble bedrock, forming the tunnels and their exotic stone pillars.

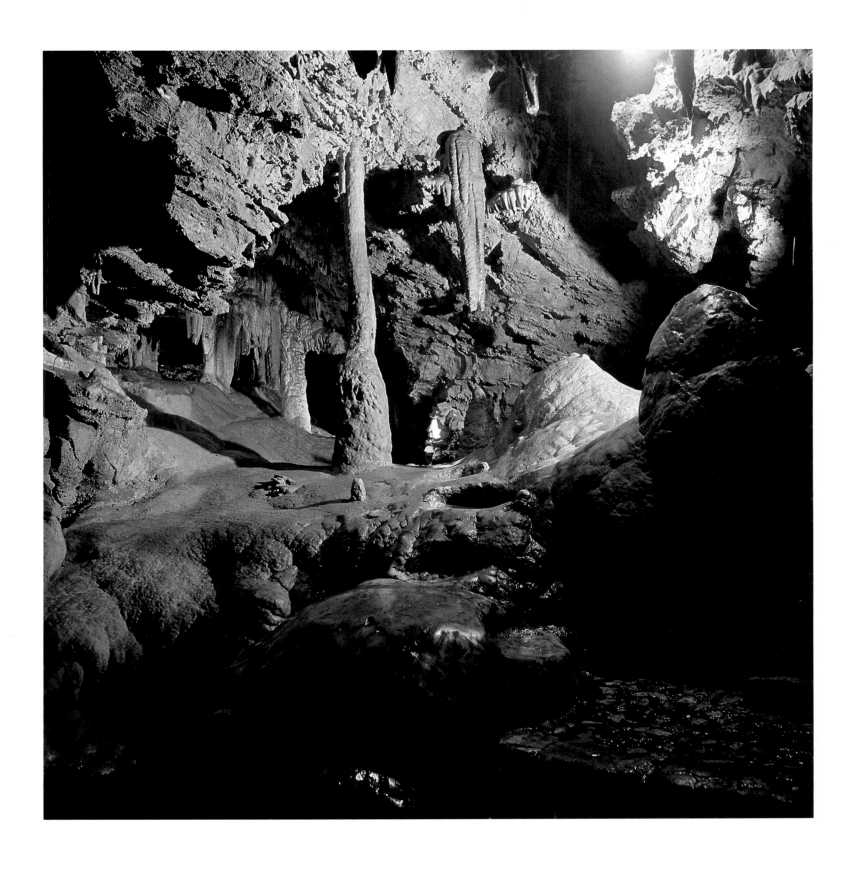

■ *Below:* A relic of the stagecoach era of the late 1800s, Wolf Creek Tavern was built along the California Stage Company's Portland-to-Sacramento line and today continues to serve the traveling public. The state leases the tavern to others who manage the restaurant, hotel, and banquet house.

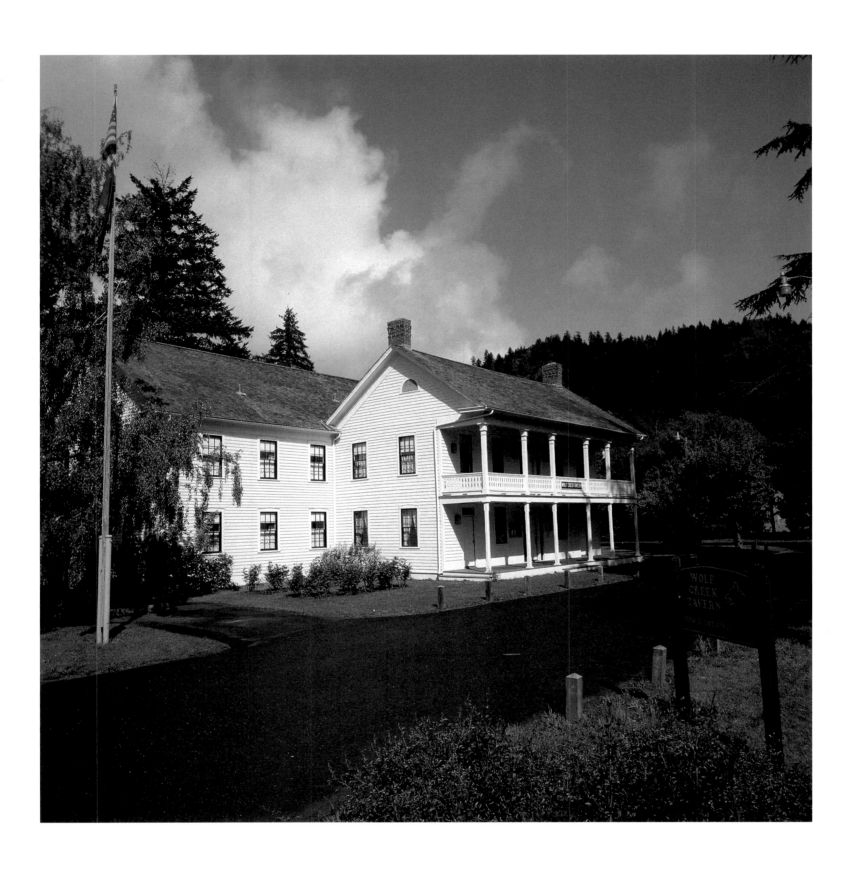

CASCADE RANGE

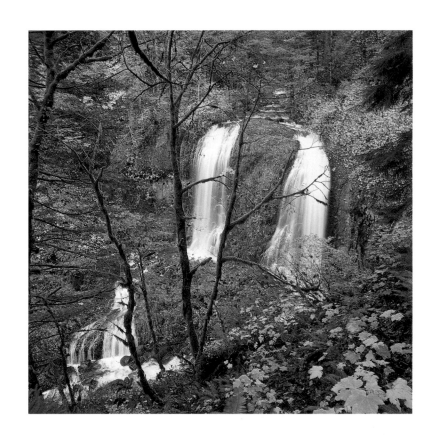

The Cascade Range is one of Oregon's favorite playgrounds with challenging and inspiring trails for the hiker, bountiful lakes and streams for the fisherman, exhilarating slopes for the skier, and unending, breathtaking panoramas for the photographer's lens or the artist's brush.

Oregon's highest mountain, Mount Hood, which has been measured at 11,235 feet, is also its most accessible. The mountain is reached from the west or the south on Highway 26. From Hood River on the north, Highway 35 runs up along the eastern side of the mountain. But from whatever direction they come, Mount Hood's visitors number in the millions every year.

Many will have taken time along the route from Hood River to enjoy one of the best views of the mountain from Panorama Point. In the springtime, that sight is especially striking when orchards of apples, cherries, and pears are in bloom. Visitors will find hundreds of vacation homes and cabins tucked in under the larch, fir, and alder trees. Fishermen's lodges line the banks of rivers carrying mountain runoff. Golfers' homes border the fairways at places like Rippling River. And sprinkled throughout the area are dozens of forest camps.

Of the many ski and recreation facilities on the mountain, Timberline Lodge is the most venerable and sees nearly a million visitors each year. Constructing the lodge during the Depression gave WPA jobs to hundreds of men and women, many of them skilled artisans over fifty-five years of age and in desperate need of employment.

Since the completion of the project and its dedication by President Roosevelt in 1937, more than thirty million pairs of boots have trod the oaken floors, and many of the hand-wrought materials show the scars of nearly a half century of use. Dick Kohnstamm took over the lease in 1955, eighteen years after the lodge was built, and has worked to turn it into the national treasure it was intended to be. And hard-working members of an organization called Friends of Timberline have rallied to replace worn furniture, draperies, rugs, and even wrought-iron hardware and bold wood carvings.

Kohnstamm is justifiably proud of the work that has been done and he also takes great pride in the completion of the Palmer chairlift, which carries skiers up to the perpetual snowfields of Mount Hood. In June, July, and August, Timberline typically sees thirty thousand skiers.

Situated right on the Pacific Crest Trail which extends all the way from Canada to Mexico (Timberline Trail, which encircles the mountain, is a part of the Pacific Crest Trail), the lodge serves hundreds of hikers traveling the trail along the heights of the Cascade Range.

Oregon's second highest peak, Mount Jefferson, which measures 10,495 feet, is fifty miles south of Mount Hood and about ten miles off the North Fork of the Santiam River. But the most majestic cluster of peaks in the Cascade Range is the Three Sisters, some twenty-five miles south of the Santiam Summit, each mountain over ten thousand feet in height. No one knows for sure who named the Three Sisters, but there is an old tale that says they were originally known as Mount Faith, Mount Hope, and Mount Charity. The story also suggests that Mount Bachelor was originally named their Brother John.

Coming down off Santiam Pass, we pull into Camp Sherman, the charming little resort community through which the crystal-clear Metolius River flows. The Metolius is one of those picture-postcard trout streams.

Les Siegner and his wife, Babe, used to own the Metolius River Cottages, and Babe worked at the Metolius Store for twenty years, under four different owners. Luther Metke, a logger, philosopher, and poet, famous for the log cabins he built, once owned the store. Babe says Luther celebrated his one-hundredth birthday a couple of years ago and passed away shortly after that. She says the children just adored him because instead of lecturing to them, he would write his advice in poetry. The Siegners have lived in Camp Sherman for thirty years. They say, "We stay here because it's peaceful and quiet ... we just love it."

On the porch at the Post Office there is a heavy wooden bench with a special inscription on it: "Dedicated to the Memory of Arthur Tifft." Babe told us that Tifft was once mayor of the city of Redmond and owned a hardware store there. He lived in a summer home at Camp Sherman. She described him as "just a nice bachelor who used to sit on the porch and talk to everyone who came along. Arthur knew everybody in town. He died at the age of ninety-one."

Donna Deignan and her husband, Paul, came here in 1975 from Eugene. They first moved to Oregon from Southern California twenty-five years ago. She says after their first visit to the Metolius, this was the only place their car would go, and they bought the Metolius River Resort so they could live here. "I'm in love with the trees and the feeling I get about the place ... the general peace ... I just need to live here ... and I try to paint it." Of the visitors who come here she says, "Some are fishermen ... or people who write, or who come here to walk around. Some come to take pictures and some just come and sit ... they don't fish ... don't hike. Once people see this place, they have to keep coming back."

A good number of the people who stay are the personnel who run the Black Butte Ranch, just south of the highway. That is the magnificent big resort developed on land that was a working cattle ranch in the first two-thirds of this century. Its two 18-hole golf courses are surrounded by hundreds of private homes and modern condominiums.

About eight miles east lies the town of Sisters, named for the mountains that form a backdrop for this quaint assemblage of tourist attractions. The Gallery Restaurant & Bar is run by Jim and Carrie Cheatham, who have a fascinating collection of dozens of antique guns. One is a Model 66 Yellow Boy, labeled "The gun that won the West." Another is a Peabody Rifle, vintage approximately 1866 to 1875.

But the bigger attraction that gives the Gallery Restaurant its name is the fine collection of prints from the works of Ray Eyerly. Eyerly once worked on a Montana ranch with Charles Russell, one of the great painters of the West. Eyerly retired to Sisters to paint his finely detailed scenes of sagebrush country and Indian portraits and used to come into the Gallery Restaurant for morning coffee—sometimes two or three times a day. Eyerly died just short of his eighty-sixth birthday, but the waitresses say his spirit is still here. Carrie Cheatham says they have the bulk of Eyerly's prints for sale with the proceeds to be shared with his heirs. The smaller prints are priced at twenty dollars. Eyerly originals sell for $13,000 to $18,000.

The largest llama breeding farm in the world stretches along the outskirts of Sisters. It is owned by Richard and Kay Patterson, who came to this area in 1973. Mrs. Patterson says that there's nothing like living with a wilderness area in your back yard. Their llama flock produces about two hundred offspring a year. Baby male llamas will sell for $1,000; an adult female brings somewhere between $10,000 and $12,000. Estimates vary, but some say there may be eight or nine thousand llamas in North America, and nearly 10 percent of them live within fifty miles of Sisters, Oregon.

One of the newer collections of boutiques along the main street of Sisters is called Barclay Square, developed by Harold and Dorothy Barclay. Harold tells us he grew up here, herded sheep, and worked on cattle ranches and in the woods. He says that in the mid-1930s there were ten or fifteen little sawmills around, and Sisters was a real frontier town with quite a few beer joints and the attendant street fights—a real "Wild West." Now it has become a tourist town, attracting thousands of visitors each year. Harold says that a person's mood improves when he comes to Sisters. "People you see on the sidewalk speak to you here. When I have to go into the metropolitan area on business, I fly my own plane to the airport and call the guy to come out there and meet me. We talk and I come home. I can think of other places to live ... like maybe Alaska ... but if I left Sisters, I'd be back in three months."

The names we find strewn among the ridges and valleys of the Cascades stir the imagination—Hoodoo Butte and Tombstone Summit, Coffin Mountain (so named because it's shaped like one), Three Fingered Jack and Broken Top (both carrying names descriptive of their jagged tops). Then there is Mount Washington, named for our first president, of course, and Mount Thielsen in the southern part of the Oregon Cascades, named for pioneer railroad builder, Hans Thielsen.

Mount Thielsen, 9,182 feet high, provides a backdrop for one of southern Oregon's popular Cascade lakes. I refer to Diamond Lake, which lies along the Pacific Crest Trail about twenty-five miles north of Crater Lake. John Koch, the manager of the Diamond Lake Lodge, says the lake produces close to 350,000 fish a year—rainbow trout. Diamond Lake is almost one mile above sea level and is usually frozen over from the first of January until mid-April. But when the fishermen come—and they do come in quantity—John has to hire a hundred people to run the resort. An average of three thousand people per week visit the lake during the summer.

John says, "Most of our business is repeat people. We have people who have been coming here for thirty years or more. We have about a million visitor-days of use here in the Diamond Lake area ... including the campgrounds which are run by the Forest Service." And he says that may be why there are no more Hollywood stars coming to the lake these days. He says, "those folks want to get away from so many people."

The man who "discovered" Crater Lake did so in 1853. He was John Wesley Hillman, who was with a small party of prospectors looking for a gold mine. Of course, Indians had known about Crater Lake for centuries, but they were superstitious about it and did not tell any of the pioneers it was there. There is some archaeological evidence to suggest that human beings may even have been here sixty-eight hundred years ago to witness the cataclysmic eruptions that took the top off Mount Mazama and left a crater four thousand feet deep. Later eruptions created Wizard Island and sealed the caldera floor. In any case, it was not until 1886 that Captain Clarence E. Dutton took a U.S. Geological Survey team out in a boat on the lake and with a piece of pipe attached to the end of a roll of piano wire measured the lake's greatest depth at 1,996 feet. Seventy-three years later, in 1959, surveyors used sonar and came up with a figure only sixty-four feet short of Captain Dutton's piano wire reading.

Rangers say that because of its depth Crater Lake has frozen over only four times in this century, once in January of 1985. Rangers also say that the water below the 328-foot level is a constant 38 degrees Fahrenheit, and that volume of water at that temperature is enough to heat the rest of the water up to the surface. So despite snow forty-five to fifty feet deep elsewhere in the national park, Crater Lake usually remains in its cool blue liquid state all year-round. The lake thus presents the most spectacular geologic feature of the Oregon Cascade Range and draws visitors by the thousands.

■ *Below:* Mount Hood's 11,235-foot high, snow-blanketed peak seems to dispute the evidence of springtime in the Hood River Valley, where buttercups cover the hills. The mountain is named for Lord Samuel Hood, who signed the instructions for Captain Vancouver's voyage. It was during that voyage of 1792-94 that Lieutenant Broughton named the mountain.

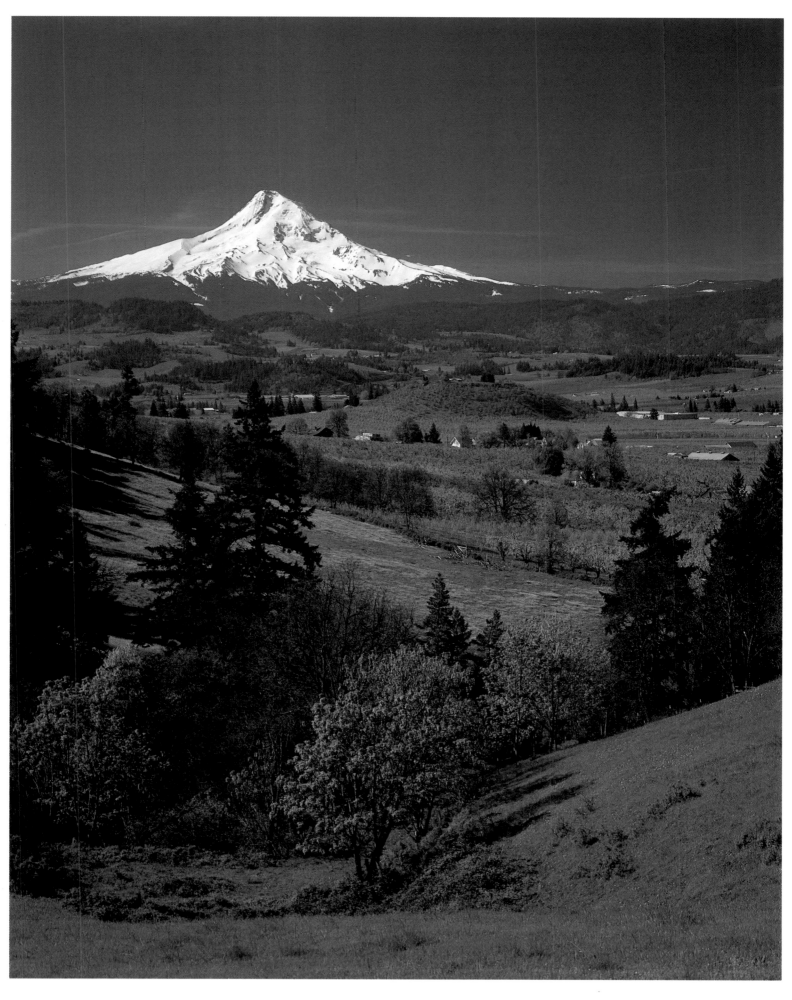

■ *Below:* Broken Top Mountain, 9,152 feet, is midpoint in the Cascade Range. Botanist David Douglas first wrote the name Cascades referring to the mountain range running through Washington, Oregon, and California. Earlier writers called them Western Mountains or the "snowy ridge."

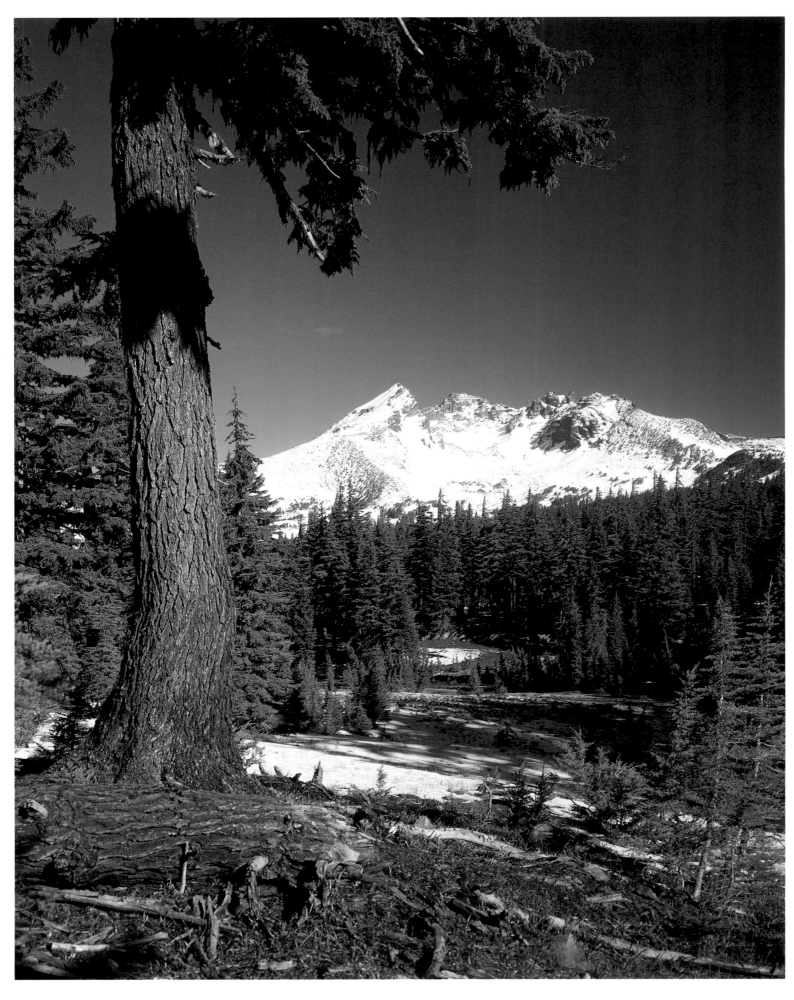

■ *Below:* Almost half of Oregon's land is forested. On the western side of the Cascade Range the trees are primarily Douglas fir, but on the eastern side of the Cascades spread vast pine forests. It is here the regal old Ponderosa pine is found, its girth covered by deeply furrowed, burnt-orange colored bark.

■ *Below:* Looking a little like Indian smoke signals, clouds rise over Washington's Mount Adams in the Cascade Range. The flower-covered foreground is Oregon above the Hood River Valley. The floral carpet is dominated by balsam root — the sunflower whose seeds the Indians found quite nutritious.

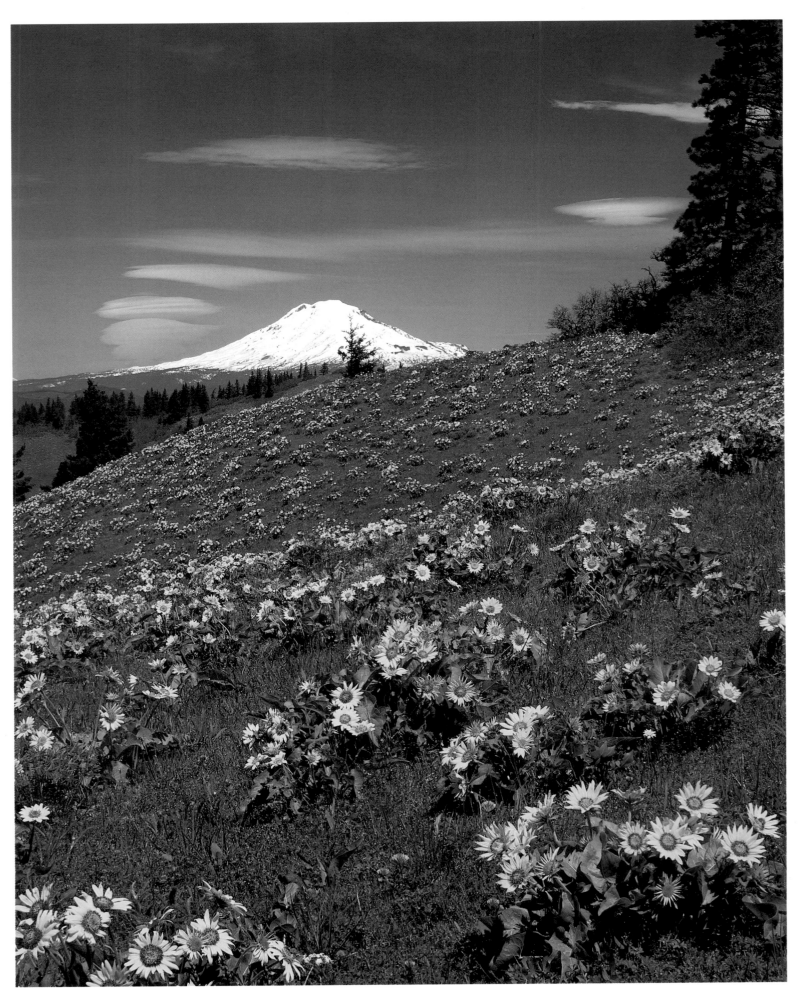

■ *Below:* Looking down on the top fifteen hundred feet of Mount Hood's volcanic cone, one can see climbing parties on the slope of the "Hog's Back" and in the "Chute" area. To mountaineers, these are familiar features on the ancient crater. Since mountain climbing is so popular with all ages, experienced guides are available to mitigate its dangers.

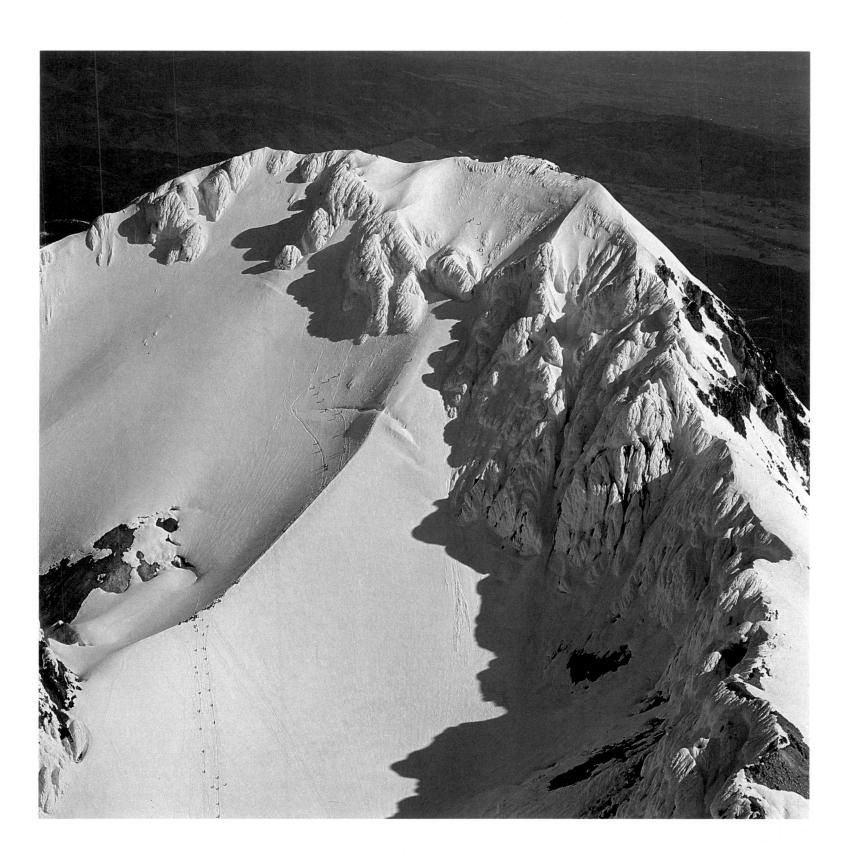

■ *Below:* Eliot Glacier, on the northeast side of Mount Hood, is named after an early Portland minister, Dr. Thomas Lamb Eliot, and is one of the larger of the mountain's eleven glaciers. The seracs, spectacular pinnacles of ice reaching from the shadows into the sunlight, are frozen even in summer.

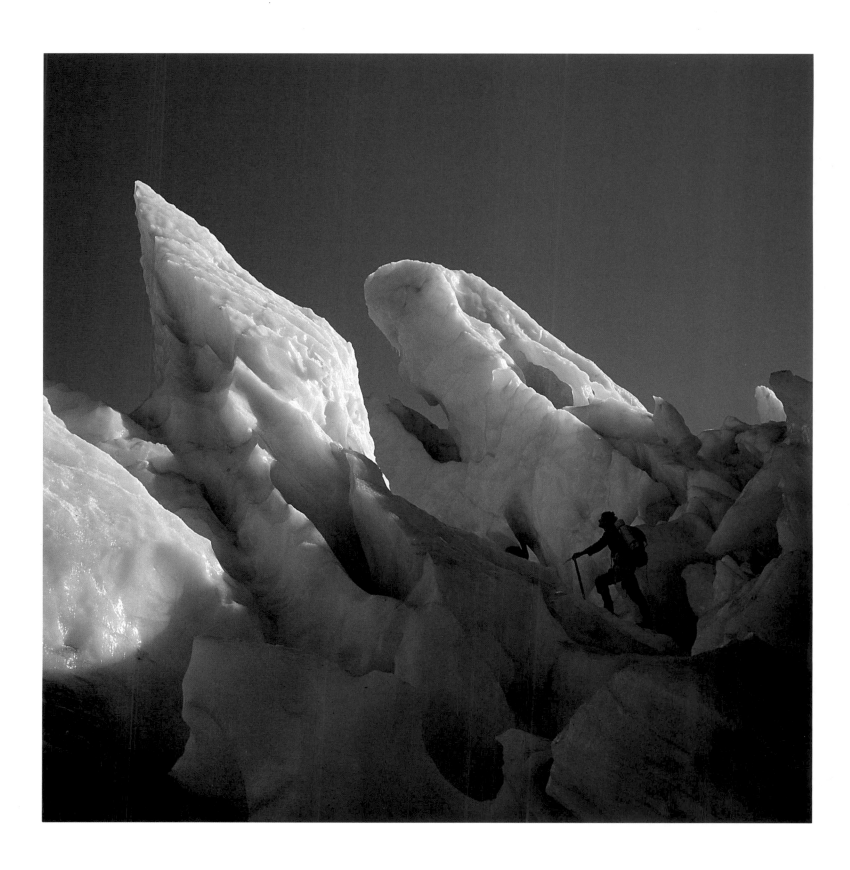

■ *Below:* Timberline Lodge, on Mount Hood's south side at the six thousand foot level, was built with flanking wings around a ninety-two-foot tall stone fireplace and chimney. Building the lodge was a WPA project that put five hundred people to work in the Depression. ■ *Overleaf:* Crystal clear spring water cascades down toward the Clackamas River.

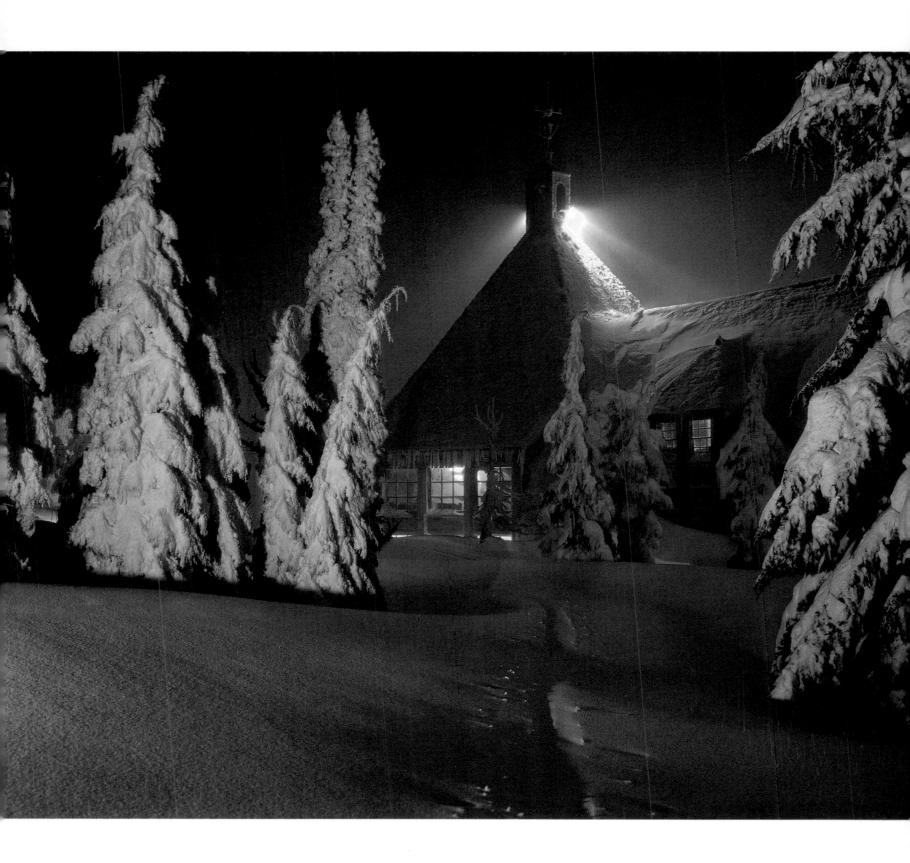

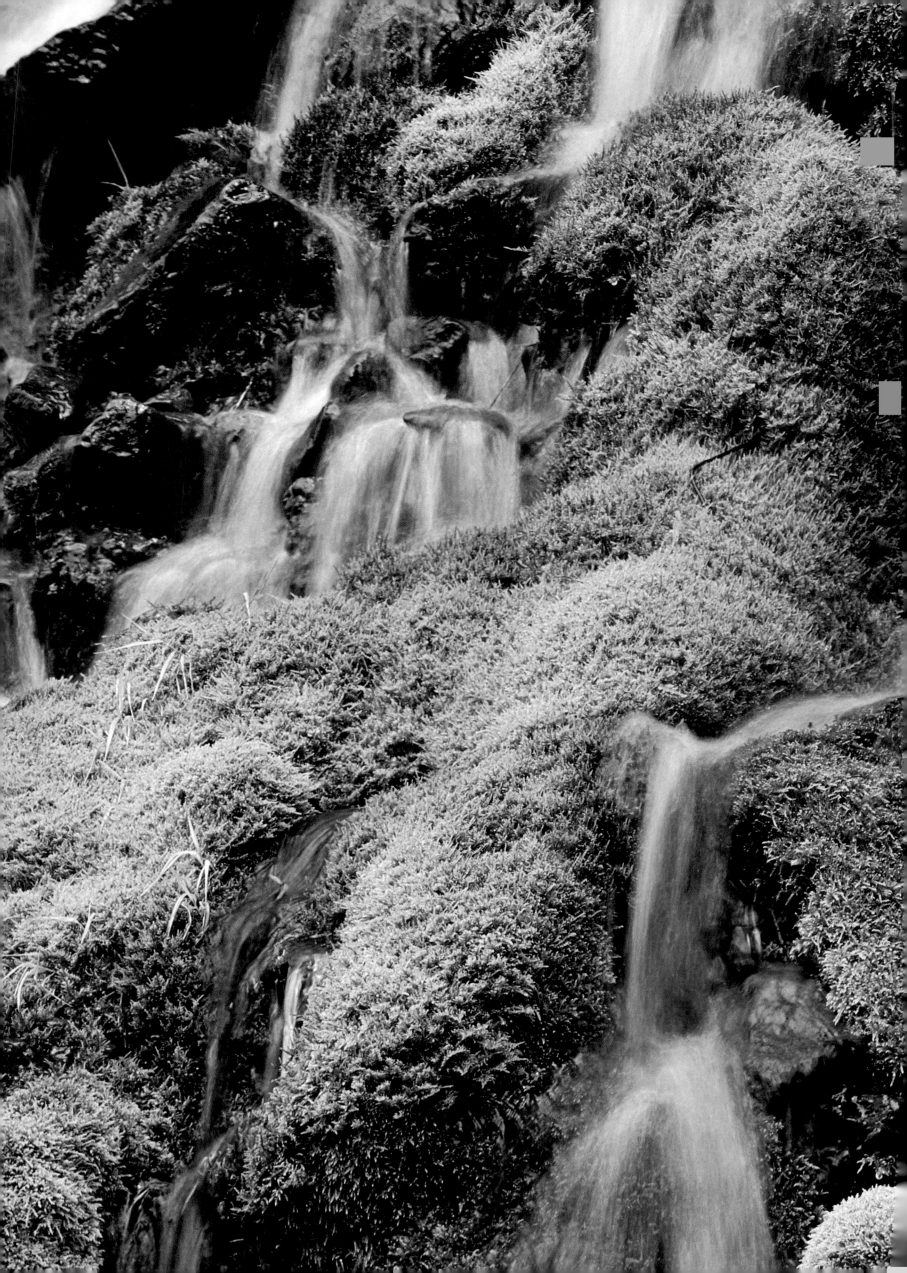

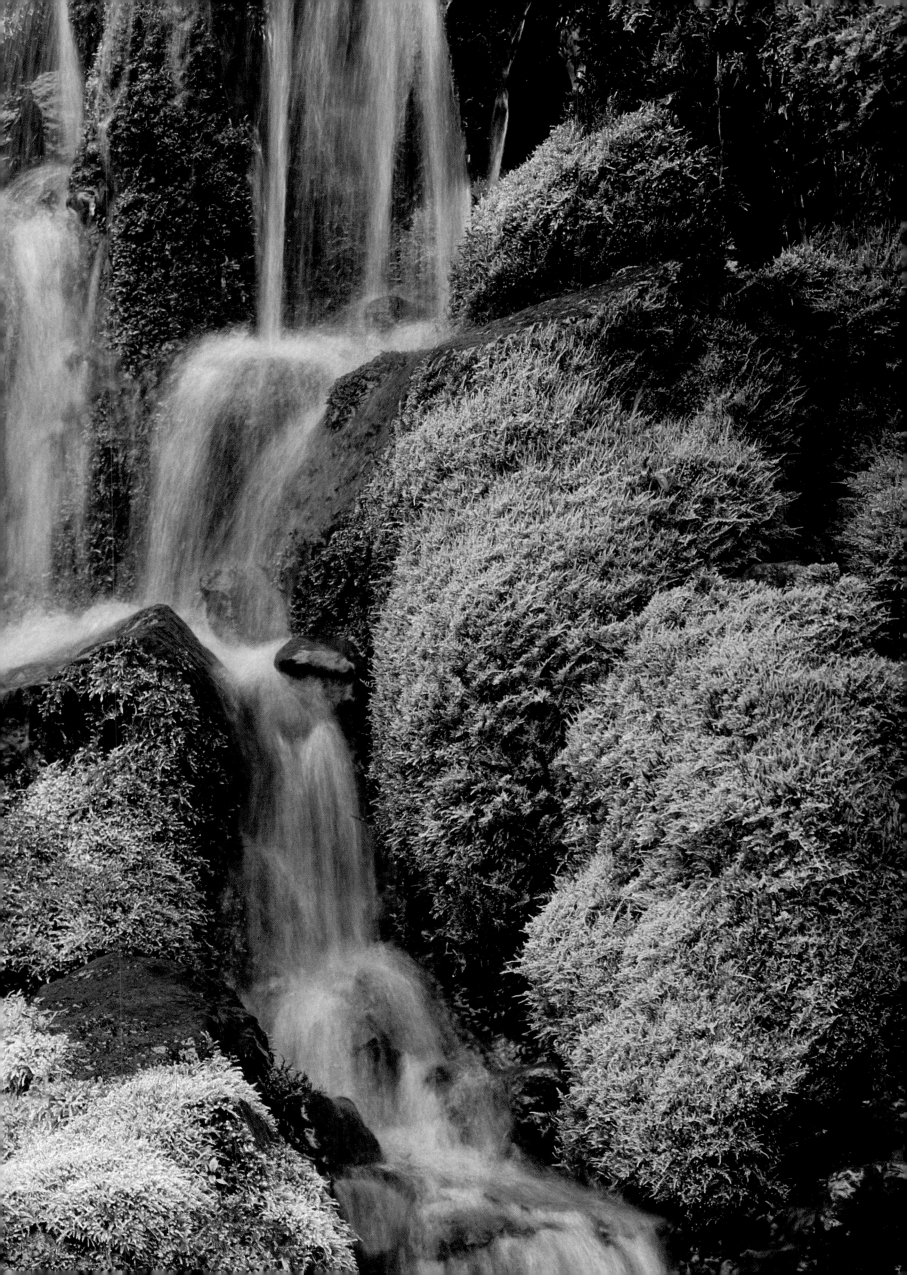

■ *Below:* A vista of Mount Hood's northeast flank is framed by pine trees above Cooper Spur near Cloud Cap Inn. Two ski clubs headquarter here, in one of Mount Hood's many cross-country ski areas. Most downhill skiing is done on the mountain's south side at Mount Hood Meadows, Summit Ski Area, Mirror Mountain at Government Camp, or at Timberline Lodge.

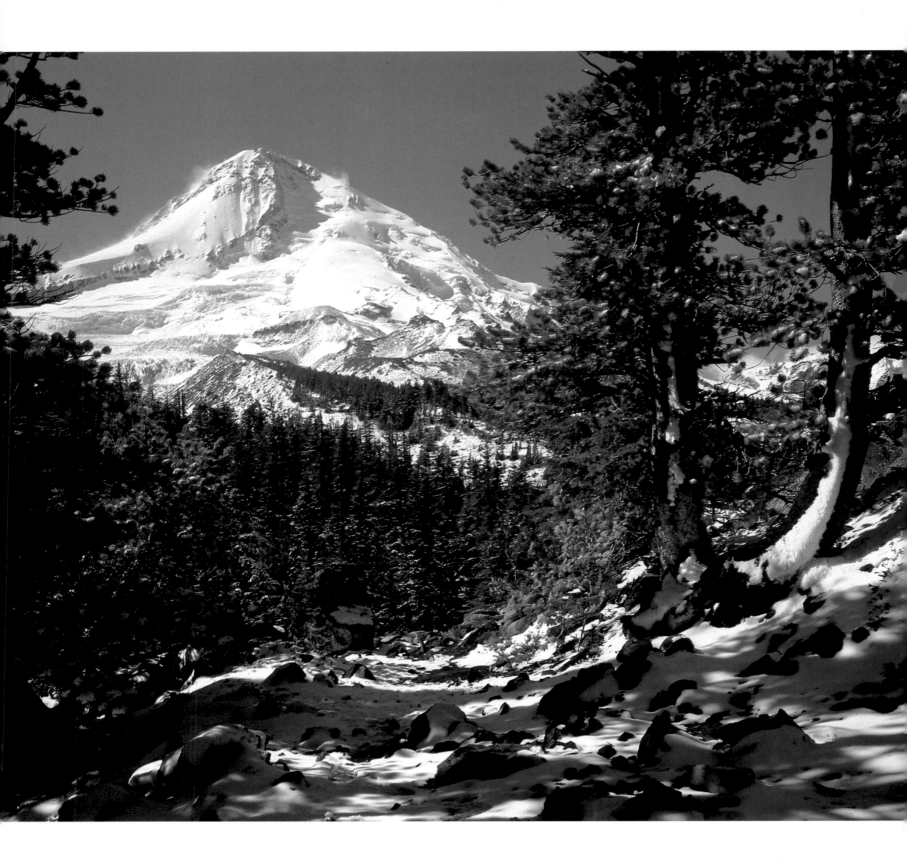

■ *Below:* Indian paint brush grows in many mountain meadows and in a variety of colors throughout the West. The brilliant crimson foliage is most common, followed by yellows and purples. Indian paint brush ranges from low growth, only inches high on Alpine slopes, to several feet tall elsewhere.

■ *Below:* The highest crater lake in the Cascade Range is an accurate description of this lakelet in the snow-filled crater bowl of South Sister Mountain. Elevation of this lake approaches 10,300 feet — more than four thousand feet higher than the more famous Crater Lake eighty-five miles to the south.

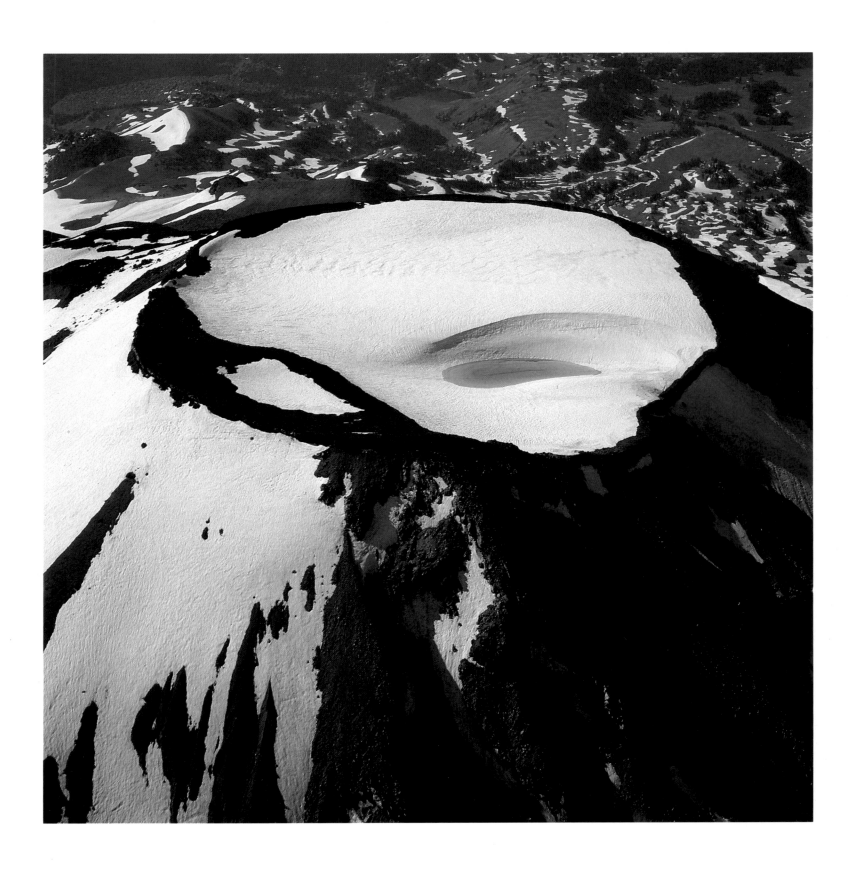

■ *Below:* Todd Lake nestles in the Deschutes National Forest, just north of the Mount Bachelor Recreation Area. The mountain, twenty miles by road from the resort at Sunriver, rises to a 9,060-foot elevation and has facilities for the most avid winter sports enthusiasts. Century Drive out of Bend also gives access to this area and more than a dozen sizable Alpine lakes.

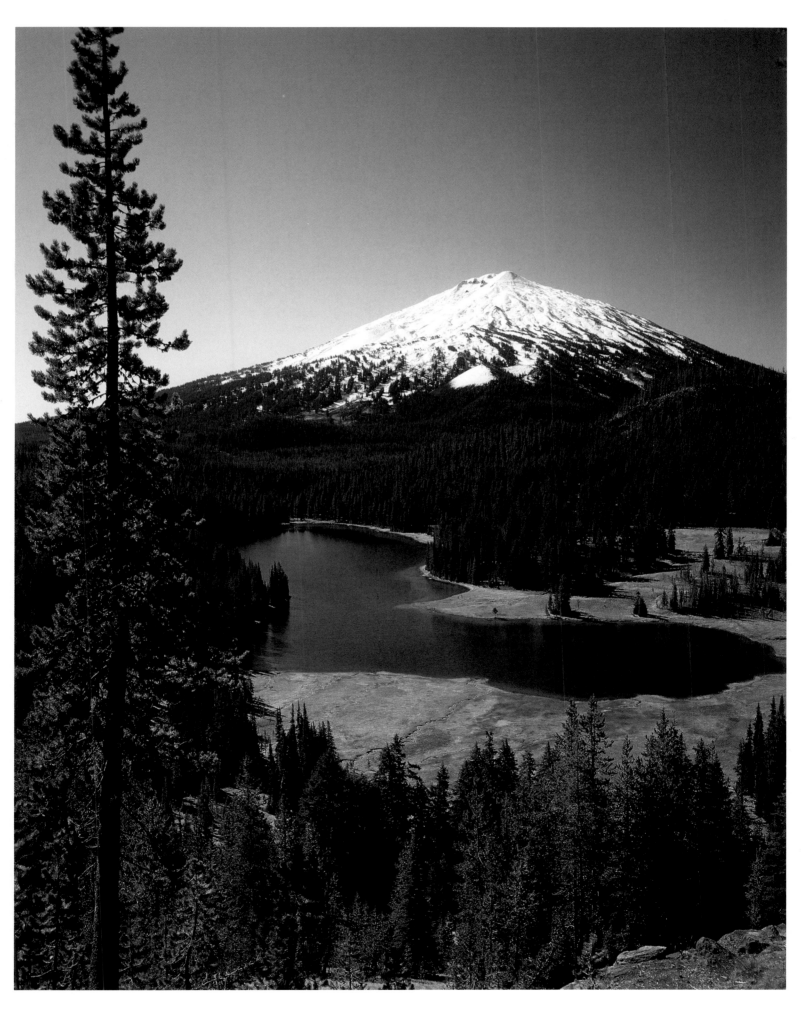

■ *Below:* Just inside the Three Sisters Wilderness, near the headwaters of the McKenzie River in the central Cascade Range, Proxy Falls thunders over a lava cliff into a bed of moss-covered logs and rocks. These waters will flow for hundreds of miles before they reach the Pacific Ocean.

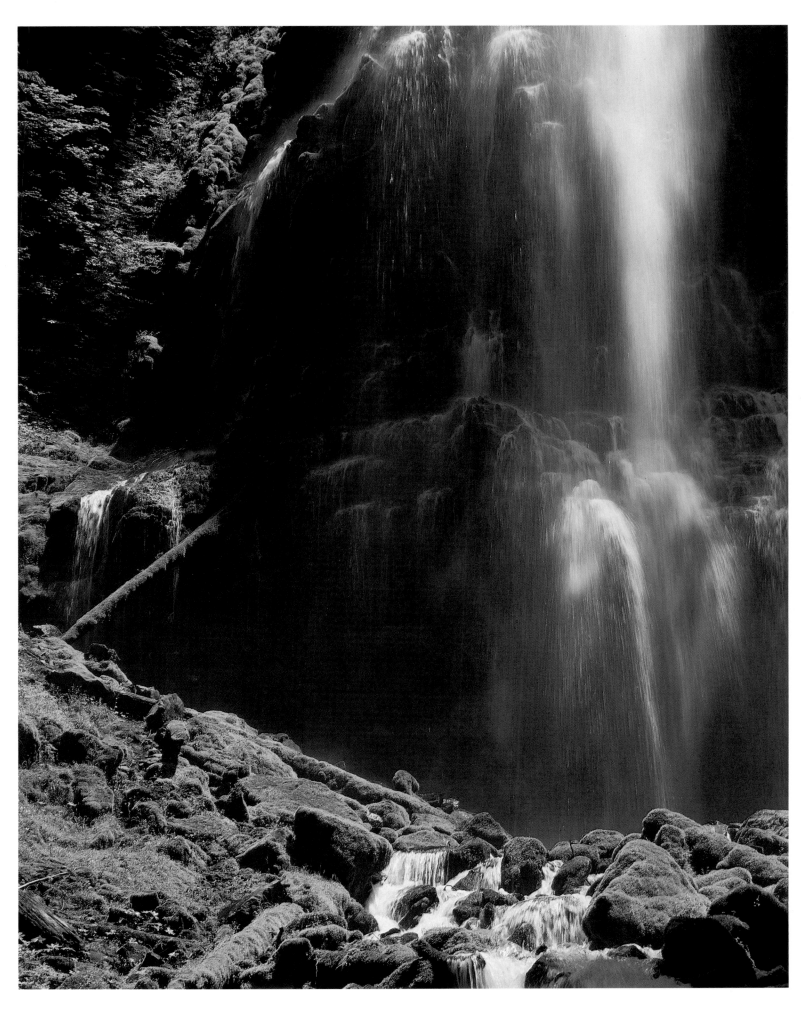

■ *Below:* Big Lake lies about five miles northwest of 7,802-foot Mount Washington. ■ *Overleaf:* Huge Ponderosa pines frame a sylvan view of Diamond Lake and 9,182-foot Mount Thielsen in the southern Cascade Range. In the winter, this becomes a snowmobile playground with three hundred miles of trails.

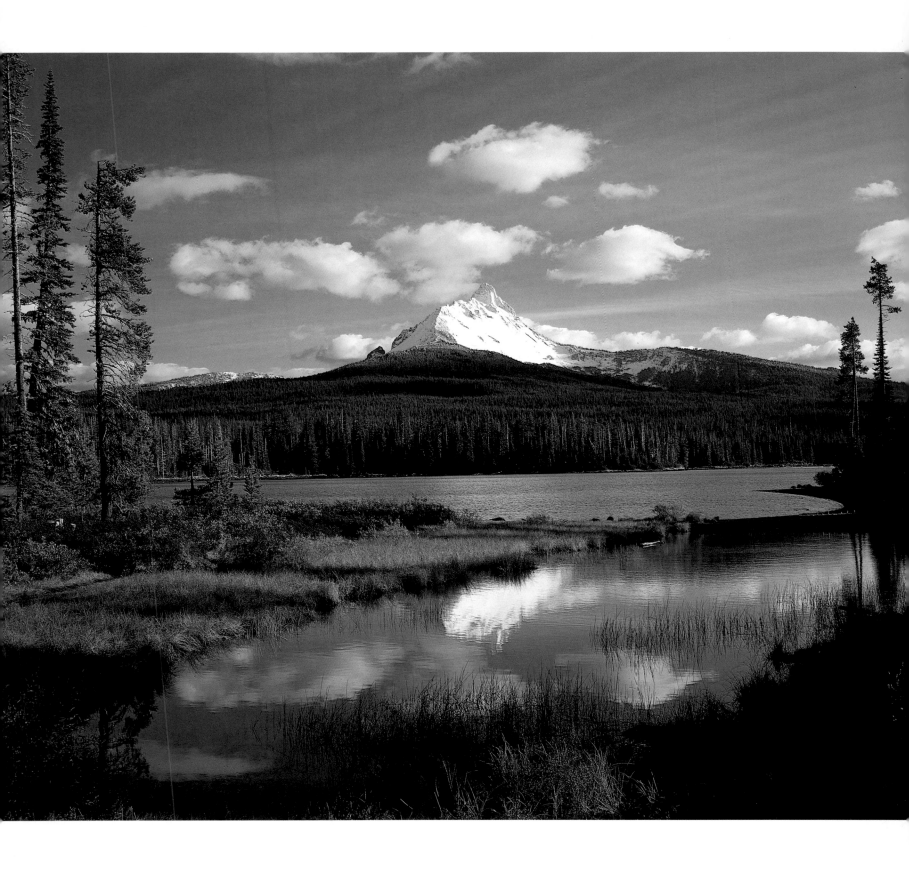

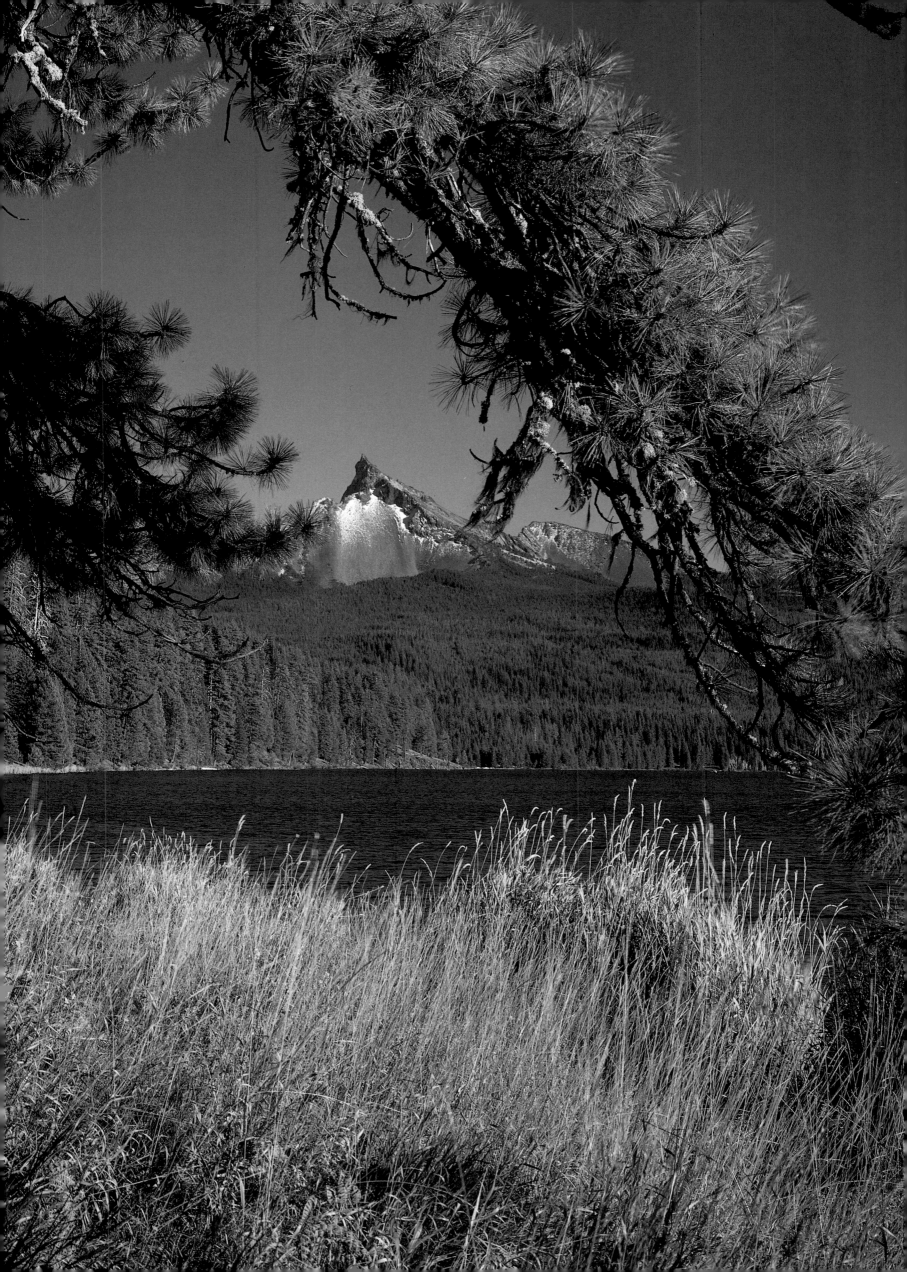

■ *Below:* At the crest of the central Cascade Range, wind-swept trees stand as naked monuments to a valiant struggle for existence in the unfriendly environment of the McKenzie Lava Flow. The snowy backdrop is provided by the North and Middle Sisters, each measuring just over ten thousand feet in height.

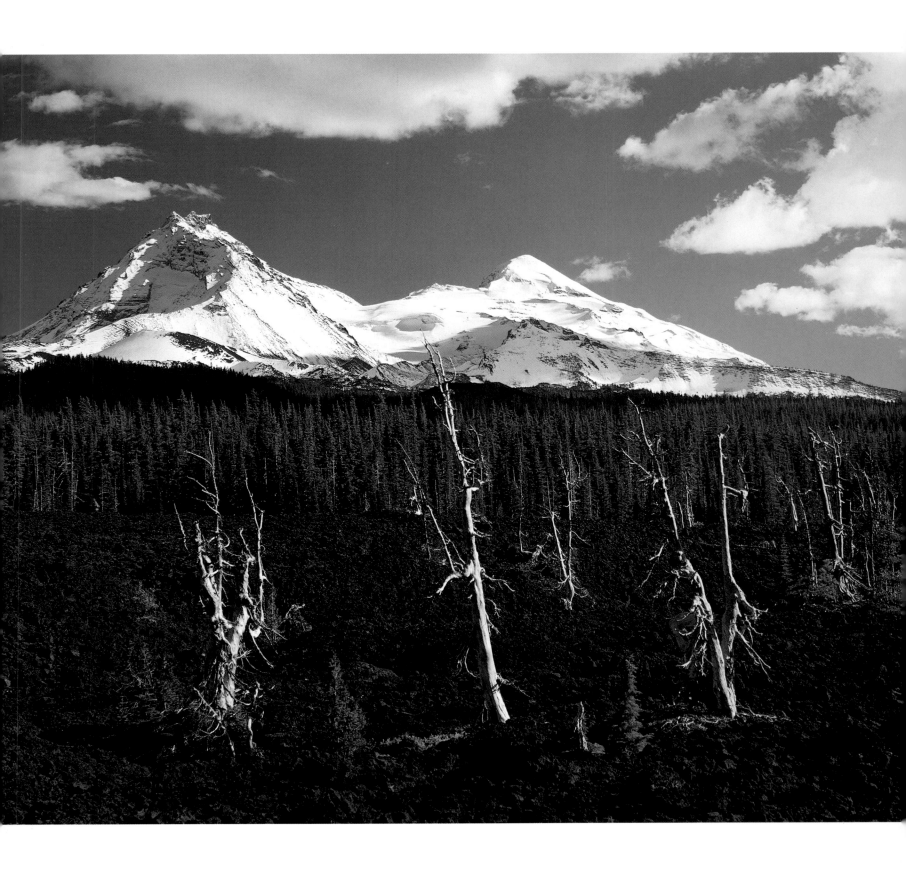

■ *Below:* Less than a mile from its birthplace on the crest of the Oregon Cascades, the McKenzie River leaps over forest-bound cliffs of lava at Sahalie Falls. The one hundred and forty foot-high waterfall is in the Clear Lake Recreation Area between Clear Lake and Carmen Reservoir.

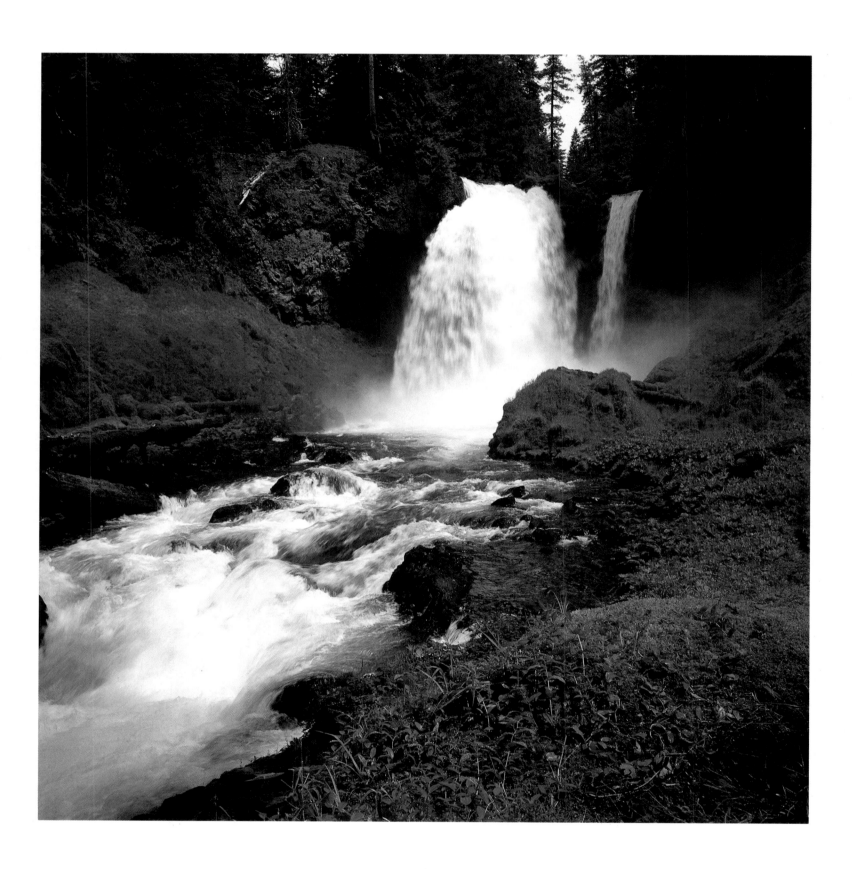

■ *Below:* The poet calls it laughter from a woodland dell. Cold Springs Creek flows swiftly among the boulders in Mount Hood National Forest, one of Oregon's fourteen national forests. In places like this, nature weaves a rich tapestry of splashing streams, waterfalls and trails through cool fern grottos, yet they lie close by rustic country inns and modern resorts.

■ *Below:* When snow melts in the southern Cascade Range, runoff flows rather directly west to the sea by way of rivers like the Umpqua or the Rogue. In the northern Cascades, the flow is less direct via the McKenzie and the Willamette rivers and north to the Columbia — thence out to the Pacific.

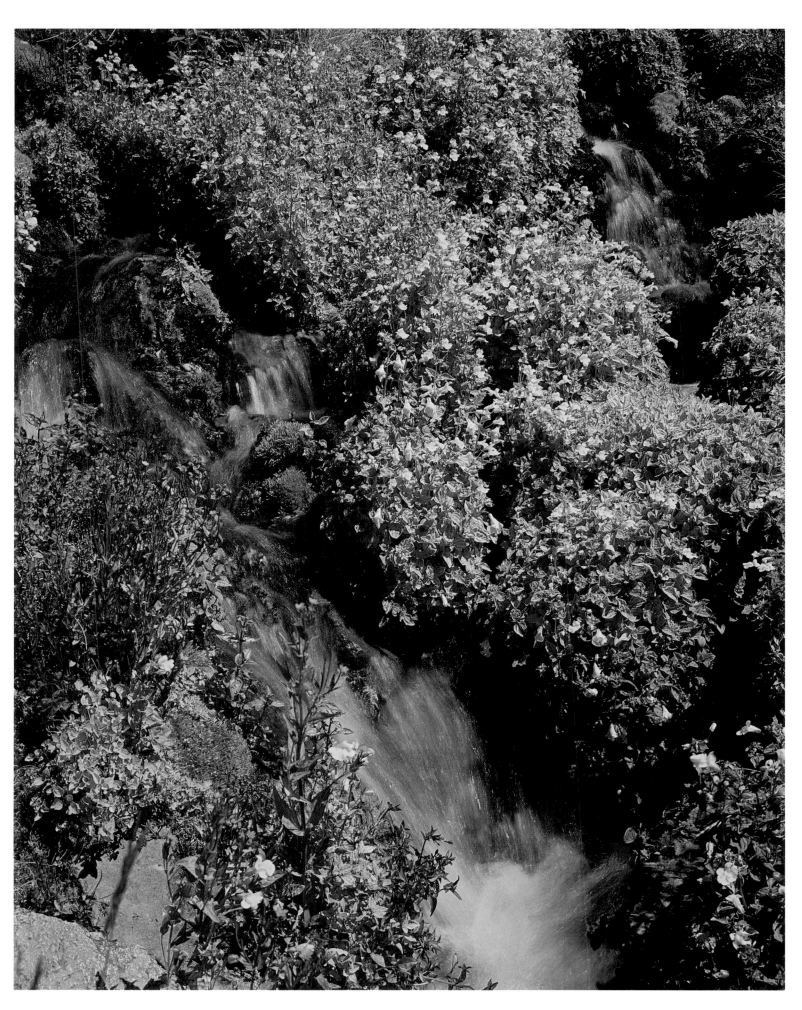

■ *Below:* Cascades runoff to the east moves at a more leisurely pace. It flows into the high country of Central Oregon. Most of the drainage is caught by the Deschutes — a long south-to-north river — and carried into the Columbia. Southern runoff heads into the Klamath River which skirts the Siskiyous in California, then reaches the sea.

■ *Below:* Chambers lakes lie at the foot of the Middle and North Sisters. These small lakes were created by glacier moraines in the heart of the Three Sisters Wilderness. ■ *Overleaf:* The crystal clear waters of Eagle Creek reveal a rocky stream bed and speak eloquently of Oregonians' determination to guard the pristine purity of their abundant water supply.

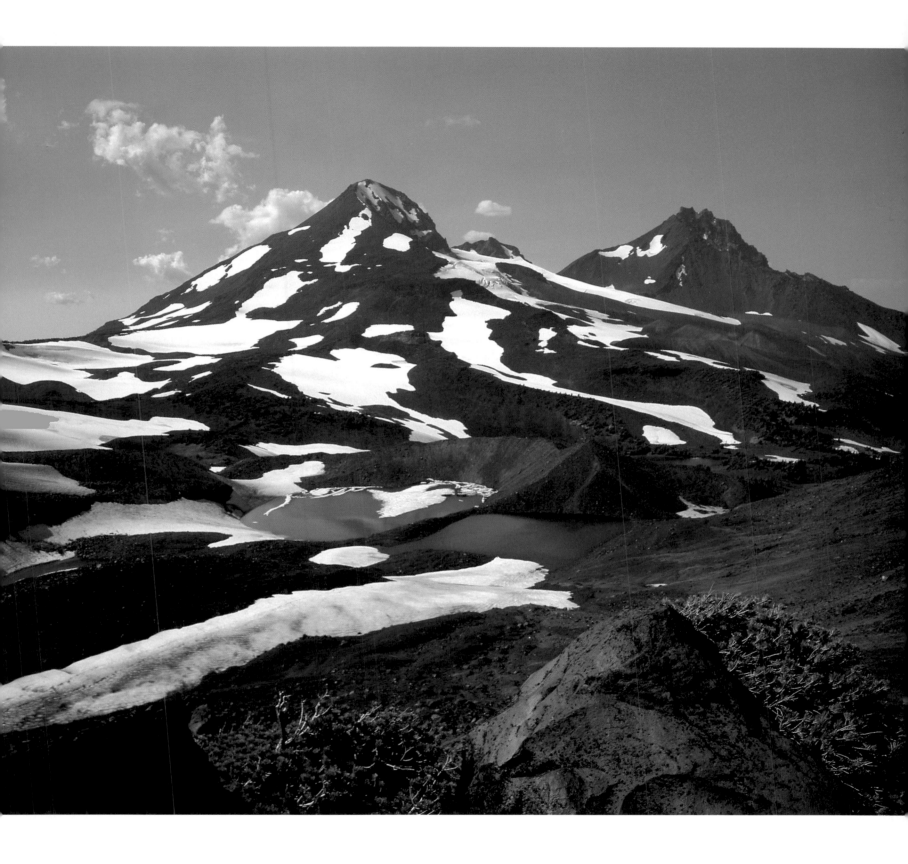

■ *Below:* Less than fifteen miles north of the place where the Metolius flows out of the ground—a nearly full-grown river at its birth—the river's sparkling cold water churns into effervescent beauty as it races down Wizard Falls. The Metolius features a ten-mile stretch that is open to fly-fishing only.

■ *Below:* Eighteen hundred-acre Black Butte Ranch is a family recreation area established in the 1970s. Just south of 6,415-foot Black Butte, hundreds of fine homes are tucked away in pine forests surrounding meadows, lakes, tennis courts, swimming pools, two golf courses, and miles of bicycle trails.

■ *Below:* A fresh spray of new snow highlights the crags of the Three Sisters. In the near background are Mount Jefferson and Mount Hood. To the right of Mt. Hood, but in Washington, rises Mount Adams. Between Jefferson and Hood, Mount Rainier is visible almost two hundred miles away.

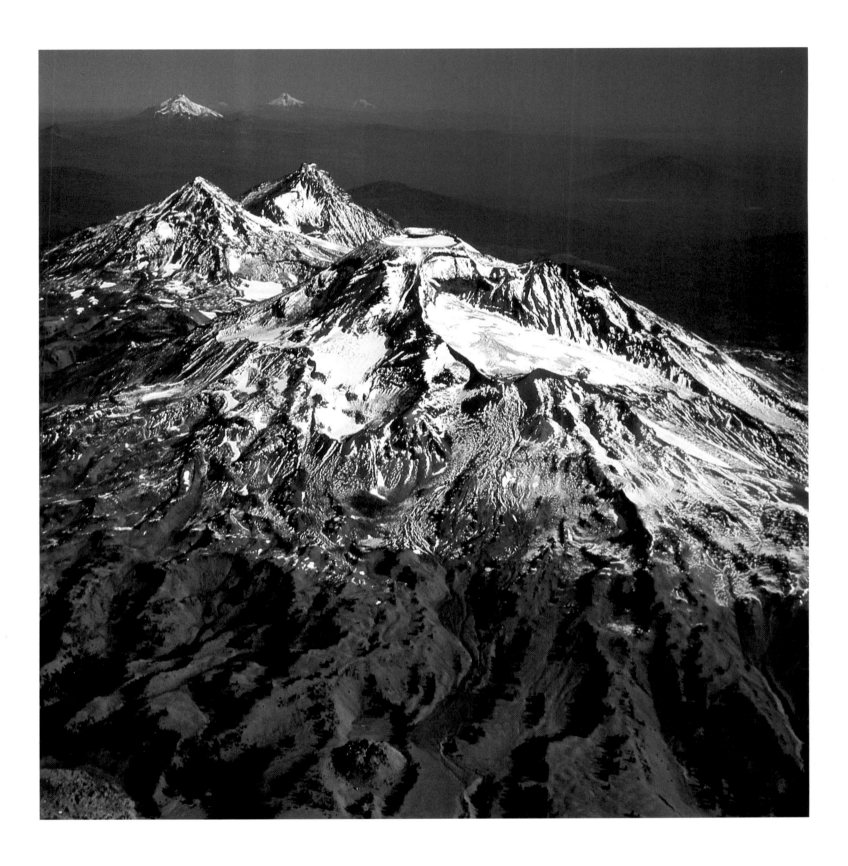

■ *Below:* One of the many busy chairlifts carries skiers up the slopes of Mount Bachelor, one of the Northwest's most exciting winter playgrounds. Adding four-seat chairlifts and a new restaurant, Mount Bachelor ski operators are in the midst of a 60-million dollar development and expansion to attract more skiers from the West and from as far away as Japan.

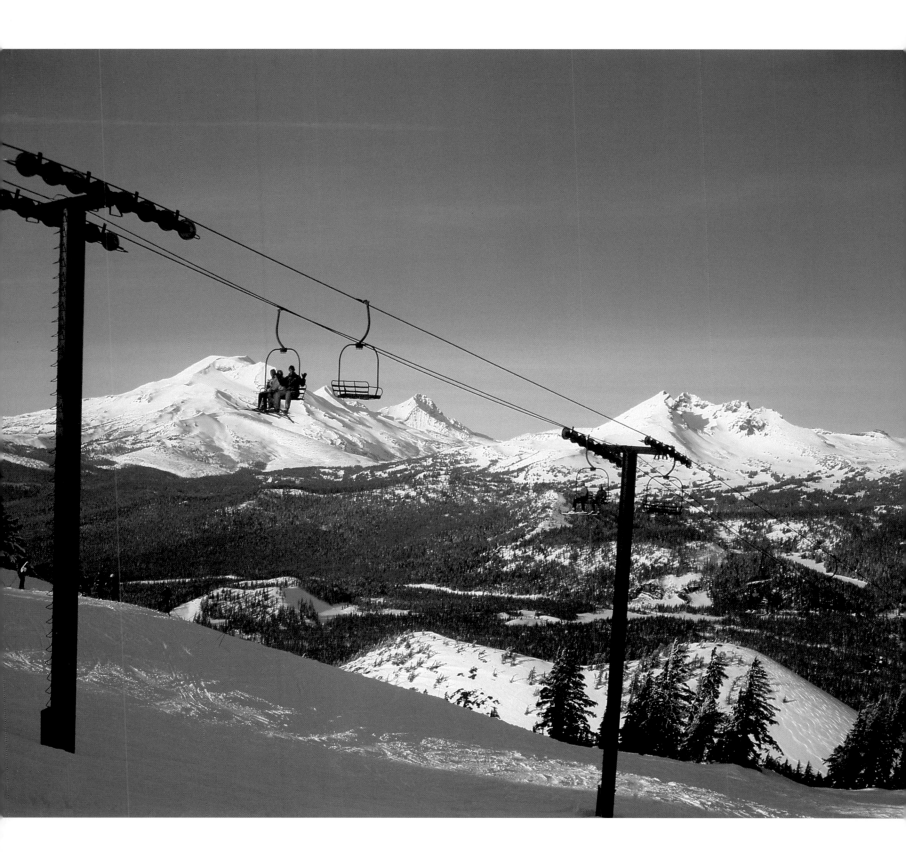

■ *Below:* A striking study of reflections reveals Crater Lake's Wizard Island. Mount Mazama, whose eruption more than six thousand years ago created the lake, once reached twelve thousand feet in elevation. Its upper half now lies scattered over eight states and three Canadian provinces.

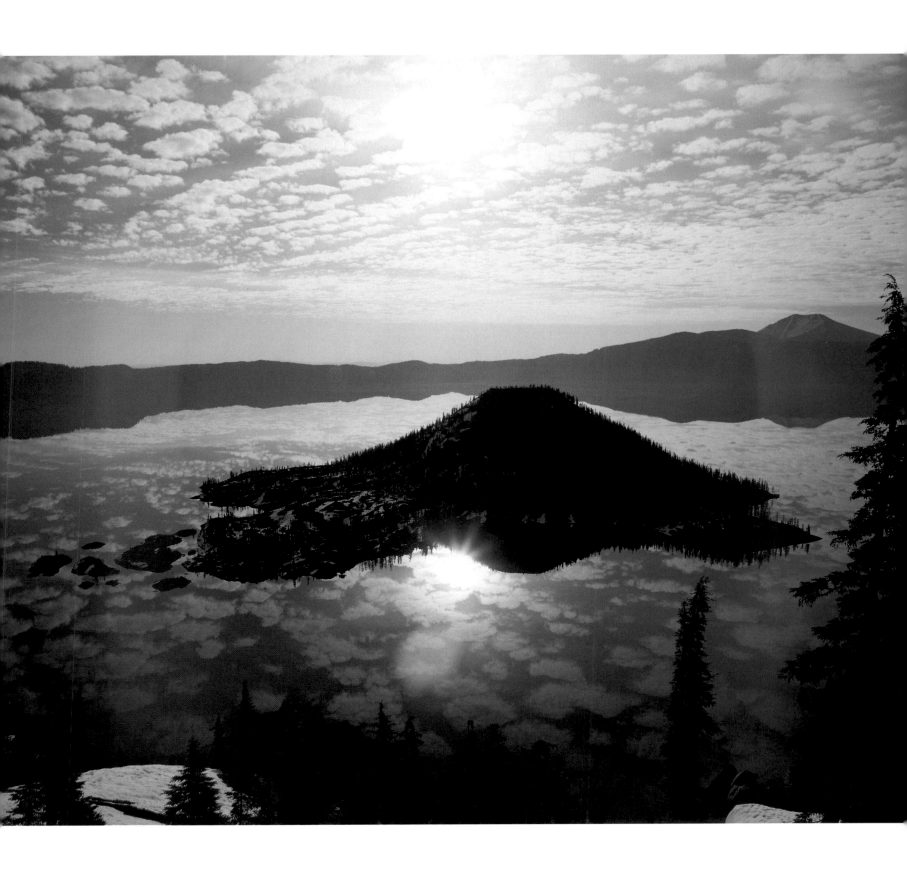

■ *Below:* Crater Lake's amazing, deep blue coloring is best seen from the air. Why so blue? As light passes through water, its colors are absorbed. First the reds go, then orange and yellow. The blues are the last to be absorbed, and the richest blues are reflected back from the great depths. ■ *Overleaf:* Winter snows turn forests into "flocked" Christmas trees.

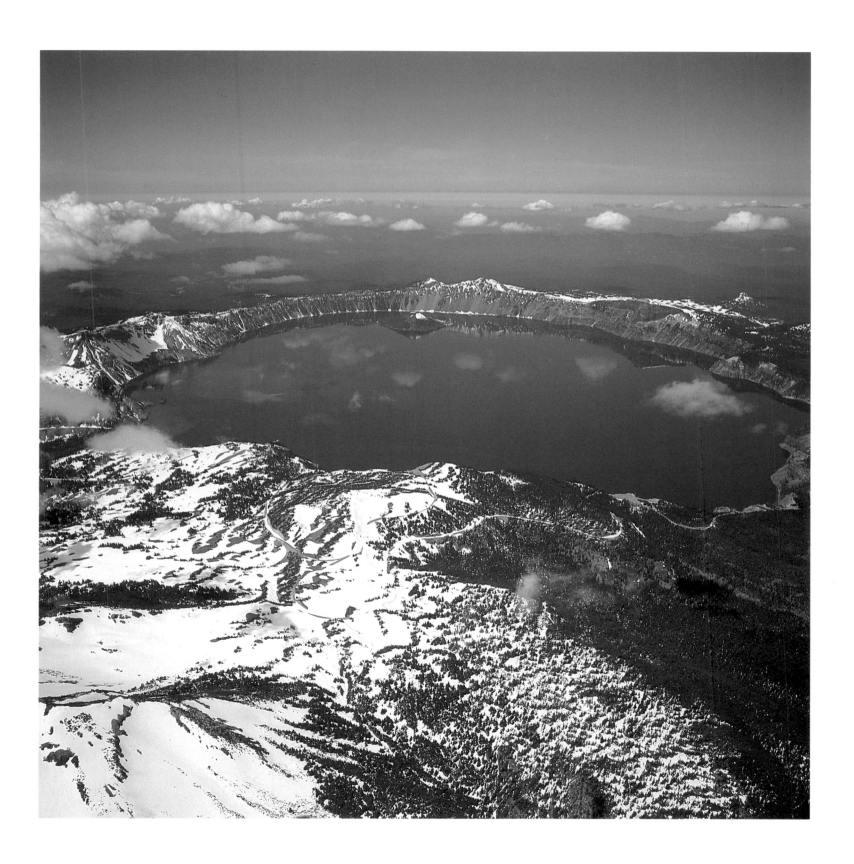

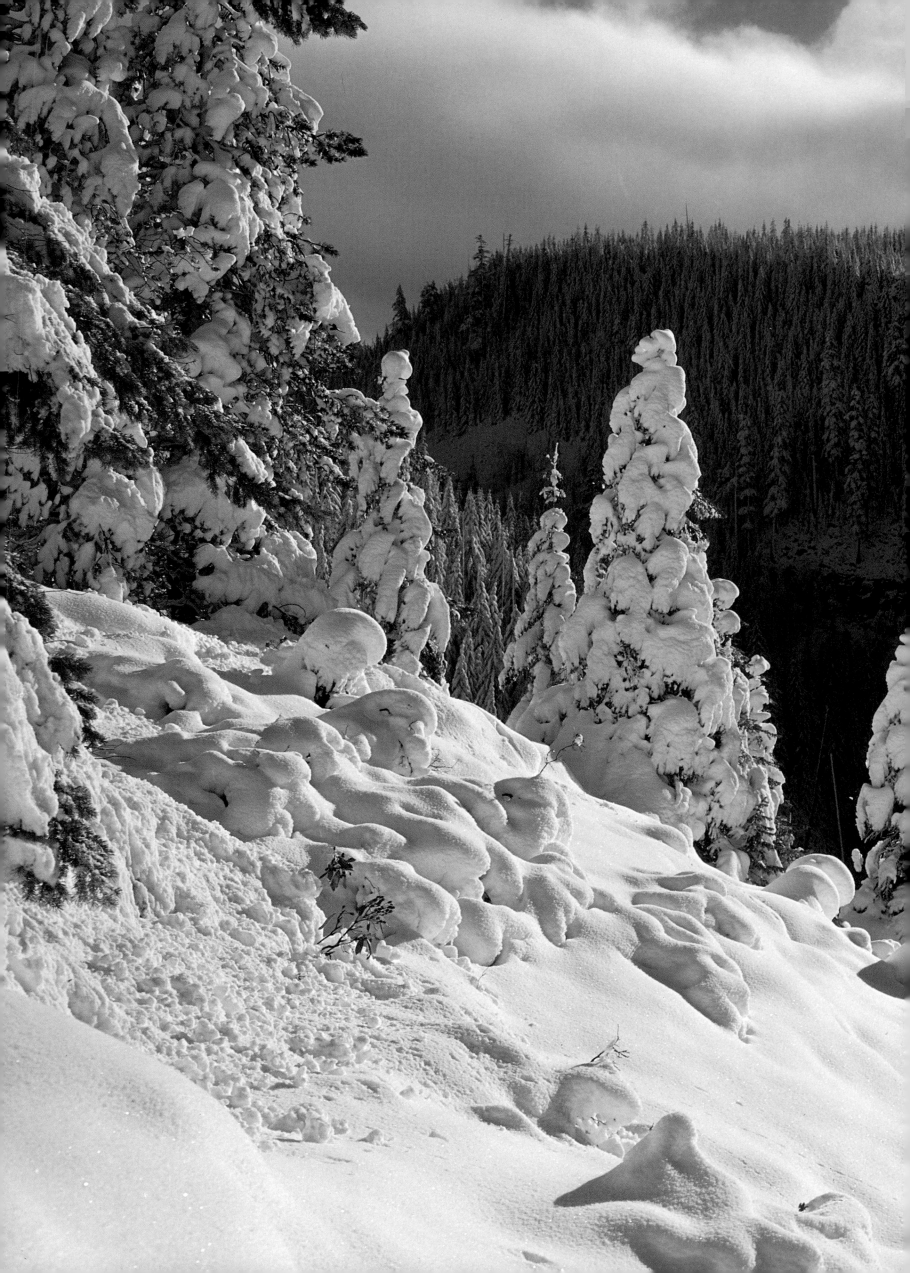

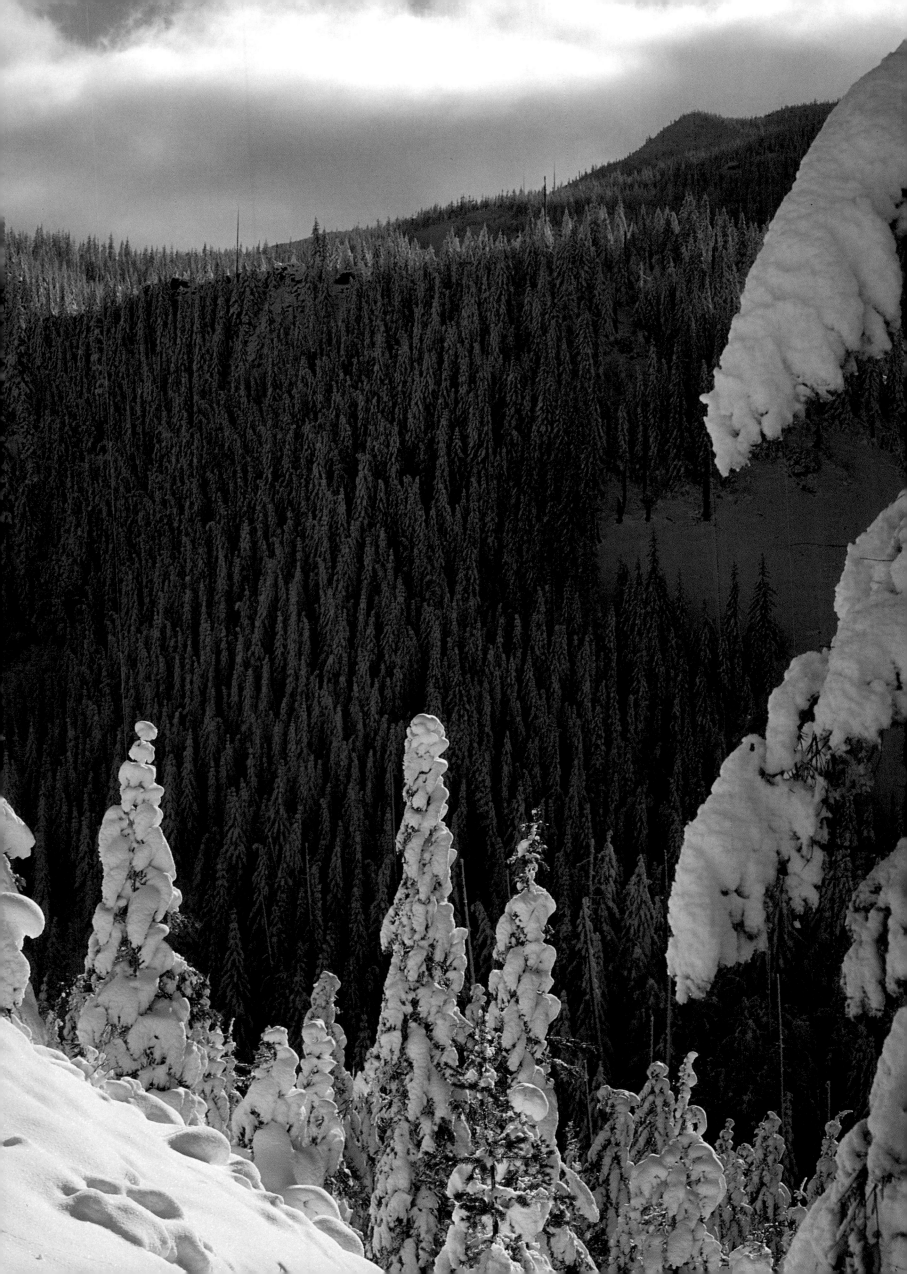

■ *Below:* Several kinds of *Mimulus,* or monkey flowers —
sometimes red, usually yellow — bloom in Oregon mountain
meadows. ■ *Right:* Each year, Oregon harvests 8 or 9 billion
board feet of its 414 billion board feet of standing timber.
Seventy percent of the cut comes from west of the Cascade
Range and is composed largely of Douglas fir.

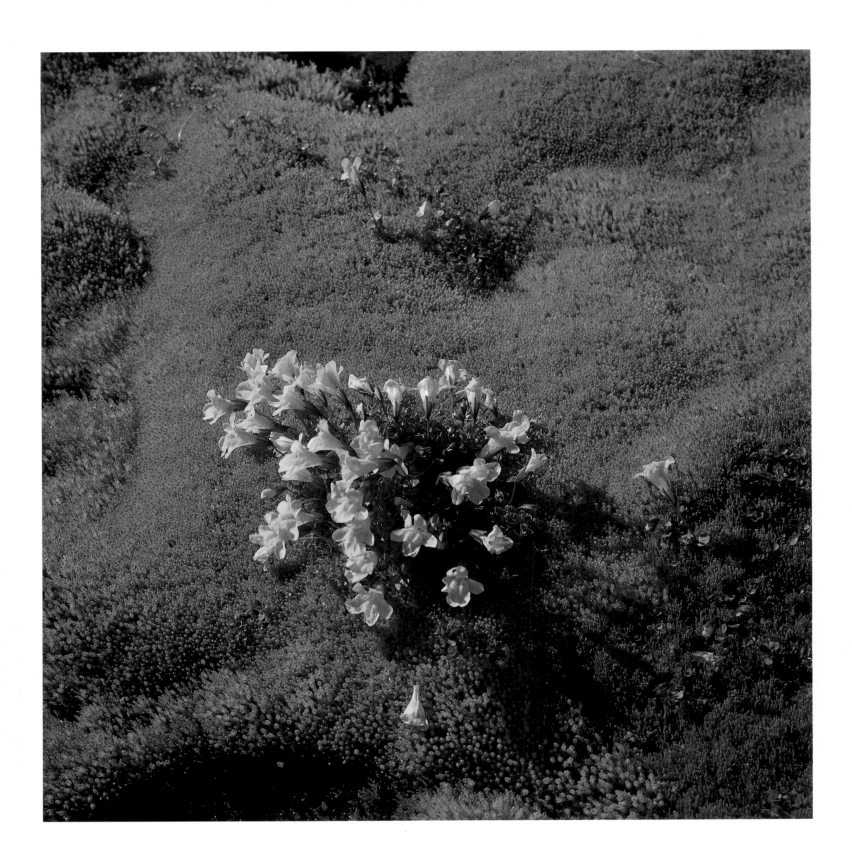

CENTRAL OREGON

Central Oregon is a playground for the people of the western valleys. They come to golf, to fish, to run the rapids, to hunt for fossils and rocks, to explore, to ski in the winter, or just to lie in the summer sun. But just as this area's sun-drenched attributes draw visitors bent on recreation, its year-round residents find it is a wonderful place to live and work. For some, as you will see, nothing could pry them from this land they love.

Central Oregon's largest city is Bend, and one of that city's prominent citizens is Bob Chandler, whose family publishes the *Bend Bulletin* and a string of other newspapers. Bob, an articulate raconteur, whose stories are laced with bold and colorful language, talks about how the nature of movers and shakers in the community is changing.

Bob says, "When I came here, if I wanted to see the biggest operators in Bend, I'd walk to the back of the store to the man at the rolltop desk. He could give me answers or help on a project, because he owned the place. Now, he'll say 'I gotta call Troy, Michigan, or I gotta call Los Angeles, or I gotta call Oakland.' And that's happened to small towns all over the country."

Chandler goes on, "The management people who work for the places where they've got to check with Oakland aren't here very long." On the other hand, says Chandler, the professional people tend to stay. "We have 116 doctors on the staff of the local hospital. We've got more doctors per capita than any other town in the United States except Rochester, Minnesota."

The big resorts near Bend have drawn a large share of retirees to the area. Chandler says, "We have a friend out at one of the resorts who's a retired vice president of RCA. Another friend was Western Bureau manager for Gannett News Service. And the leading banker in Kansas spends five months a year out here. He has an answering machine, a computer, and a modem to connect him to the home office."

As for the housing market, Bob says he just hired a new city editor from San Jose who bought, for $90,000, a house that is better than the one he sold in San Jose for $200,000. Bob says, "You can get the best bargains in housing in the United States of America in Bend, Oregon."

A favorite Central Oregon success story is the High Desert Museum run by Don Kerr. It was opened in 1982, six miles south of Bend, and welcomes seventy-five thousand people every year. Set on one hundred and fifty acres, it presents a huge outdoor classroom for the study of the geology and living things native to the region, such as lizards, porcupines, birds of prey, and river otters. The museum's public relations man, Jim Crowell, took us out to watch a demonstration of the feeding habits and the radar-guided flight patterns of the owl. Don Sorenson, a retired airline pilot, and his wife, Gladdy, who live at Sun River, perform these demonstrations with live specimens every weekend.

Crowell names other people who are doing satisfying and creative work in Central Oregon: Dwight Newton, an escapee from Los Angeles where he was a script writer for the "Gunsmoke" series, has made his living as a Western novelist for the last forty years. Crowell describes Newton as an exceptional Western historian who has a modest home close to the local library and lives "this kind of nice life."

The first community college in this state, Central Oregon Community College was built in the Bend area. One of Jim Crowell's favorite teachers there is Bruce Nolf, a brilliant teacher and researcher who knows the geology of the West. Nolf feels that everything he wants to do professionally is right here in his own backyard, and Crowell says, "We're lucky to have him."

Harry Lonsdale is another of Jim's favorite subjects. Harry arrived ten years ago and established Bend Research, Inc., a chemical research and development company. He operates in a big, rambling ranch-style house on a high prairie above Tumalo, outside Bend. Harry told us he came West from New Jersey to get away from crowds. He says, "I've always liked to fish. In New Jersey on opening day, unless you got there by 5 o'clock in the morning, you would literally be in the third row of fishermen . . . You'd be casting over people's shoulders." He says, "I still have some New Jersey left in me. Even around this company I'm considered 'East Coast Pushy.' I probably am. I find Oregonians extremely tame, gentle, even-mannered, peaceful people."

After thirteen years in California, and coming to agree with the premise of the book *Future Shock* — that the world is getting tighter and increasingly complicated at an ever-faster pace — Lonsdale set out to find a quieter clime. He says, "We toured through five states. I've been in every national park and down every crummy dirt road in the West, I think. And I fell in love with the *remote* American West . . . and this is the *best* . . . spacious, very pretty, lots of blue sky . . . and I love the mountains."

The people at Bend Research do not manufacture anything. But, using their special man-made membranes, they develop products that are then manufactured by spin-off companies. One is funded by Bethlehem Steel and another by the W. R. Grace Company. Bend Research also has a major contract with NASA to create a filtering system for liquids in the space station that is being developed.

The project backed by Bethlehem Steel is fascinating. There are about fifty million tags sold around the world each year and hung on the ears of cattle. These tags are impregnated with a pesticide to ward off the face flies that bother the cattle and tend to make them weak and scrawny. With most tags, when the pesticide release reaches a low level toward the end of its use, the flies develop a resistance to this lower, non-lethal dosage. So right now, most of the flies on cows in the American Southeast,

from Texas to Florida are resistant flies. But Bend Research developed a membrane for the tags that releases only lethal doses and then quits. Therefore the flies are either dead or not harmed by the pesticide at all and the problem of resistant flies is eliminated. This unique invention has a very real economic benefit, because it is estimated that half the calories consumed by a cow are used up in worrying and switching its tail and fending off flies.

Lonsdale says that Bend is a fine place to do business on a worldwide scale. "We get fast service here . . . and in these days of computers, telephones, and facsimile machines . . . we can communicate with the world in seconds. And Bend is a marvelous place to bring up your children."

Another California escapee in his mid-thirties is Don Bauhofer. Formerly a trial lawyer and a designer and builder of custom homes, he worked for a time with Lonsdale at Bend Research as director of business operations, then headed out on his own in real estate. He and a friend, Tom Dunnell, bought the old Bend Post Office building, refurbished it, converted it into office space, and in three months had it entirely leased out.

Bob Foley, retired Court of Appeals judge, who recently celebrated his seventy-fifth birthday, lives with his wife, Irene, in a mobile home on the south edge of Bend. He says that before he went to the Court of Appeals, he was a circuit judge for three counties—Crook, Deschutes, and Jefferson. Now in retirement, he occasionally serves as judge pro tem. He says, "I used to handle all three counties by myself. Now they've got three circuit judges, two district court judges, and all kinds of staff. Last week in Madras and Prineville, they kept me busy all week long. And as I was leaving, the clerk said she was awfully glad they were able to set up a light caseload for me."

Bill Healy, who developed the Mount Bachelor Ski Resort, has had a very beneficial effect on the Bend area economy. The ski resort gave rise to the building of other resorts like Sun River and The Inn at Seventh Mountain, and these, coupled with Black Butte Resort, contribute to the tax picture for the people of Bend.

One couple wanted so much to live in the high desert country of Central Oregon they simply bought a town. The town, a hundred miles southeast of Bend, is called Wagontire, and its owners make up its entire population — two. In his sixties, William E. Warner was working in a hotel in Reno, Nevada, when he saw the Oregon town advertised for sale. He and his wife, Olgie, looked the place over carefully and made a deal to buy it. They don't say for how much. When Barbara and I stopped by for coffee and a breakfast roll, William was in the restaurant kitchen and Olgie served us at the table. The restaurant is their main source of income, but there are also a half-dozen motel rooms, a gas station, an RV park, and a dirt airstrip.

Due south on Highway 395 is Lakeview, whose residents make much of the fact that it is at the highest elevation of any incorporated city on the Oregon Highway system — four thousand eight hundred feet. Lakeview is the home of Oregon's only regularly spouting geyser. It shoots two-hundred-degree water sixty feet in the air about every minute and a half. The geyser is the main attraction at Hunter's Hotsprings Resort, but many visitors are drawn to the museum with its singular collection of classic cars and — would you believe — outhouses.

About ninety miles due west of Lakeview, the city of Klamath Falls lies a scant twenty miles north of the California border and at the southern tip of a great body of water, Upper Klamath Lake. A former Klamath County Commissioner, Floyd Wynne, says that the man who founded the city of Klamath Falls was never given much public recognition for that fact until about three years ago — after a lot of pressure on city hall.

The way Wynne tells it, George Nurse was an orphan who worked his way from the East Coast out to San Francisco during the Gold Rush days. When the army established Fort Klamath a bit north of here, Nurse came up and obtained a hay contract to furnish feed for the U.S. Cavalry and eventually opened the Settlers Store at the fort — sort of an early day Post Exchange. When the Civil War ended, it became obvious to him that a lot of army forts would be closed down. So Nurse packed his things and had some lumber sawed up at the fort. He floated that lumber down Upper Klamath Lake to the place where the city now stands and there he built himself a cabin. He applied to the federal government for a land patent for the area and he started the whole town in 1867.

Nurse would give land to any responsible person who came along and wanted to start up a business. He also gave ground to build schools, gradually developing the community until the year 1884. Then, almost as suddenly as he had arrived seventeen years before, Nurse left the area, moved to Yreka, California, and never came back.

Wynne believes one of the reasons Nurse left was that he had received no personal recognition for his contribution to the development of Klamath Falls. Until Wynne began to pressure for recognition of Nurse's influence, there was not a thing in the city named for him—no school, no building, no park, not even a street. But Wynne finally persuaded the City Council that a road that cuts through Veterans Park should be given Nurse's name, and so today it is called George Nurse Way.

The community of Klamath Falls worked together on the building and shaping of what is now the Oregon Institute of Technology. Mikel Kelly, editor of the *Klamath Falls Herald & News*, describes the institute as on the cutting edge of advances in the industrial and technical world. He says that under president

Larry Blake the school has a real creative flair and that members of the teaching staff are all problem solvers who now teach other people how to solve problems. Paul Angstead, a retired school administrator for Klamath Falls, says that in the last five years O.I.T. has placed 97 percent of its graduates, a record unmatched by any school anywhere. He calls Blake a great administrator and a great diplomat who will go to the state government in Salem and get what the school needs.

Klamath County is cattle country, timber country, and the ancestral home of the Klamath Indians. In the mid 1950s, under the federal policy of termination, the Klamath Tribe had its lands sold and its tribal status terminated. (Through an Act of Congress, one man, Edison Chiloquin, managed to retain use of his land as a spiritual encampment.)

In 1986, after thirty years of effort, the Klamath Indians managed to regain their tribal status by an Act of Congress. Throughout this difficult period, the tribe has continued to play an active role in Klamath County.

Klamath Falls has what may well be the most outstanding museum of contemporary Western art and Indian artifacts to be found in this country. It is called the Favell Museum and it was built by Gene and Winifred Favell fourteen years ago. Gene Favell's parents were in ranching and had a real estate business in Lakeview. His wife, Winifred, was a Lamm, and her father owned the Modoc Lumber Company just north of Klamath Falls. So the Favells inherited money from their parents.

For the Favells, the collecting of Indian artifacts has always been a hobby-love. At first they kept their large collections in their home, but in order to do something of a lasting nature for the community, they built a public place to house them.

Museum manager Bev Jackson says visiting tourists tell her that this is the finest museum of its kind they have ever seen. Sixty thousand arrowheads are on display, and for every one on display there are seven more in storage. A fantastic collection of one hundred miniature firearms is kept under lock and key. Each one is a working model, and they range from tiny Gatling guns to inch-long Colt 45s. As if this were not enough, on display are all forms of Western art — including oils, watercolors, bronzes, woodcarvings, photography, dioramas, and taxidermy — the work of more than three hundred artists.

Bev told us the museum is located right where Indians used to camp out and fish for salmon. Dozens of artifacts, including cooking pots and mortises and pestles, are embedded among the stones of the lobby walls. All of these were unearthed when the excavating was done for the museum foundation. Bev also says they found three Indian graves which are still there under the building. She says she always says "Goodnight" to the spirits when she goes home at night.

The people in the northern reaches of Central Oregon are primarily concerned with farming—the raising of cattle, grasses, and grains. The town of Grass Valley was named by the early pioneers who found the grasses here so tall they were "well over a man's head...even when he was on horseback." The grasses don't grow in such proliferation here anymore, but the land is producing wheat and barley.

The population of Grass Valley is 160. At Carol's Kitchen Cafe we talked with Willard and Charlotte Barnett. Married fifty-one years, they have lived here all their lives. When they were farming, they raised cattle and wheat. They still live on the farm but about nine years ago they started leasing the land out to others. "Up until then," Willard says, "I did the field work and Charlotte was a cowboy ... checking the springs on the rangeland and rounding up cattle. In fact she's still got her old horse."

On the way to Grass Valley we drove through a couple of "almost" ghost towns. Since nearly two thousand followers of the Bhagwan Shree Rajneesh pulled out of Oregon, the population of the town of Antelope has stepped down to twenty-eight. Don and Linda Spears have taken over the Antelope Store and are trying to build the business back up to where it was before the Rajneeshees came. Don says they still get a lot of tourist traffic—mostly curiosity seekers who just want to get out to see the 64,000-acre Rajneesh ranch that is about nineteen miles up the road.

Eight miles north of Antelope is a bit more of a ghost town—Shaniko. About fifteen people live here. There is a service station, and Art Fine runs two gift shops which ply the tourist trade that a ghost town will draw. Clarence Keiffer was tending one of the gift shops when we stopped by. He is staying in the vacated old Shaniko hotel right now as a sort of watchman and says the owners hope ultimately to have at least sixteen hotel rooms refurbished and available for rent.

Joe and Sue Morelli owned the hotel in the early 1960s. Sue is the local historian. She has published some pamphlets on the town, which was once called the world's largest inland wool shipping center. At one point, just after the turn of the century, the sale of wool in Shaniko reached five million pounds, and the wool was shipped out on the Columbia Southern Railroad.

But later, the Great Northern and the Union Pacific railroads competed with one another to run an additional rail line up the Deschutes River Canyon to serve Southcentral Oregon — bypassing Shaniko. This, and range wars that cut back on sheep production, killed the town. The banks closed, and the Columbia Southern train stopped running. The tracks were pulled out to furnish steel for defense plants during World War II. Still, Shaniko and other ghost towns sprinkled through central and eastern Oregon hint at a frontier richness in Oregon's past.

■ *Below:* Sun River Lodge and Resort is set in the Deschutes National Forest just fifteen miles south of Bend. The thirty-three hundred-acre resort boasts two eighteen-hole golf courses, miles of hiking and biking trails, tennis courts, swimming pools, and riding stables, plus an extensive shopping center.

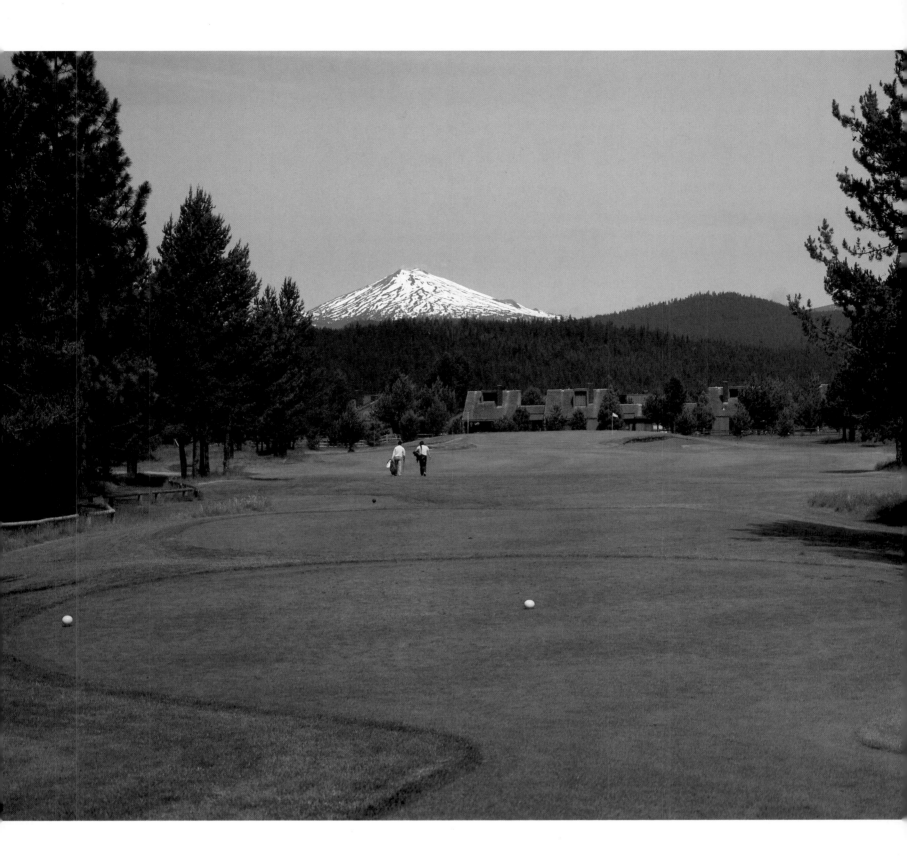

■ *Below:* Central Oregon is cattle and horse country. Ten miles northwest of Bend, near Tumalo, Rock Springs is a low-keyed guest ranch — an informal retreat surrounded by giant pine trees towering over ageless junipers, cool green meadows, and great expanses of sagebrush.

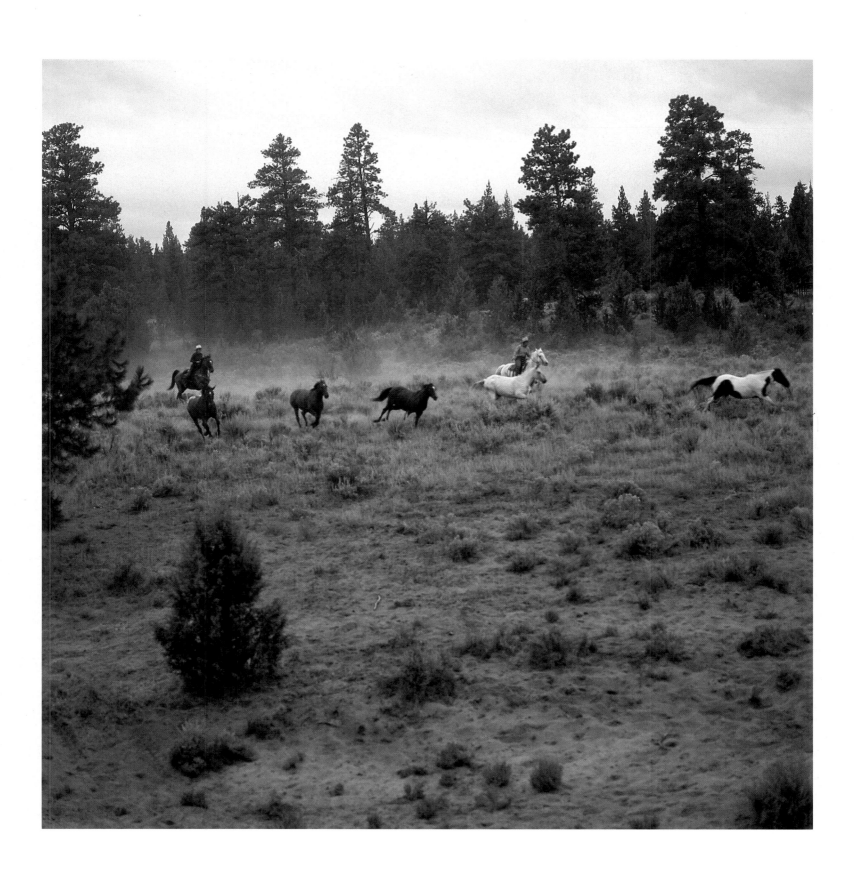

■ *Below:* The citizens of Bend enjoy delightful sunsets over the mountains to the west. Here, Black Butte and Mount Jefferson are silhouetted against the late afternoon sunshine. Bend, with a population of just over eighteen thousand, is the county seat of Deschutes County and stands on the banks of the Deschutes River at an elevation of 3,628 feet.

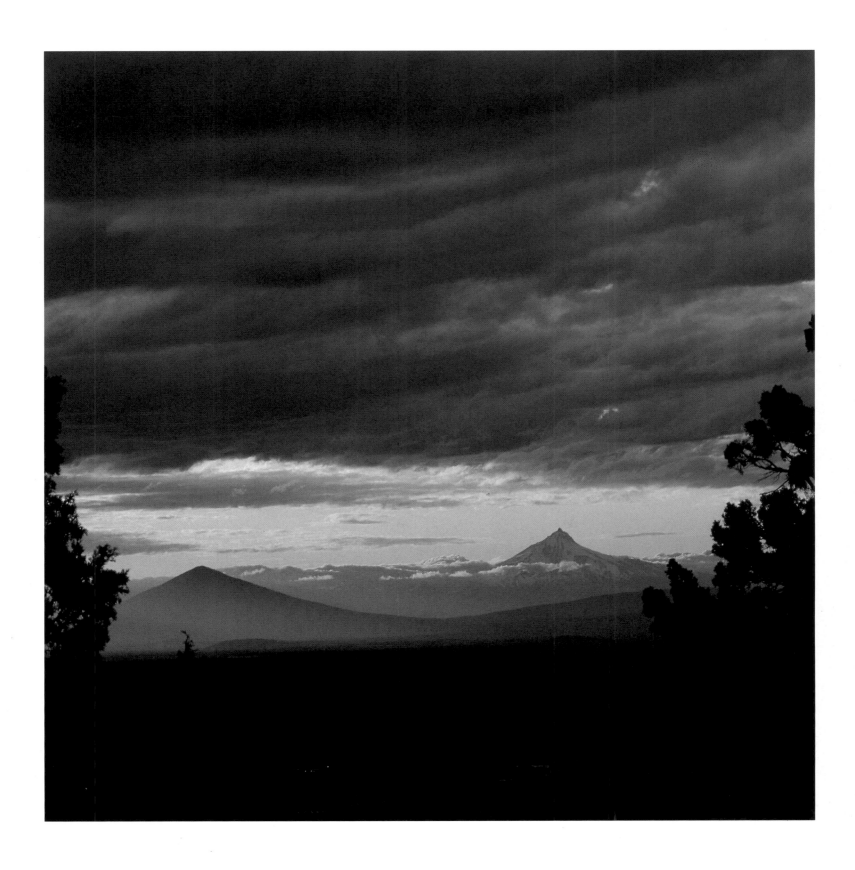

■ *Below:* A Cascades forest playground surrounds 8,036-foot Pelican Butte, reflected in the waters of the Upper Klamath National Wildlife Refuge. ■ *Overleaf:* Clouds tinted by a setting sun silhouette 9,495-foot Mount McLoughlin. The mountain is about fifteen miles west of Upper Klamath Lake, which is Oregon's second largest lake after Malheur.

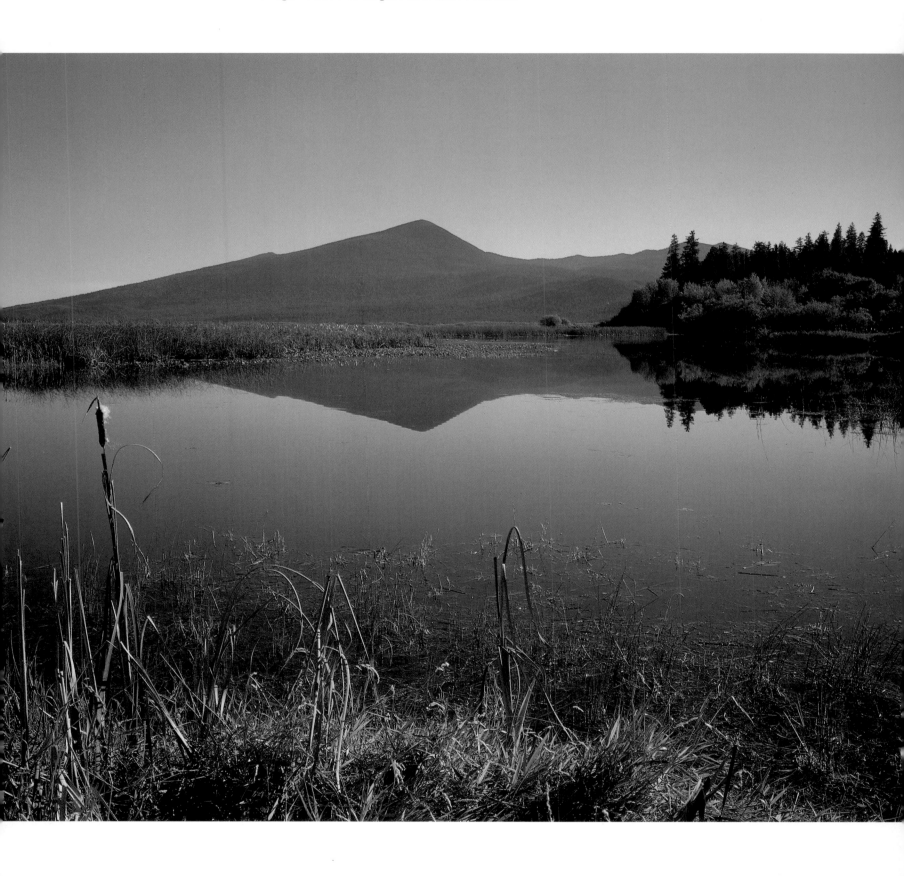

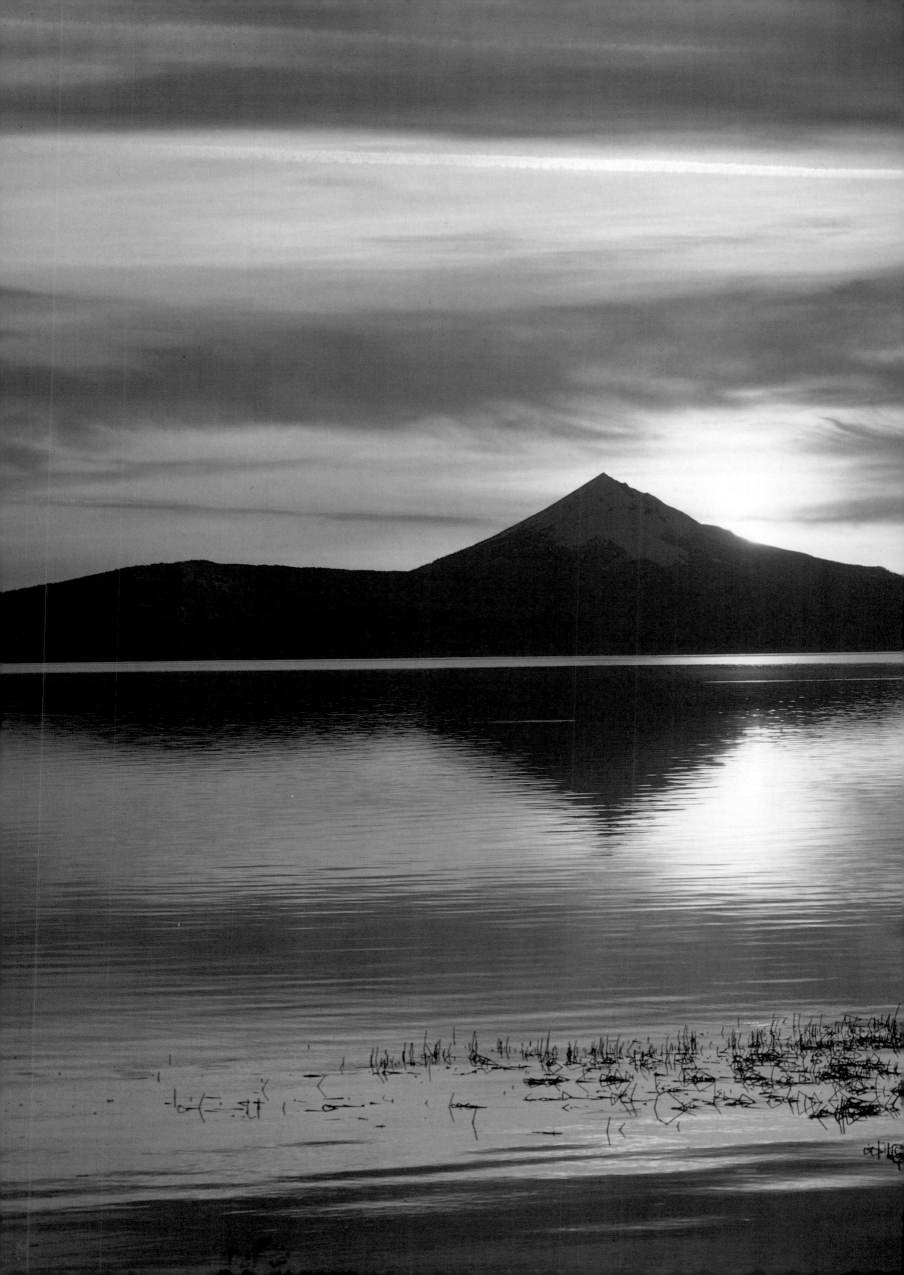

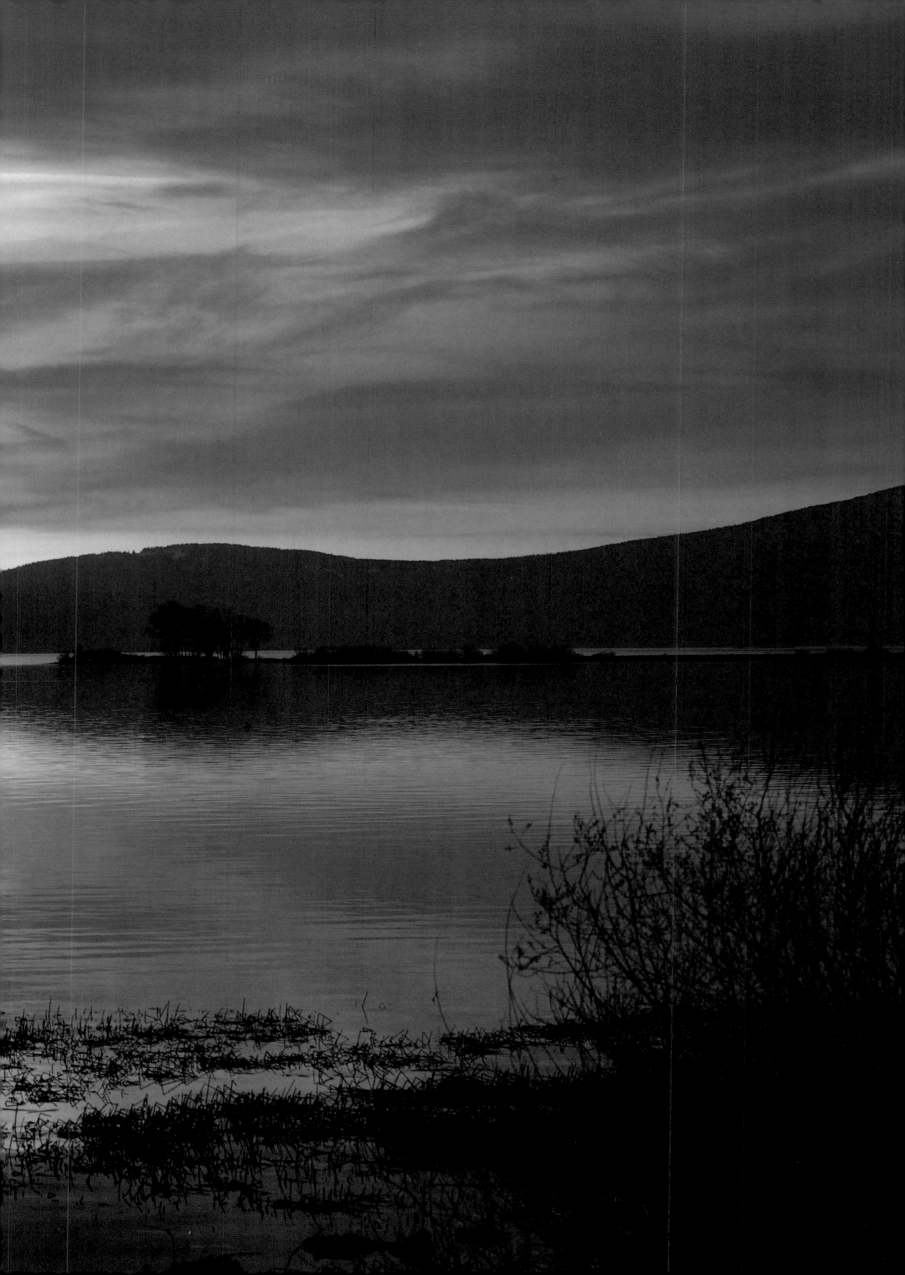

■ *Below:* The striated landscape of volcanic ash called the Painted Hills is part of the John Day Fossil Beds National Monument. Its artifacts tell the 40 million-year history of the "Golden Age of Mammals"—a time when horses the size of fox terriers and Titanotheres, herbivorous mammals the size of elephants, roamed the tangled forests of this land.

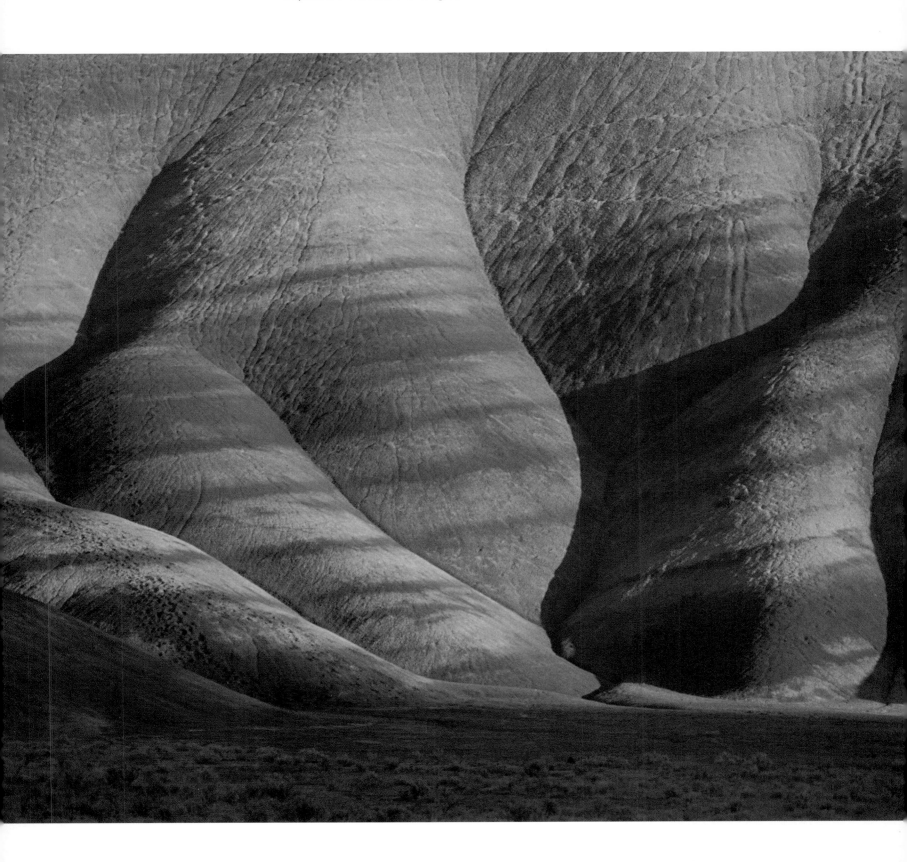

■ *Below:* Dramatic cliffs and spires in Smith Rocks State Park rise above the Crooked River. Sheer walls lure expert rock climbers from all over the nation to practice their skills. The rocks may be named for a soldier who was killed when he fell from them, or for John Smith, a nineteenth century sheriff of Linn County who is said to have discovered them.

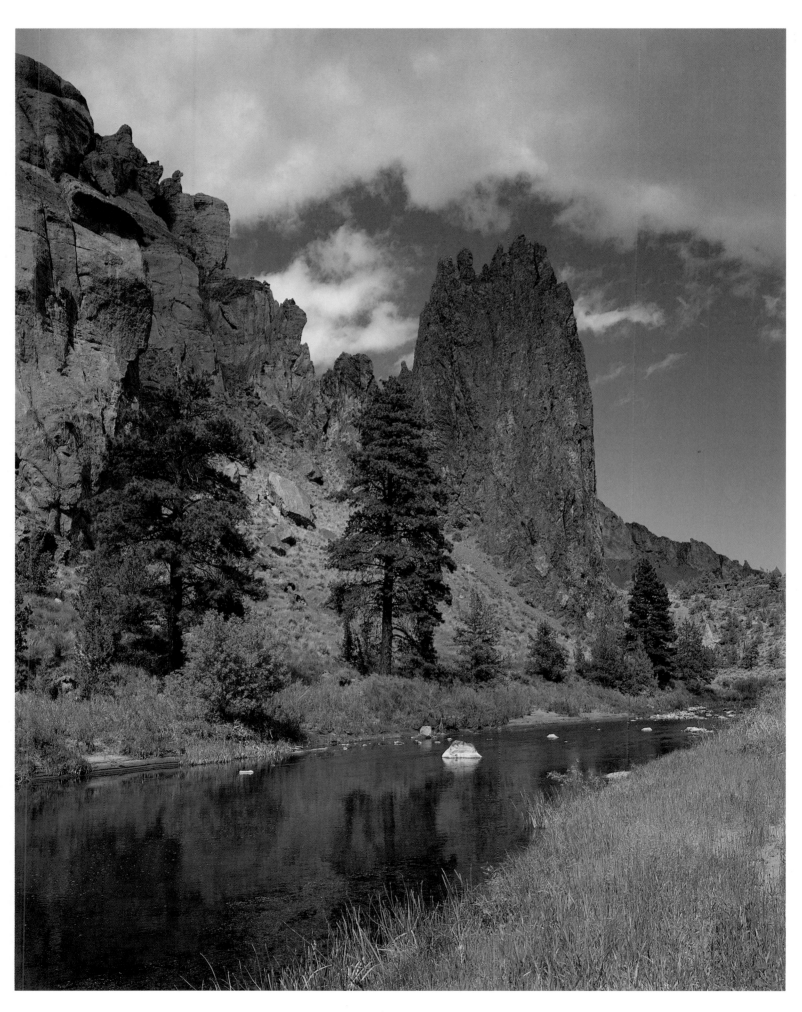

■ *Below:* The Deschutes River flows through Central Oregon many miles from its source in the central Cascades on the distant skyline. The Deschutes is recognized as one of Oregon's best fishing streams and—north of here in its lower reaches—as one of the finest white-water challenges for river rafters.

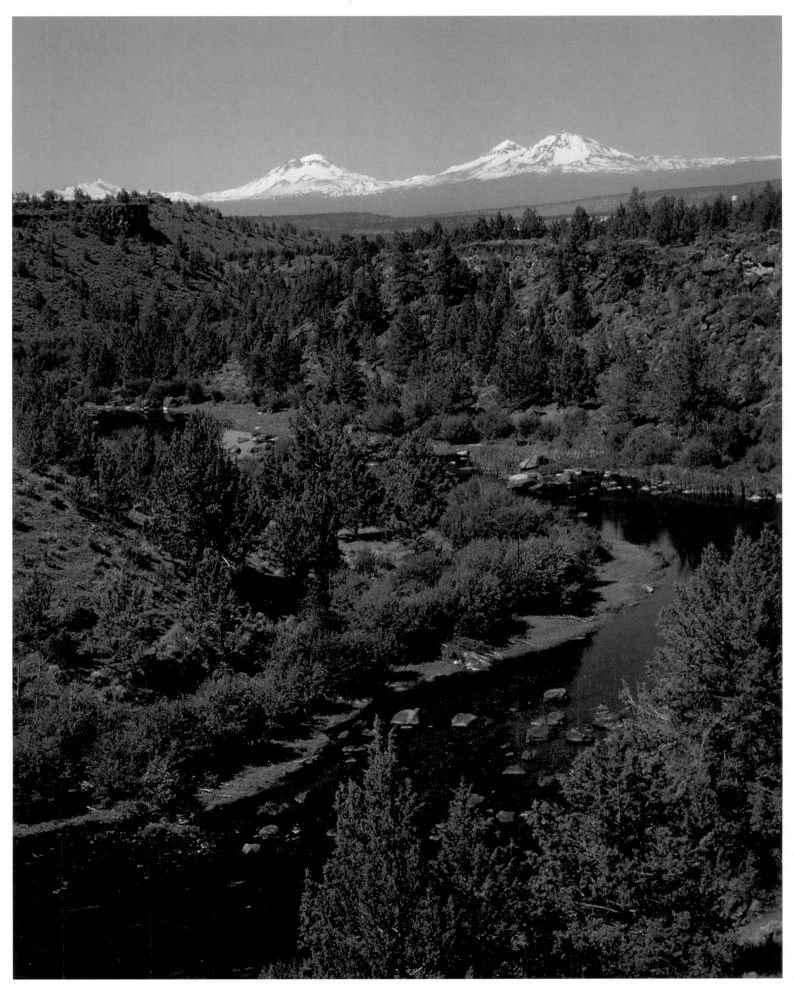

■ *Below:* On the desert floor northwest of Lakeview rise the crescent-shaped remains of an ancient volcano now known as Fort Rock, a 190-acre state monument. The landmark, a third of a mile across, rises 325 feet above a plain of sagebrush. Carbon tests on early man's weapons and sandals found in caves at the rock's base show them to be at least nine thousand years old.

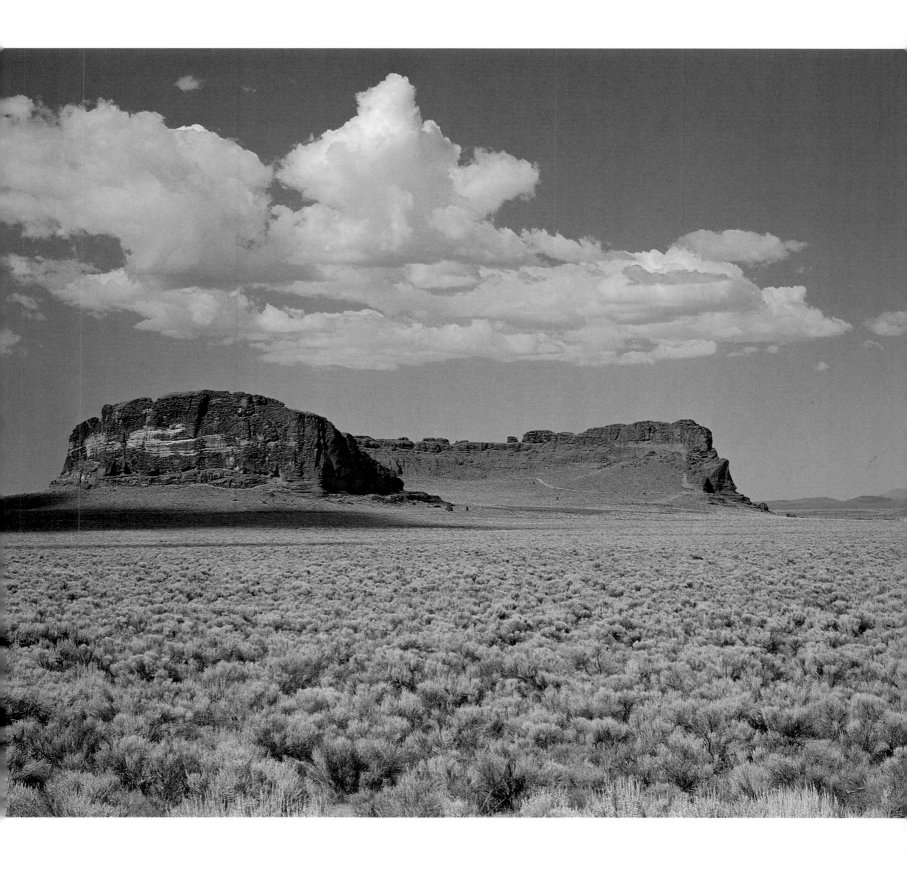

EASTERN OREGON

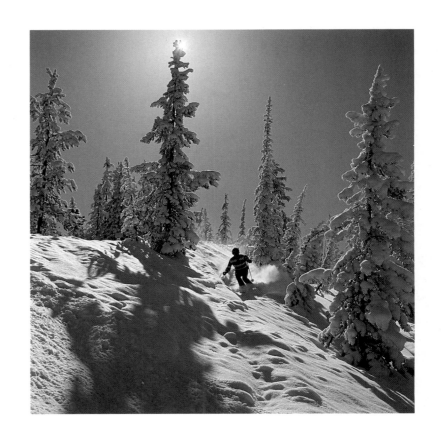

There are thirty-one million acres of sagebrush in Oregon, most of it in the southeastern quarter of the state. Here there are places where the only things you see as you look to the distant horizon are sagebrush and some juniper trees. This is cattle country and it is said cows outnumber people nine to one. In Harney, Oregon's largest county, which is the size of New Jersey, there is one person for every 1.4 square miles.

One of the most important bird refuges in the nation is located in Harney County. The Malheur National Wildlife Refuge is a breeding ground and resting area for hundreds of species of migratory birds in the Pacific flyway. The larger ones include pelicans, sandhill cranes, trumpeter swans, and Canada geese.

A man who devoted thirty-five years of his life to the development and care of the wildlife refuge is John Scharff of Hines, Oregon. John and his wife, Florence, spent an entire day with us, guiding us around the perimeter of Steens Mountain and through as much of the refuge as is reachable by road, since the two lakes, Harney and Malheur, merged and flooded over about four years ago, making it the largest lake in Oregon.

John studied animal husbandry at Oregon State and then worked for the Forest Service for thirteen years. He was asked to take over management of the Wildlife Refuge in 1935. We asked him what was here at that time. He said, "Nothing. The refuge headquarters was just a sagebrush hillside. Florence and I spent two winters in an old homestead cabin out there. It would get to 39 or 40 degrees below zero and I'd get up in the morning and thaw the teakettle out so I could go out and get a bucket of water. I'd come home in the evening, and my wife would have her coat and overshoes on while cooking dinner." Then he told us about building the stone headquarters, three hundred miles of canal, three major diversion dams, and miles of road.

He knows just about every foot of the land and probably knows as much as any man living about this state's most famous cattle rancher, Peter French, who came here in 1872. French, working for a wealthy California rancher, Dr. Hugh James Glenn, bought up almost all of the Donner und Blitzen River Valley, south of the big lakes. He had one hundred and thirty-two thousand acres of deeded land and ran forty thousand head of cattle and more than eight thousand head of horses and mules.

John took us to the "P" Ranch where French made his headquarters and built a country-wide reputation as a good manager turning out high quality grass-fed beef. French was murdered by a disgruntled neighbor, Ed Oliver, on December 26, 1897. That was four years before John Scharff was born, but he was to oversee much of French's domain, because the government bought all of this land and assigned John to manage it.

Florence says she used to make pets of the antelope on the refuge. They had a doe and two sets of twins that used to hang around headquarters. When school buses rolled up with students on a field trip, John would call the antelope in so the children could pet them. The Scharffs, married almost fifty years and now retired from government service, own four thousand acres of land they lease out to sheep herders.

At the southern end of the Malheur Refuge the Scharffs brought us to Frenchglen to meet the operators of Oregon's most unusual hotel. Catherine Fine, who works there, says the Frenchglen Hotel was built about 1916 by Swift & Company, and her parents ran the hotel for Swift. When the government extended the Malheur Refuge to include this land, the hotel went with it.

Catherine now works for the present hotel operators, Jerry and Judy Santillie. They have eight rooms for rent and there are two long tables for dining on one side of the lobby with room for maybe fifteen dinner guests at a time. Judy Santillie says they would like to run the place the way it used to be when people would stay at the hotel while they moved their sheep and cattle down in the winter, and a ranch hand might have a room for a month. Right now, much of their business depends on the tourist trade, and their favorite clientele are the folks who come in the springtime to watch the birds. In addition to the hotel, Frenchglen has two or three houses, a gas station, a general store, and a post office.

We took the gravel road around the east side of Steens Mountain, a three-hour drive during which we saw maybe four other vehicles. For about thirty miles we ran parallel to the Alvord Desert, and then John had us pull up a steep side road to the left. We drove as far as we could, then walked a couple hundred feet to a quonset hut set back into the flank of Steens Mountain.

This is the home, workplace, and retirement center of the Weston brothers, Jim and Mike. Jim is eighty and Mike is fifteen months younger. For twenty-eight years they have mined cinnabar out of the mountain with machinery they designed and made themselves. When they "cook" pure mercury out of the ore, it is worth about twenty-two dollars per pound.

We asked if they make a pretty good living out of it. The answer was, "No. But we're retired now so we don't have to make a living." The Westons went to high school in Bend, but not to college. Out front, a tiny orchard with apple, peach, and cherry trees clings to the hillside. They also raise some strawberries, corn, and squash. Their quonset hut is fully equipped with a microwave oven, electric dishwasher, a large food freezer, a separate refrigerator, a complete and official weather-reporting station, a ham radio transmitter, and a word processor that Jim uses to write letters. They have even rigged up a microphone on the roof to pipe in bird sounds from the outdoors!

Back in Burns, we talked with a young couple named Tim and Vickie Clemens. A fifth-generation resident, he is the Farmers

Insurance agent in the Burns-Hines area. Tim says people in Burns take great pride in their homes, but they are not interested in a $100,000 one. They want a $30,000 home and a nice pickup truck so they can use their money to get out every weekend. He says, "When we get off work, we're home in five minutes and we take off somewhere. We can go deer or elk hunting...right now it's bow and arrow season."

Seventy miles north, David Blood is editor of the *John Day Blue Mountain Eagle*. He reminds us that Grant County consistently has the fourth or fifth highest timber cut among Oregon counties and that all four of eastern Oregon's National Forests touch Grant County. So timber is important here. But so is cattle ranching. David says, "We still have cattle drives right down through the streets of John Day."

In sharp contrast to these affairs is the Chinese Festival held each summer. It is called the Annual Kam Wah Chung Festival and was named after the building that for years served as an office for a Chinese herb doctor, Ing Hay.

In the early 1970s, Gordon Glass, John Day's Chevrolet dealer, became a prime mover in opening the building up and analyzing and classifying its contents. He also promoted establishment of a museum based on the turn-of-the-century Chinese population of eastern Oregon during the gold-mining days.

Up in northeastern Oregon, if you talk to the people of Pendleton for more than a few minutes, you will find the conversation inevitably turning to the Pendleton Roundup. Allen "Monk" Carden, a member of a pioneer Pendleton family, calls the Roundup, which started in 1910, a leveling experience. He says that when the old wooden grandstand burned down, "A local contractor named McCormick offered to build a concrete grandstand in its place. His crews worked around the clock and every working person in Pendleton gave a day's wages to help pay for it. Thirty days later, the crowds were sitting in that new grandstand. That tells the Pendleton Roundup story about as good as I could tell it."

Clarence Burke is a most revered and longtime leader of the Indians, who are prominently featured in the Happy Canyon show that accompanies the Roundup. Burke is somewhere near ninety and has been Roundup Chief for many years. Monk says one time a fellow came in and wanted to organize the Indians at the Roundup, telling them not to go into the arena to perform and saying, "'They're herding you out into the arena like cattle.'" Monk says, "This was his big pitch ... until Chief Burke came riding up on his horse and he says...'Hey you...You go out the front gate... and you watch white people come in like cattle ... don't talk to my Indians.'"

Two executives of the Pendleton grain industry, Don Cook and Wes Grilley, are recent leaders of the Roundup—Cook serving as president of the Roundup, Grilley as president of the Happy Canyon Show. They say that the events generate from three to four million dollars of economic activity and in four days they will have fifty thousand spectators. On a Saturday, in a community of fourteen thousand people, there will be seventeen thousand in the stands.

Cook and Grilley say that about five hundred people help directly with the show itself, and certain families or groups of company employees traditionally do certain jobs in which they take great pride. Some of these assignments carry on down to the third and fourth generation. Cook says, "It's like the old boy says in *Fiddler on the Roof* ... it's TRADITION."

Linda Mautz is a former Roundup Princess. Now the wife of Pendleton lawyer Bob Mautz and the mother of three college students, Linda says her two sisters were Roundup Queens and their family has long been associated with the event. Her husband serves on the Happy Canyon Show board. Asked whether young people will return to Pendleton to work after college, Linda is pretty sure that her elder daughter likes city life. "But our younger daughter loves horses. She'll be back."

On the Umatilla Indian Reservation just east of Pendleton, Anton Minthorn is the Chairman of the Tribal Council. He says that the Indians of the confederated tribes — the Umatilla, the Cayuse, and the Walla Walla — are becoming more independent, more skilled, and more self-sufficient. "We are sending our people to school to learn the skills necessary to manage this reservation in today's modern world. We need doctors and lawyers...we need all of these professionals just as much as electricians and carpenters."

In town, at the offices of the *East Oregonian*, Publisher Mike Forrester has this view: "We go back and forth in this country over the independence of the Indians and then the dependence. We're in a swing now where the tendency is to treat them as a sort of sovereign nation within a nation. They have their own police department and they have their own courts and planning department and water department. They issue their own hunting and fishing licenses."

About fifty miles southeast of Pendleton lies La Grande, a gateway to the Wallowa Mountains, the Hells Canyon Recreation Area, and the eastern valleys of the Blue Mountains. The principal economic factors in this area are timber, agriculture, and the college—Eastern Oregon State College—Oregon's only four-year institution east of the Cascades. Jim Peterson, the president of the Oregon Board of Higher Education, lives here and he says that the presence of the college is pervasive "...not just in La Grande...but throughout the region. I think you'll find people talking about 'Eastern' in John Day, Ontario, and Pendleton ... because the faculty go there and teach. So you have

sort of satellite campuses. And the college contributes an immense number of cultural benefits that a lot of remote towns don't have. We're talking about the dramatic productions, the lectures, and the symphony performances."

Peterson says that another thing unique to the La Grande area is the Grande Ronde Hospital, the rural medical center for three counties. "We started with fifteen physicians in 1974. Now we've increased it to forty-five. I think a lot of these medical people are attracted here, not just for the practice of medicine... but the character of the people and the land. They came here not to make money necessarily, but to enjoy life." Bob Moody, the editor of the area newspaper, *The La Grande Observer,* reinforces Peterson's view on livability. Moody says, "I just interviewed a guy for a job at the paper. He has a Doctorate in Music from California. He says, 'I'll do anything to get up here... a paper route...or I'll free-lance doing some writing for you.' He says he wants room to breathe...room to roam." It's obviously a feeling shared by others.

It is a good hour-and-a-half drive from La Grande into the heart of Wallowa County. This is the land once claimed by Chief Joseph as the ancestral home of his Nez Perce Indians, and one look at the scenery, no less than spectacular, will show you why the Nez Perce fought so long to keep this land. The town of Enterprise is the center of commerce in the county, while Joseph, six miles south, is the entry point into the resort at Wallowa Lake and a breathtaking tramway ride that rises four thousand feet to the top of 8,200-foot Mount Howard. At this point, you stand at the edge of the Eagle Cap Wilderness, which encompasses eleven other peaks towering above nine thousand feet.

Irene Wiggins owns the Wallowa Lake Lodge, but she has turned the management of it over to her sons. Irene is almost ninety. She gets out and walks or runs with some regularity and she says, "I don't have a darned thing the matter with me except my hearing...and memory. But you have to get old some way... you can't die young."

Mike Brennan moved up to Joseph, to his father's 12,000-acre Lightning Creek Ranch, in 1941 just after he finished high school in North Hollywood, California. His father, Walter Brennan, had wanted to buy some ranch property, and it was Mike's agriculture teacher who persuaded the late film and TV star to buy, saying, "You won't find better grass in the whole country."

Grace Bartlett, whose father owned the *Bend Bulletin* for several years, is in her seventies and lives right across the road from her daughter's ranch. Grace has written a lot about the relations between the Nez Perce Indians and the settlers. After the Nez Perce War and the Bannock-Payute uprising in 1878, people really started moving into this part of the country. They were mostly stockmen and farmers — vigorous people with no

money, but willing to face real hardships. She says, "This is very rough country to survive in. The weather is very severe and unpredictable. It took people with a great deal of intelligence as well as 'guts' to make a go of it here."

Some people who are making a present-day "go" of it are working in a big quonset hut just a block west of Joseph's main street. They are the people running the foundry called Valley Bronze. Glenn Anderson started the company at the urging of a sculptor named Dave Magnoni. Kim Barnett and Lyle Isaak form his management team. They have grown from a start with three people to a staff of forty-five. Glenn says there are only five other foundries of this size in the United States. At Valley Bronze they are casting the work of about one hundred and twenty artists from many parts of the country. About a fourth of their clients are Oregon artists and a growing number of them are actually moving to the community of Joseph in order to be near the foundry that is casting their work.

One of these transplants is Ray Parmenter, formerly of Eugene. He has bought a house here and piece of ranch land and says he has worked with Valley Bronze for better than two-and-one-half years, beginning with a series of ten Olympic athletes. Now moving into a different style, he has created a ballet dancer, silver plated and priced at $3,600, called the *Dying Swan.* Fifty casts of his most well known piece, a female nude done in silver, sold out in seven days.

A pair of sculptors from Duvall, Washington, bought homes in Joseph as well. They are the identical twins, Debbie Lermond and Vicki Keeling. These two work as a team and they do nothing but Arabian horses. They created a trio of horses' heads in silver that they call *All the King's Horses* and have crafted other Arabians in bronze for clients around the world.

Another artist who brings her work to the Valley Bronze people to cast for her is "Gabe" Gable, a painter-turned-sculptor who markets her work throughout the Northwest. About the relationship between the foundry and the artist she says, "The foundry takes my original and turns it into its final form. So whatever they turn out...that's what it is. If the foundry doesn't do satisfactory work, then it doesn't make any difference what my original looked like...They've never let me down."

At the foundry they put it this way... "Every piece is the child of the artist. We take their children from them and recreate them. If we do it wrong, we'll hear about it."

So here we have another of Oregon's unexpected riches. In a tiny town like Joseph, artists have found nurture for their craft. They come here for the quality of the foundry work — and the quality of life. And that applies to so many of the places we have seen in Oregon. As one artist puts it... "The fresh air... the peace of mind... what can you say? It's just beautiful."

■ *Below:* The John Day River curves along the valley floor at the foot of Sheep Rock. The river is named for a Virginia backwoodsman who was a member of the Astor overland fur party in 1811. Day was captured by Indians near the mouth of the river where it enters the Columbia. He was rescued, but his name was attached to the river where his ordeal took place.

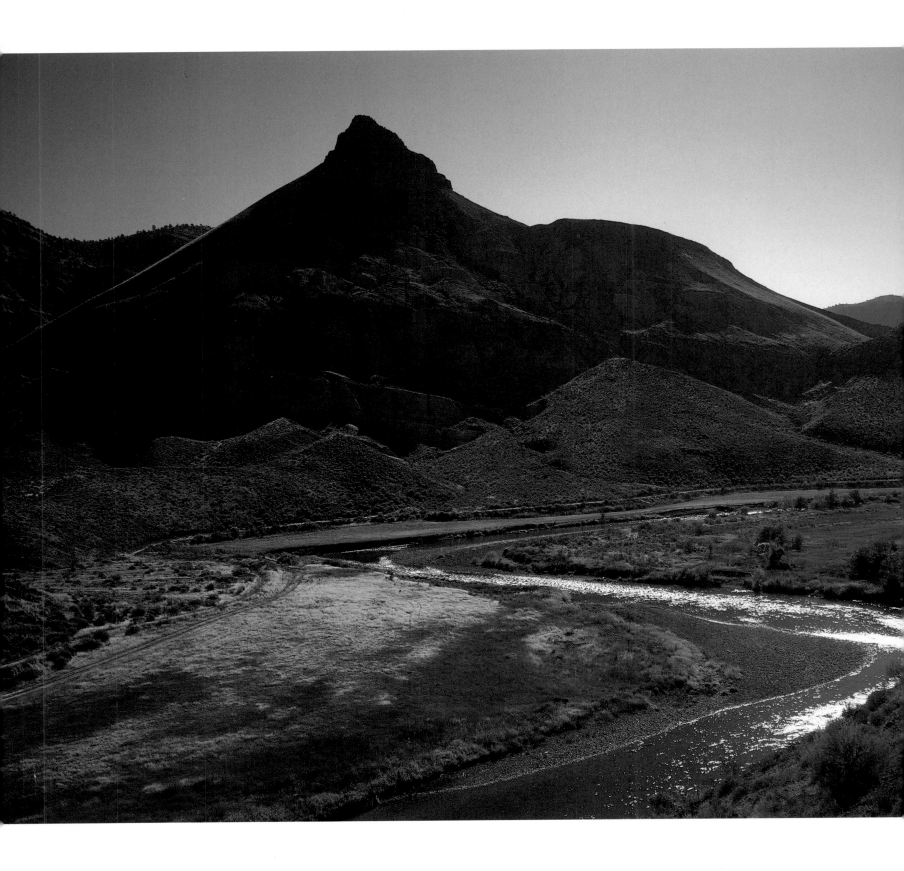

■ *Below:* Cold October weather explodes these cattails in the John Day River Valley. Strawberry Mountain, 9,038 feet tall, looms in the background. It is situated in the Malheur National Forest, some twenty miles southeast of the town of John Day.

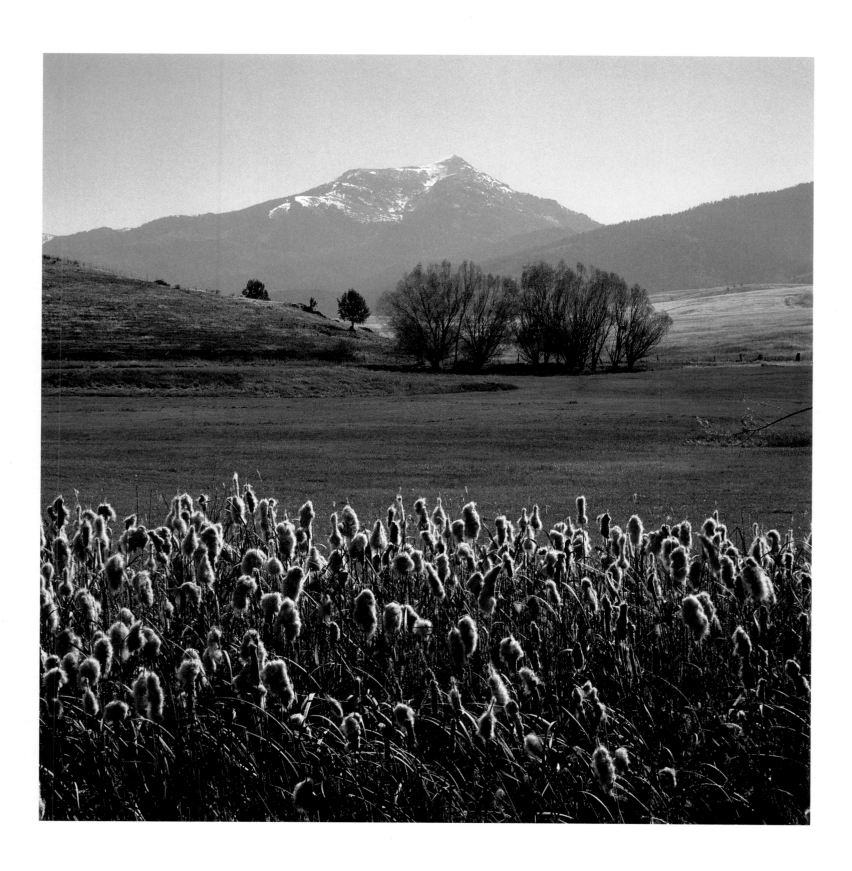

■ *Below:* Pendleton, home of one of the great rodeos of the West, is flanked by cattle ranches where roundups are more than celebrations. This is a food-raising and meat-producing community, where pointed boots and cowboy hats are not just ceremonial costume but normal year-round attire. It is also the home of the world-famous Pendleton woolen mills.

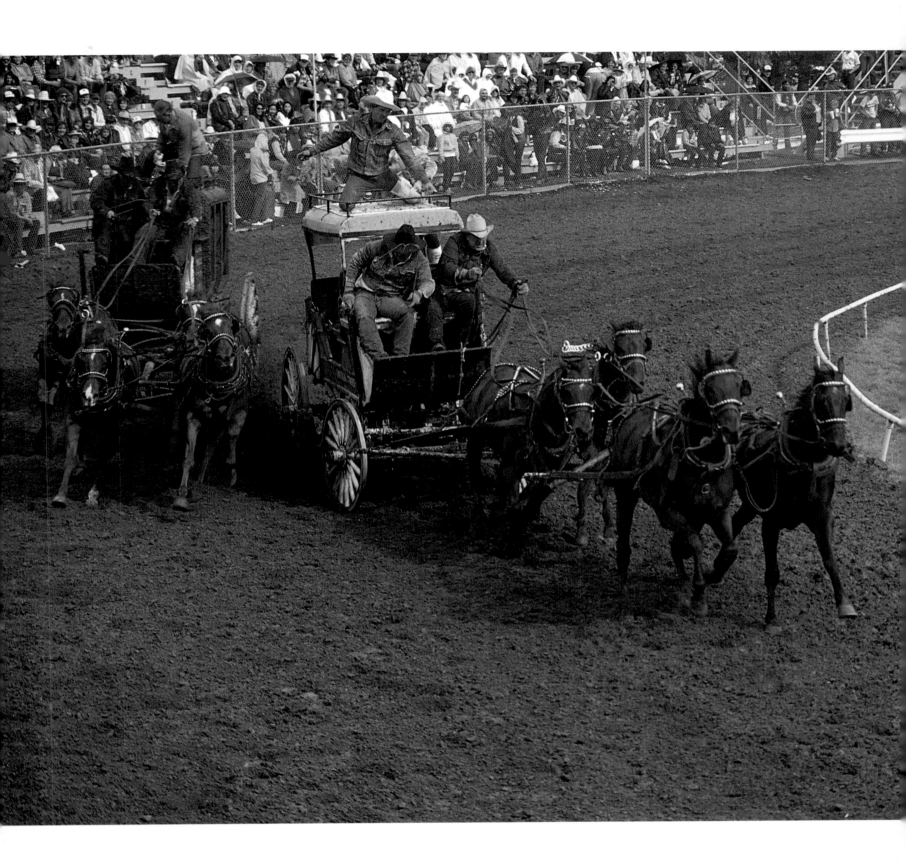

■ *Below:* Golden fields of ripe wheat spread over Umatilla County in northeastern Oregon. The soft white winter wheat used in noodles and pastries is the variety principally grown here. For over a century, wheat has been Oregon's leading cash crop. Prominent customers are Japan, Korea, and Egypt.

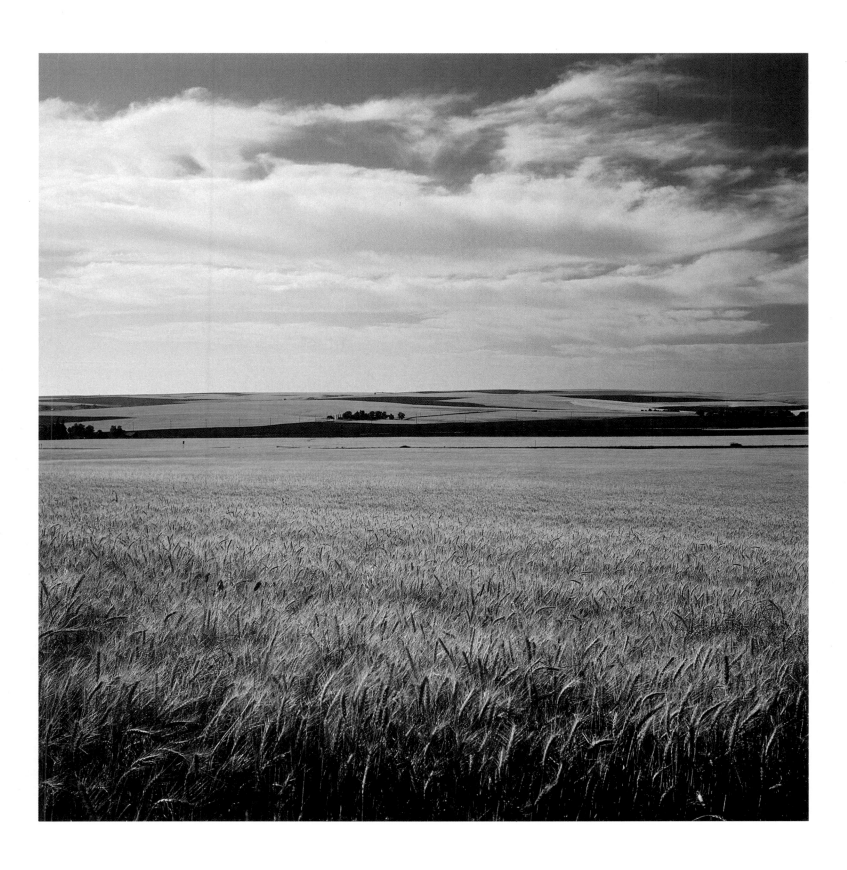

■ *Below:* A northerly view into the deepest canyon on the American continent shows where Hells Canyon Dam harnesses the power of the Snake River. On the left, in Oregon, river rimrock gives way to grassy benches and timbered ridges. On the right are Idaho's Seven Devils Mountains. Legend says a lost Indian hunter fancied he saw devils in their black cliffs.

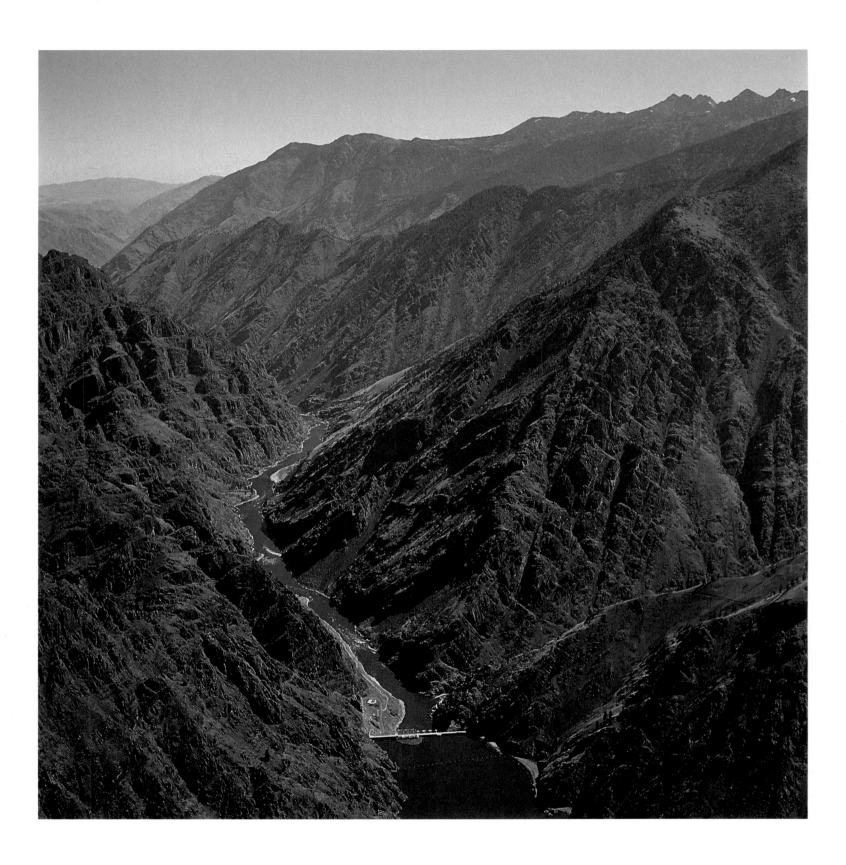

■ *Below:* Handsome pronghorn antelope are found in the sage-lands of the Malheur National Wildlife Refuge in Harney County and in the Hart Mountain Refuge in Lake County,
■ *Overleaf:* Wallowa County's Eagle Cap Wilderness area is two hundred thousand acres of lofty lakes, gushing streams, and Alpine ridges inlaid with limestone and marble split by monstrous upthrusts of granite and basalt.

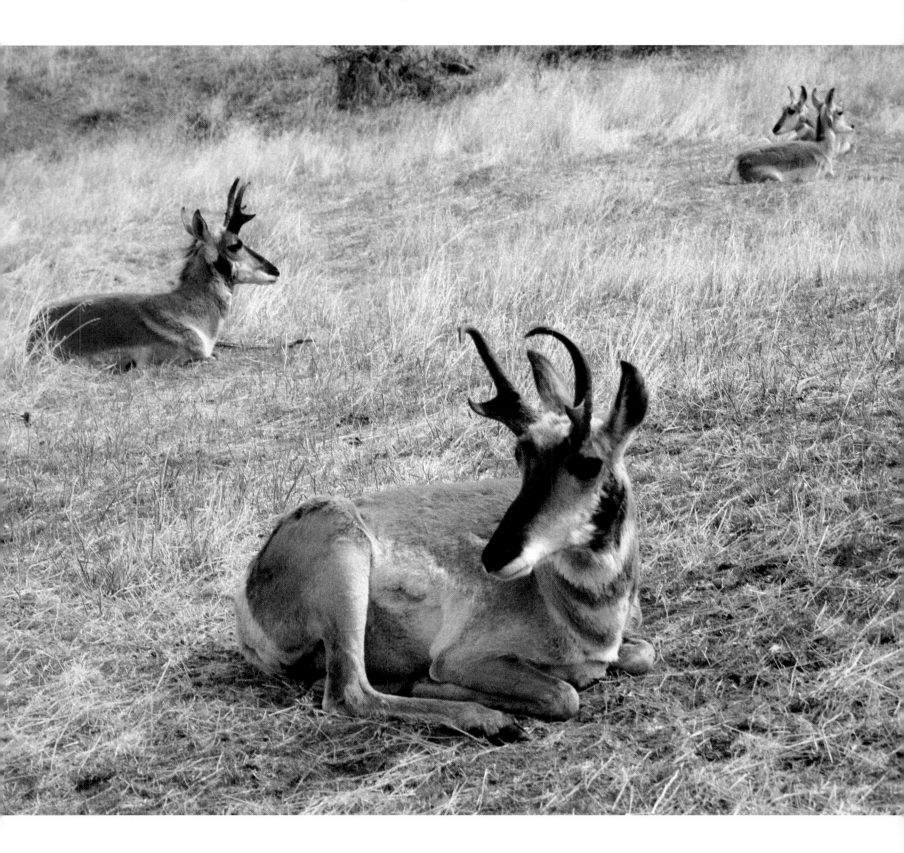

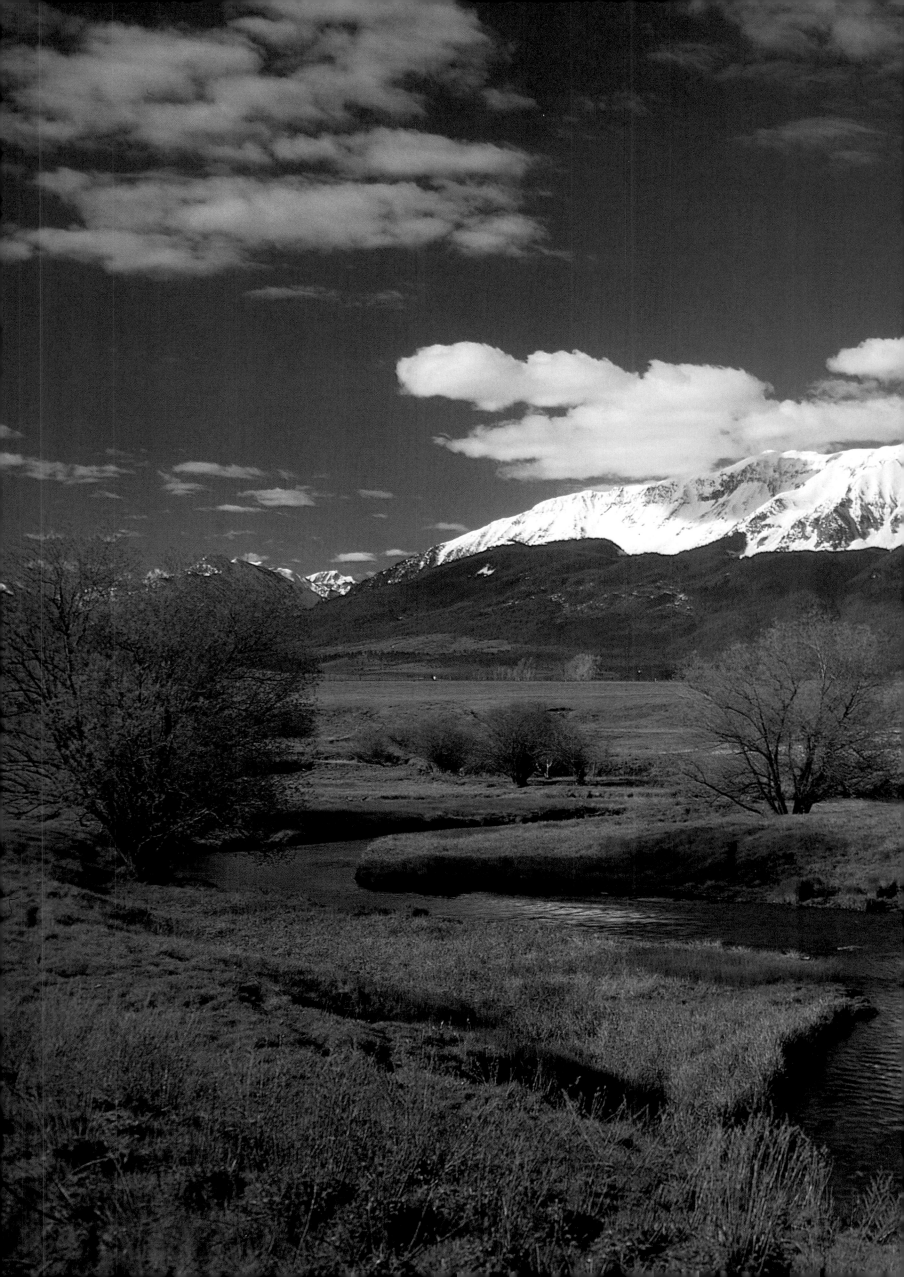

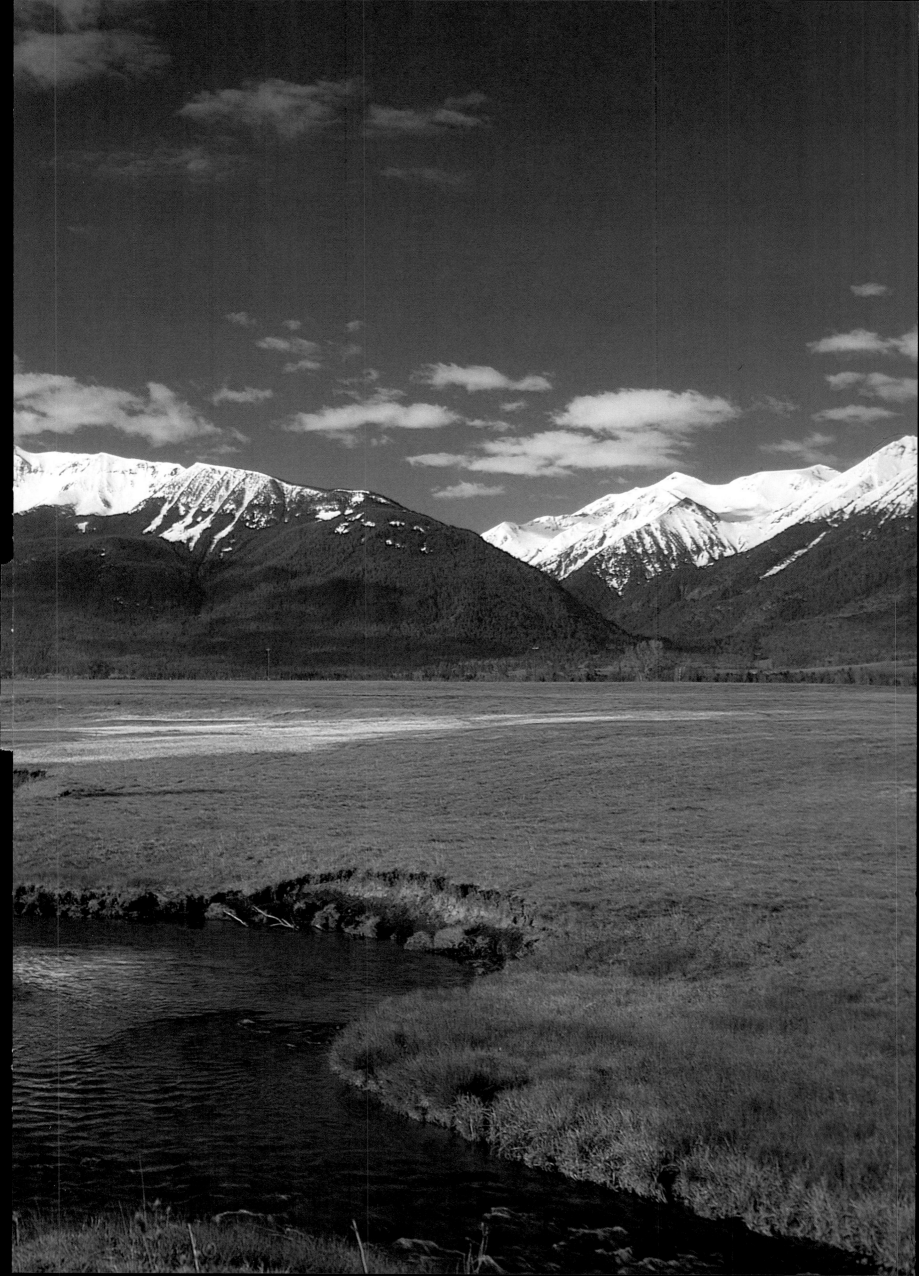

■ *Below:* Wallowa Lake, which Chief Joseph's Nez Perce were forced to leave, was formed by glaciers during the Ice Age. Its fishy inhabitants are smallish, land-locked salmon. ■ *Right:* Jewel-like Tombstone Lake lies just below the crest of the rugged Wallowa Mountains. Fishing and hunting is at its best in this wild region, which is accessible only by foot or horseback.

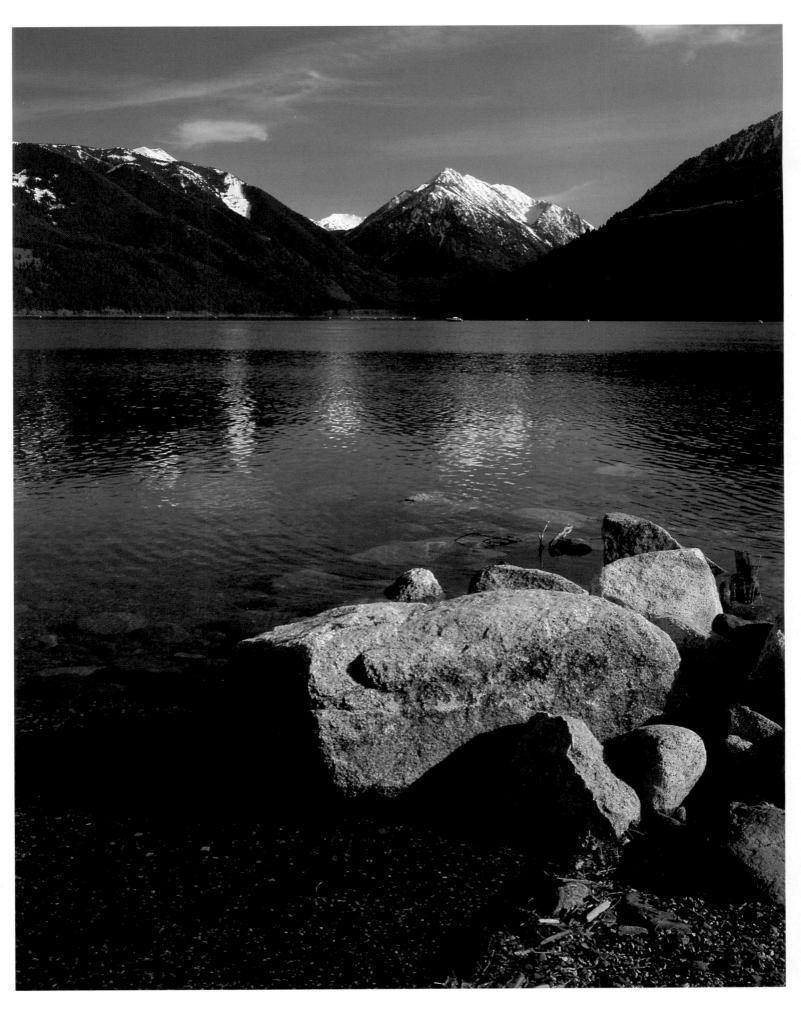

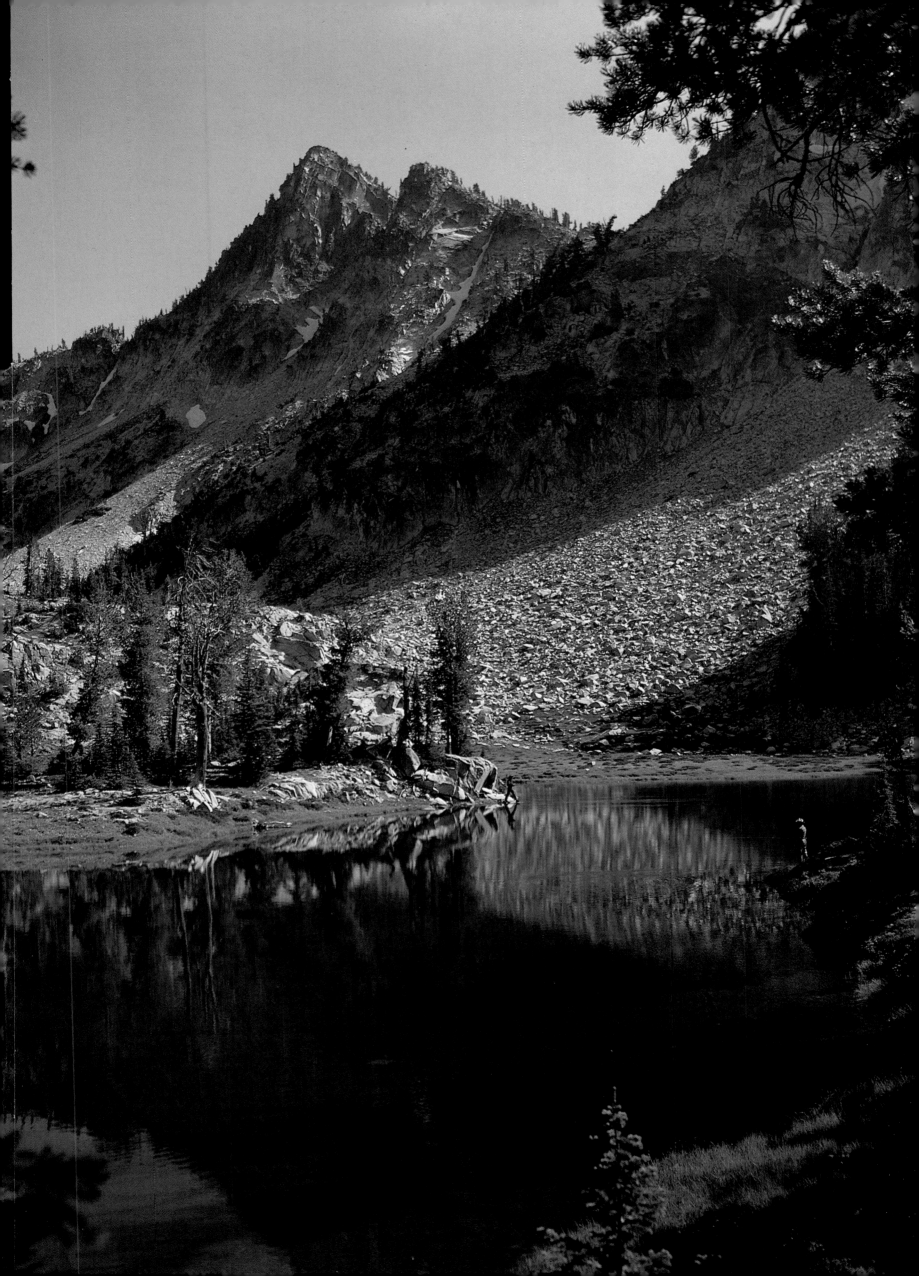

■ *Left:* A colorful mosaic of lichen spreads across the volcanic lava cliffs of southeastern Oregon rimrock in Harney County.
■ *Below:* An introductory "rush" greets river runners when they enter the deep gorge of the wild Owyhee as it approaches its rendezvous with the Snake at the Idaho border.

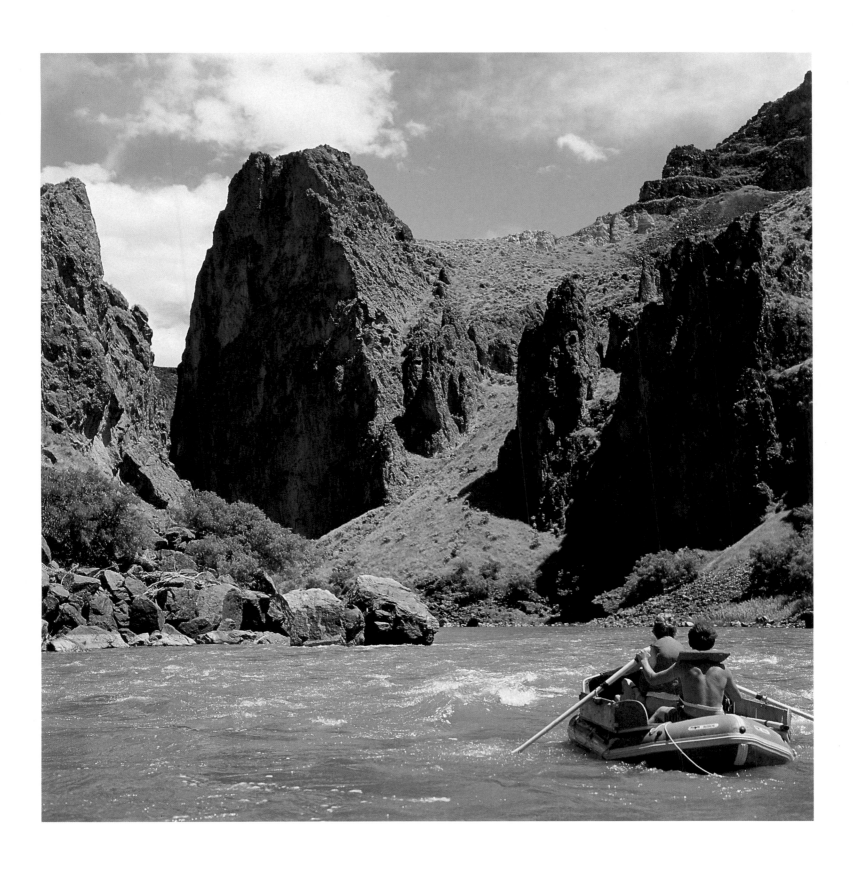

■ *Below:* A unique roof-truss design was used by pioneer Oregon cattleman Peter French in building the historic "Round Barn," the only one remaining of three round barns French erected in the late nineteenth century at his various ranch stations in the Donner und Blitzen Valley. Round construction permitted the exercising of horses during the winter months.

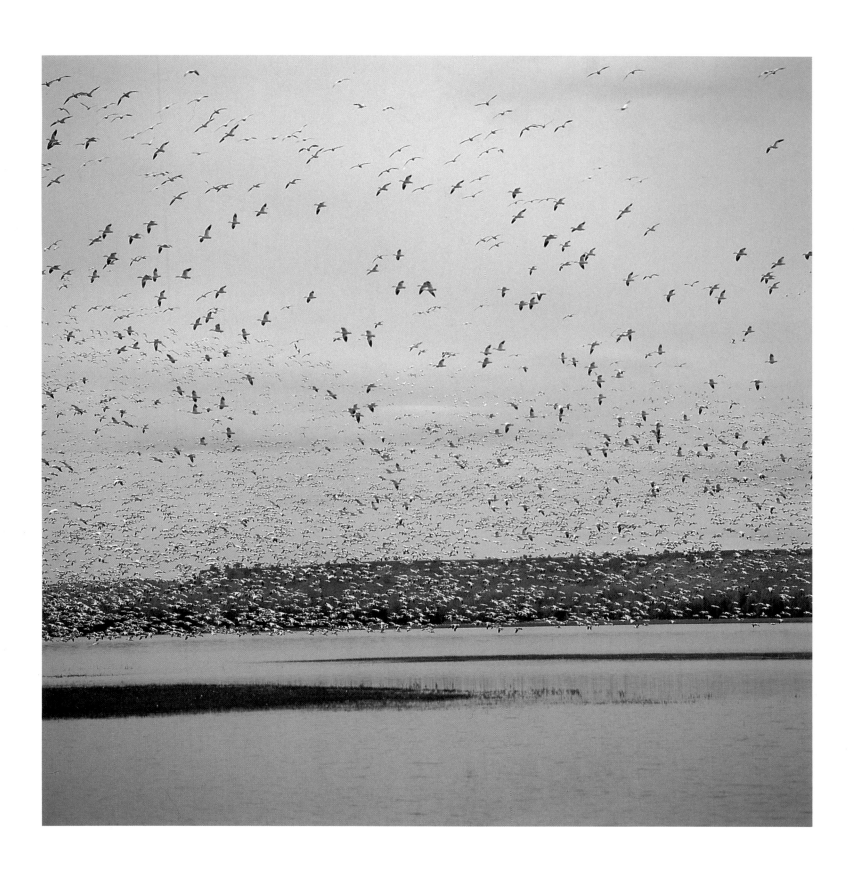

ACKNOWLEDGEMENTS

Oregon has been a happy hunting ground for me for well over half a century. In fact, it was just sixty years ago that I discovered this great part of the world after spending three summers exploring the west. It was a year later, in 1928, when I landed a job with Photo Art Commercial Studios and moved to Portland. It was then that I first began photographing the beauties of Oregon and the northwest during limited, spare-time trips into the mountains and along the seashore.

 OREGON III is a gallery of recent photographic impressions of Oregon. I am grateful to Graphic Arts Center Publishing Company for giving me another opportunity to preserve a few of these impressions so that others may enjoy some of the Oregon experience with me.

I wish, also, to express my appreciation for all the help I have received during the years from my wife, Doris, who has endured my obsessive pursuit of the photographic images of Oregon's immeasurable natural beauty.

My thanks, too, to countless others who have contributed to the development of OREGON III and the two volumes that preceded it through the years; and to Doris, and others who have relieved me of driving responsibilities on extensive trips throughout the state. Some of those trips on highways and trails have been made even more enjoyable by the companionship of enthusiastic, amateur photographers who are also infected with the compulsion to capture the beauty of Oregon on film. My special thanks to my stepson and protege, Rick Schafer, who has been working with me for several years. Rick's assistance on OREGON III was most valuable and appreciated.

My continued pursuit of my photographic profession would not be possible without the dedicated help of Doris and Rick, who relieve me of countless hours of tedious activities that are so necessary for success in the free-lance photography profession.

Ray Atkeson